The
Gift
of
Guylaine
Claire

Also by
 A.V. Walters
 THE EMMA CAITES WAY

 Winner of the 2012 "Best Literary Fiction" Award, by
 the Bay Area Independent Publishers Association (BAIPA)

The Gift of Guylaine Claire
by
A.V. Walters

Two Rock Press

Cedar, Michigan

This novel is entirely fictional, with no intent to depict actual persons
or events other than those within a few historical allusions.

Copyright © 2012 A.V. Walters

Published by Two Rock Press
P.O. Box 209, Cedar MI 49621
TwoRockPress.com

Book and Cover Design by Rick Edwards

ISBN: 978-0-9832172-7-5

Library of Congress Control Number: 2012946393

Printed in the USA

To
My
Parents

Notes on Pronunciation of French Names

I'll admit that sometimes I get stuck reading, even a great book, if there are foreign words that I just cannot pronounce. I didn't think that could be the case here, after all, I grew up in Canada; these names aren't foreign to me. But, my editor set me straight. These are French names and the English-speaking reader might have a problem. So I'm including some general, and some specific, tips for the principal names you'll encounter in this book. I apologize to those of you who speak French for the simplification of pronunciation.

Off the top, **Maisonneuve**, is pronounced, *May-Zone-Oove*. Actually there's a vowel sound at the end that we don't have in English, but this is close enough. (It means new house, but that's not relevant here. It's a venerable, old Quebecois name.) In French, like in English, when a 'g' is followed by a 'u,' it gives us a hard 'g,' like in guest. So, the name Guylaine, (and her father's name, Guillaume) starts with a hard 'g,' followed by the 'ee' sound. Thus, **Guylaine** is *Gee-Lain* and her dad, **Guillaume** is *Gee-Yoam*. (That double 'll' in French makes it sound like a 'y.')

Maybe you're old enough to remember Jean Claude Killy—the Olympic ski champion? (Oh, am I showing my age?) Or, perhaps you remember the annoying, coffee commercial with the "Jean Luc" character? No? Well, the 'j' in French is pronounced like the 's' in 'treasure,' a sort of *zh* sound. That should help with **Josette** and **Jean Luc** (the 'n' is almost silent and the Luc part sounds like *Luke*.) **Claudette** sounds like our friend, Mr. Killy (that we pronounce, *Kee-Lee*, by the way, which isn't quite right) ending with the *'ette.'*

Pére Michel (Father Michael, in English) is pronounced, *Pair Michele* (like the English name Michelle.) **Françoise** is, *Fran-Swah* (That's close, and once you hear it, you'll recognize it.) Finally, the name **Hélène** has a silent 'h' so it's pronounced *Ay-len.*

Ben Levin is pretty easy. Levin, sounds like leaven, as in bread. (The French have a problem with it—I think it's something to do with wine, but that shouldn't be a problem for the English reader.)

Some French names are spelled the same as the English version, so I won't trouble you with the way the French say **Lucille**, **Robert**, or **Roger**. (It may be easier just to read them, as you know them.)

vii

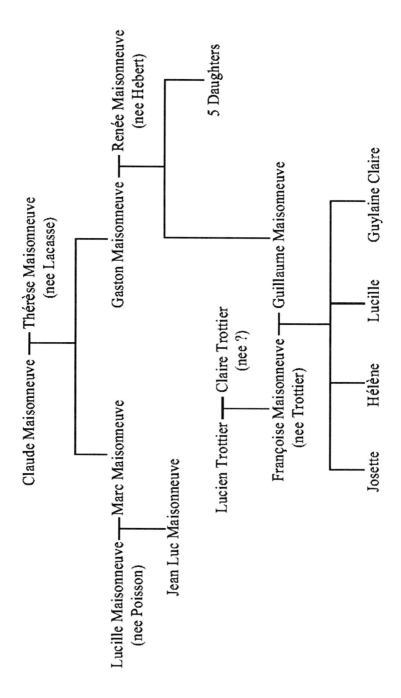

Claude Maisonneuve ── Thérèse Maisonneuve (nee Lacasse)

Lucille Maisonneuve (nee Poisson) ── Marc Maisonneuve

Jean Luc Maisonneuve

Gaston Maisonneuve ── Renée Maisonneuve (nee Hébert)

5 Daughters

Lucien Trottier ── Claire Trottier (nee ?)

Françoise Maisonneuve (nee Trottier) ── Guillaume Maisonneuve

Josette Hélène Lucille Guylaine Claire

Père Michel was headed home from the retreat just outside of Toronto. He hated those things—they required much more formality than back home in Red Wing. He tugged at his clerical collar. The church was changing and he knew it was necessary. Rocked by the molestation scandals and dwindling attendance, recruitment was at an all time low. Those who remained faithful were aging and required more services. That meant more work, with fewer resources. And, it was the same everywhere. Priests, once respected, were now regarded with suspicion.

These damned retreats required *full dress uniform*, like Halloween trips to the see *The Wizard of Oz*. At home in Red Wing he was far less formal—maybe a sport coat, maybe even a collar, but full cassock *only* on Sundays. His was a very tight knit, old-fashioned parish. With the manufacturing plants in Windsor, Red Wing had a stable population, even with the shift away from farming. He'd served there for over twenty-five years and was as much a part of the fabric of the community as the meandering river and the noisy birds that gave the town its name. Père Michel was the only bilingual priest ever sent to Red Wing. It was a brilliant choice, a quarter century earlier. It had helped to knit the French and English communities together, where before there'd been only friction. His arrival had stemmed the Anglican flight they had been experiencing in the English speaking community. Père Michel—Father Michael was an old-fashioned parish priest. He belonged in Red Wing in a way that he'd never experienced in his early life and in a way that was out of time. For that, he felt blessed.

He reached over and fiddled with the radio. With any luck he'd be out of Mississauga before the Friday afternoon traffic hit. He looked for a soft-rock station and realized he was getting old—years ago, a trip to Toronto was a welcome break. He'd take in a

1

museum or wander downtown, but now he just wanted to avoid traffic and get home. He'd tried calling Guylaine, but there was no answer. *Too bad.* Even though Oakville was out of the way, a trip to her eclectic studio-home was always a treat and it gave him something to report back to her parents. They were old school. In their time, a girl didn't move out till she'd found a husband, but they were proud of her. She was, after all, a famous sculptor. Still, they worried about her unorthodox choices. At thirty-four Guylaine was successful and renowned. She lived and worked in a converted cannery that accommodated her home, workshop, foundry and a number of small studio/apartments that she rented to struggling artists. She had a steady, long-term relationship with an art-history professor at the University of Toronto. By all modern measures, Guylaine was a complete success. Still, they *were* her parents, so, they worried.

She did not seem inclined to marry or have children. Her partner, while accepted with open arms by most of her family, was Jewish. Guylaine had always been a little odd and that out-of-stepness had made her parents over-protective, even as the same trait inclined Guylaine to strike out on her own. As usual, Père Michel saw both sides and, for once, that was not a torment; it was part of the glue that was his connection to this family. He'd been part of the Maisonneuve clan since his arrival in Red Wing. They were the main reason he'd stayed so long, and why he knew he would never leave what had become his adopted home. Family had never been a pleasant experience for Michel, so landing in a village where he was accepted and included had come as a surprise, and then once embraced as family, as a blessing.

The music now changed to *country*, so Michel searched for another station. He eventually settled on the news, in French—Ici Radio Canada. But, the regular broadcast was being interrupted for an update on the siege up at Crowsfoot. Père Michel sighed. Like many, he'd hoped that the new Crowsfoot Cultural Center would finally lay to rest the tensions of Oka. Now, *another* siege, at yet *another* disputed indigenous site, threatened to undermine what little progress the Canadian Aboriginals had made. There was always some angry splinter group that fractured the peace. When Père Michel caught the lead-in on the radio, *"Indian Activist, Paul Labute..."* he turned up the volume. Labute was a former lover of

Guylaine's, from an angry time more than a decade ago, when Guylaine was working through her family's history. The guy was bad news.

The call came while Josette and her mother were out in the garden. Josette wiped her brow with her free hand and squinted into the slant of the late afternoon sun. The weather was unseasonably warm for late October. Josette smiled inside and smirked—*Indian Summer*. She thought she heard the phone ringing. Shifting the bushel basket of green tomatoes to her left hip, she asked, "Maman, do *you* hear the phone?"

It was a silly question, really. At her age, it wasn't likely her mother could hear any better. Françoise looked up and cocked her head.

"Oui, I think you're right, but you'll never get it in time." Françoise stooped back down to the task of giving each of the green tomatoes a squeeze to see if it was soft enough to harvest before the frost. She waved her hand, "Don't worry, if it's important, they'll call back."

Josette rolled her eyes. It drove her crazy that her parents still wouldn't use an answering machine. They were probably the only home in Red Wing whose calls went unanswered. Not that they didn't *have* an answering machine—they had several. All *well-intended* gifts. Her folks just couldn't figure out how to make one of the darn things work. Inevitably, the machines found their way into the closet, right after another failed installation attempt.

"We've got three bushels, Ma. How many you think you're going to pick?"

"Well, there's no use letting them go to waste. A lot of these will ripen on the windowsill, and I told you, I'm going to make chutney. What with the long season, there was a big article in the Windsor Star. I asked Guylaine about it."

Josette turned her head and caught the faint ring in the warm breeze. She turned, and bushel basket still perched on her hip, she sprinted for the back porch, hurdling the remains of the summer garden. By the third ring she'd cleared the garden and threw herself up the peeling back steps, through the door and into the

kitchen. *Not bad for 53*, she thought, reaching for the phone on its fifth ring.

Breathing hard, she panted into the handset, "Maisonneuve residence. Josette speaking."

There was a pause on the other end, then, "Josette, are you okay?"

"Sure," she said, breathing hard. "Just ran in from the garden is all. Who's this?"

"It's Bill Campeau."

Josette knew Officer Campeau from her work at the bank. Even in semi-retirement from the funeral home, her parents continued to be the connection when an accident took a local life. Red Wing was small enough that the Ontario Provincial Police still handled most matters.

"Josette, I'm glad it's you who took the call. I've got some bad news. Are your folks around?"

"Well, my mom's here, but dad's out at the hardware. What's up, Bill?"

"That business goin' on up at Crowsfoot's gone and turned ugly. Don't know any better way to say it—Guylaine was involved, and she was shot."

Josette paused to catch her breath. "But she's not in that, you know. She's not involved with that guy anymore. Not for a long time."

"Josette, we really don't know the players yet. Just that Guylaine went up there today and she was shot. It's all over the TV. We've got to tell your parents what happened before they flip on the news or hear it from someone else."

"Back up a minute, Bill. *Shot*? What do you mean she was shot? Is she okay?"

"I'm... I'm sorry Josette. I guess I'm not making myself clear. Guylaine was killed today, up at the siege at Crowsfoot."

The basket slipped from Josette's grasp. One of its wire handles caught on a cabinet knob—green tomatoes cascaded out, rolling every which-way. Josette leaned over the kitchen counter and let out a moan.

"Josette!" The voice in her ear was strident, "Josette, you can't help your sister now. But, your parents are going to need

you. You have to tell your mother. I'll go down to the hardware and see if I can find your dad. So, *please,* pull yourself together."

Of course, he was right. Her parents were going to need her. This was the second time they'd have to bury one of their children. Josette heard her mother coming up the back stairs.

"Thanks, Bill. Find my dad and bring him home, okay?"

"I'm on my way now, Josette." He hung up.

Françoise stepped into the kitchen. "Josette, what's going on here? You're bruising up all the tomatoes."

Josette slowly turned to face her mother.

Officer Campeau turned on his flashing lights and pulled out onto the highway. He turned into the old section of town towards the hardware, only to see a second set of flashing lights already in the parking lot. His jaw tightened. This was what he'd hoped to avoid. He saw the gurney as it was wheeled out between the pumpkin displays, Guillaume Maisonneuve, ashen, strapped in. Guillaume's cousin, Jean Luc, followed the attendants to the ambulance, wringing his hands. Bill Campeau stepped out of his patrol car and caught Jean Luc's eye.

"*Jesus*, Bill. I just can't believe it."

"I know." He nodded towards Guillaume, "Did he find out about it on TV?"

"Yeah, we all did, right there at the check out. I swear, he just keeled right-over."

Bill turned to the paramedics, "How's his heart?"

"S'good, probably just shock. I guess he saw his daughter killed right there, on the TV, eh?"

Bill shook his head, "You mean they *showed* it? The actual shooting?"

"Yeah, in *Technicolor*," Jean Luc spat bitterly. "Aren't they supposed to notify the family *first* or something?"

Bill Campeau turned again to the ambulance crew, "Any chance we could get him straight home?"

The attendant looked up from rolling up the blood pressure cuff, "No, not likely."

"If I picked up his wife, could you hold off a bit so we could accompany him into town?"

"Sure, it's not critical, but he's got to get checked out. Not a bad idea to bring the wife. They'll probably want to prescribe sedatives for the family. We'll hold for ya on the highway, just past the river."

Bill reached out and shook his hand. "We'll be right there." Then, shaking Jean Luc's hand he said, "I'll keep in touch." Officer Campeau slid into the patrol car and headed out to the big house on the edge of town.

With the radio volume up, Père Michel listened to the update, "...*authorities are unsure of who is responsible for today's tragedy at Crowsfoot, the Mounties or the armed insurgents under Paul Labute's control. So far, we know only that all of us bear the senseless loss of Canada's foremost French-Canadian sculptor...*" Michel hit the brakes and swerved wildly on the 401 highway. He recovered control and fumbled with the volume. "*...more news at the top of the hour on the shooting death today, of Guylaine Claire.*" Michel couldn't breathe and thought he would choke. He pulled over to the shoulder and sat shaking in the driver's seat. Suddenly, he felt very old. His mind was racing and he was dizzy. He knew that, back in Red Wing, his dearest friends and family, the Maisonneuves, were hearing this same tragic news—their youngest daughter, and his own dear friend, was dead. He knew that he should be there, in Red Wing, for them. But, just now, he couldn't drive. He struggled to step out of the car for some air, and leaning against the vehicle, he stumbled away from traffic to the passenger side before he retched and vomited.

Michel didn't notice that he was not alone. Behind him, a provincial police patrol car had pulled to the side of the highway, lights flashing. Two officers behind mirrored glasses peered out at him, shaking their heads. The one on the passenger-side stepped out and approached the shaken priest.

"Excuse me, Father, is there a problem here?"

Père Michel, in full cassock, turned, startled. But overcome, he could only manage to lean over and vomit again.

"Okay, that's it, pops. You're obviously in no shape to drive. You need to step over here, please." The officer motioned him over to the patrol car.

"*No*, you don't understand…" Père Michel stood, leaning on his car and wiping his mouth with a used Kleenex from his pocket. He gestured vaguely at his car, "No… *On the radio*, I've just heard terrible news." He took several steps back, in the opposite direction.

"*Hold on there*. This way, pops," the cop was pointing to the back of the patrol car.

"But, you don't understand. My friend has been *killed*." Père Michel realized they thought he was drunk. He knew that it didn't look good.

The other officer stepped out. He was shorter and stocky. "Is he resisting? You need a hand with the priest?" He was almost laughing. Père Michel started to cry.

The short cop piped in, "What is it with priests these days? I'm Catholic, and *my* priest doesn't drive around drunk!"

"I'm *not* drunk," Père Michel sobbed. He approached the first officer. "I just learned on the radio that my friend has been killed." Then, slipping on the loose gravel, his ankle turned on the uneven shoulder. He lost his balance and fell. Both officers jumped to try and catch him. Michel was acutely aware how bad this all looked. Traffic was now slowing as rubberneckers gawked at the unlikely scene. The first officer scooped him up, while his partner cuffed him, then they stuffed the priest into the back seat of the patrol car. The stocky cop secured the priest's car and returned to the driver's seat of the cruiser. Père Michel lay on the backseat, weeping. He heard the tires churning the gravel as they pulled away to take him in.

"I just hope he doesn't throw up, again. I really hate it when they barf in my car."

7

Chapter 2

"So, what's his full name?" the sergeant asked, peering up at him.

"His full name?" Uncuffed, Père Michel leaned on the sergeant's desk like a pulpit.

"Yeah, this friend who died. What's his full name?" The desk sergeant was starting to question whether this priest was drunk after all. It wasn't exactly clear *what* was wrong with him, but he wasn't drunk.

"*Her* full name is Marie Eva Simone Guylaine Claire Maisonneuve. Her professional name, as an artist, is Guylaine Claire. She didn't *just* die. She was shot up at Crowsfoot, today. Just turn on the news. I heard it on the radio and that's why I got sick."

"Sarge, I think the guy is right, it's on the news." The arresting officer was beginning to feel sheepish.

"So what *are* his numbers?" the desk sergeant snapped.

"Zero. No booze, boss," reported the partner.

The desk sergeant shook his head. "Did anybody even bother to talk to this guy? Was a field sobriety test even done?"

"No sir, but he was staggering and vomiting. He didn't appear capable of taking a field sobriety test, sir." The taller cop cringed, stooped at the desk.

The desk sergeant shook his head, "*Jesus Christ…* Excuse me Father. So we've arrested a grieving priest, have we? And just what *is* the charge?"

"Well sir, he was in no condition to be driving."

"But he wasn't driving when you picked him up, was he? He had pulled over." The arresting officer was beet-faced.

The desk sergeant turned to Père Michel, "Just what is your relationship to the decedent?"

"I am her parish priest." For the first time that day, Michel was relieved to be in full, official attire.

"Father, I'm sorry that these officers can't tell the difference between a drunk and a motorist in distress. I think the least they

owe you an apology and a ride back to your car. Is there anything that we can do to try and make up for your inconvenience today?

Michel thought for a moment. "Yes. Two things, sir. I'd like to use a phone and, on the way back to my car, I'd like to ride in the *front* seat."

The desk sergeant smiled. "Done. I guess it does look pretty bad for a priest to be riding in the back seat." He turned to the patrol officers, "Well? You guys heard him, get him a phone, boys. It's your lucky day—he's going easy on you, eh."

Now seated in a quiet office with a phone, Michel paused a moment before dialing the familiar Maisonneuve number. *These dear sweet people, how could they bear up through this?* He bowed his head and spoke quietly under his breath. "This is *your* call, God, and it had better be good. I can't say that I see your ways here, and I'm going to have to explain it somehow to these people who have loved and served you so well." Père Michel had a different kind of relationship with *his* God.

He dialed the number, and was relieved when Josette picked up the phone. "Josette, it's Père Michel, how are you? How is everyone?"

"Not so good. Dad collapsed when he saw it on TV. He's in Windsor, at the hospital, for the night. Mom and Hélène are with him."

"He *saw* it? What's his condition?"

"They think it's probably just shock but they wanted to keep him for observation. Michel, he just can't stop crying. Mom's a brick, but she's just gone into emergency mode, you know?"

Michel knew too well. The Maisonneuve family operated the main funeral home in the area. Through thick and thin they had consoled the people of Red Wing through almost every tragedy and loss over the past fifty years. No matter how close their loss, the Maisonneuves didn't get to grieve until everyone else was taken care of. Françoise was stepping up to the plate for Guillaume and the others, as she had always done.

"Where are you?"

"I'm still in Toronto, but I'll be on my way, any minute."

"Père Michel, maybe that's a good thing you're still there. Mom's worried about Benjamin. I haven't been able to reach him at home. Lord knows he must know by now. Can you try to find

him? And when you do, bring him here. Maman insists. He must know that he *is* family."

Michel swallowed hard. *Of course, Benjamin.* He had been with Guylaine for more than a decade—partners without papers. His loss was as much as anyone's, maybe greater.

"I'll do what I can. Do you have his numbers, work and home?"

Josette gave him the information and added, "Please, find him, then come home. You don't know how much you're needed here. I am worried about Maman. She can't carry it all."

"I'll be there as soon as I can."

"Thank you, and hurry home." Josette hung up.

Père Michel's heart ached. He could barely stand the loss of Guylaine Claire—his favorite of the Maisonneuve girls. And, he felt a little cheap that his heart soared to be of use to this adopted family that he loved so much. Their loss provided the opportunity for him to give back. Only tragedy revealed how tight their bond was and he felt selfish at that satisfaction. He turned to his *personal escort*, the arresting officers, "Gentlemen, there'll be one more thing. We need to find a grieving man."

It's amazing how effective grateful police officers can be. He could have been angry, but Père Michel wasn't. He did not curse or rail. A police escort and their assistance in locating Benjamin Levin was payment-in-full for their error. If it hadn't been for them, Michel would have rushed home to Red Wing. Without them, Benjamin would have been left to suffer alone.

When they found him, he was on the floor in his office, leaning against the closet door and leaning even harder on a near-empty bottle of bourbon. Père Michel thanked his uniformed escort and turned to the task of bringing Ben home to Red Wing.

Chapter 3

Josette set one of the grocery bags on the kitchen table and smirked at her compulsion to stock the larder when a crisis hit. In the dark kitchen she slung her purse over the back of a chair, opened the fridge with her foot and loaded the remaining bag, intact, onto the cold shelf. Her parents would need those staples when they got home. She'd also picked up morning rolls, which she left on the counter. Josette stood stocking-foot, in the refrigerator's dim light, to reflect. After some tests, her father had been admitted for observation and then sedated. Her mother had decided to stay at the hospital with him. Thankfully, they'd offered her the unused bed next to his, in the double room. Josette pursed her lips. That was good because she didn't like the idea of either Guillaume or her mom being alone tonight.

Once they'd settled, Hélène had waltzed in with Roger. Josette wanted to believe that her sister would take up some of the slack in this, but if this evening was any indication, Josette shook her head and sighed.

She checked her watch, shocked to see how very late it was—too late for any real dinner. She reached into the refrigerator, grabbed a chocolate vanilla swirl pudding-cup and closed the door, stopping for just a moment for her eyes to adjust. With her free hand she opened a drawer and plucked a spoon from the tray. She closed the drawer with her hip and padded back to her bedroom.

Crisis was an interesting time to observe family dynamics. Not that this was new to Josette, or any of the Maisonneuves. In the funeral business you get to see the best *and* the worst of a town. Josette knew too well from painful personal experience the toll an unexpected death could take. People didn't have the time to contemplate or to conceal their real motives, so life's baser natures and their tangled, unmet needs spilled out. Josette pulled a flannel nightgown over her head, and slipped into bed. She reached for her pudding cup and peeled off the foil lid. She licked the top clean and set it back on the nightstand before reaching for her spoon. The pudding itself was just okay—what Josette really liked about it was the ritual of eating the combination of chocolate and vanilla without mixing the flavors in any single bite. She'd take

her spoon and carefully run it along the edges of the swirl, trying to keep each mouthful pure. Josette saved these treats for hard days at the bank. It was the perfect, focused dessert. It could take her as much as forty minutes to carefully carve through a pudding cup, bite by bite. Usually, it put her mind at ease, like meditating. Tonight she shook her head between bites. *Hélène.*

Josette was the oldest Maisonneuve daughter, followed seven years later by Hélène. They'd grown up very differently. Josette was there in the early, lean years. Her parents were young, a little insecure and under the thumb of her dad's uncle in the operation of the funeral home. Times had been tight, but her parents bloomed with the challenges. Josette grew up learning to pull together with the family, to fill in the gaps and help. By the time Hélène came along, Josette's helping out had become second nature.

She skimmed a perfect, curled ribbon of chocolate in her spoon and sighed—maybe there *was* something to birth order when it came to personality. Not that Hélène didn't *occasionally* pull her weight—she did. The woman could be a powerhouse of energy if she chose to put her mind to it. And, Hélène had talents. She was a great cook and had an eye for decorating and gardening, she did flowers. Hélène really did have a flair for things. This wasn't the first time Josette had pondered this particular puzzle.

As best she could tell, it was just a question of perspective. Somehow, Hélène managed to take *any* situation and make it all about her. That evening she had come into the hospital room distraught, her eyes pink and swollen. Under the circumstances, this was understandable—they had, after all, just lost a sister. But, when confronted with her father looking tiny and frail in a hospital bed, Hélène had collapsed into the only visitor's chair *and wailed*, instead of reaching out to comfort him or even inquire about his condition. Soon the nurses gathered at the commotion, and Hélène was trundled off to get *her* vitals checked. Josette and her mother had just shrugged. *Hélène.*

Josette paused to work out the angle of attack on a difficult corner of the pudding-cup. The effort underscored her concern about her own reaction to the tragedy. Her initial kick-in-the-gut reaction, to Bill Campeau's call, captured her true feelings. Since then, she'd been cruising on autopilot. She wondered when it

would hit, when she'd feel the loss. As adults, she and Guylaine had become close. Josette shared things with Guylaine that she couldn't share with any one else. Those confidences were rich—richer than she'd have ever thought possible with a sister almost twenty years her junior. Despite her sometimes "odd" mannerisms, Guylaine could really be present. Josette had been able to smooth the way for her in the banking and business worlds. And, Guylaine had given her older sister a way to connect with long buried feelings. She laughed out loud, realizing that she and Guylaine were truly opposites. Guylaine often had trouble relating to others but was squarely in tune with her own feelings while Josette, on the other hand, was adept at the interpersonal, often at the expense of her own emotions.

She and Guylaine had often talked about their parents' age and health. They'd acknowledged the unthinkable—that their parents wouldn't live forever. In their own *catty* code, they'd shared their opinions on Hélène's reactions when either, or both, of the elder Maisonneuves finally succumbed. Guylaine couldn't imagine either parent without the other. In her mind they were solidly joined at the hip, one completed the other. But, Josette took a more practical view; if anything happened to one of their parents, the other would need to be cared for. And, they both agreed that when the time came, it would again be center stage for Hélène, and *her* take on grief. Taking a line from a favorite comic strip, Guylaine called Hélène's antics, *"Good Grief."*

Here they were though, faced with the loss of the youngest of the tribe. Josette shrugged, shaking off the depth of that loss. She was now left to comfort her parents without an ally, and Hélène pulling in her own direction. Josette scraped out the last of the pudding, with no choice except to mix together what little remained of the chocolate and vanilla. Licking her lips she set the plastic cup on the nightstand with the spoon. Josette scootched deep under her covers and switched off the light.

Chapter 4

Even under sedation, the beeping monitors, the institutional background noise and the constant interruptions kept Guillaume from getting any real sleep. But, neither could he fully rise to consciousness, or have any understanding of where he was or why. From time to time he'd jerk to an almost present state, with a full recollection of the television image of Guylaine, her attention riveted by a fallen young man, starting into the courtyard at Crowsfoot and then the shocked look on her face as she fell with that stain spreading across her white shirt. Even in death, his daughter was beautiful. Was this pride? At one point he wondered, maybe even called out the question, *"Am I in hell?"* Surely if there was one, this would be it. Several times he felt Françoise's hand on his forehead, his shoulder and maybe soft kisses. He knew it was Françoise because she was humming that shapeless little tune she usually hummed while doing dishes. So, *this* could not be hell. Françoise, even if she, too, had died, would surely not be in hell. For Guillaume, this was a certainty.

That wafting tune brought Guillaume to music. There, he could grasp some order in his freewheeling state. He ran through the standard choir repertoire for Sunday mass and searched his memory for special pieces for the Christmas or Easter Mass. He remembered favorite passages from opera. In music, and in that sliver of awareness it brought, Guillaume found some sense of peace. Then, he'd drift a bit more and, disturbed by the nighttime rhythms of the hospital, it would start again.

Guillaume wondered why *he'd* be in hell. A devout man, he believed he'd confessed his sins and been absolved. But, this torment, this recurring image conjured up memories of his failings, his petty resentments, so much so that Guillaume felt his soul just might be at risk. He was an old man. His recent behavior was generally beyond reproach. Ah, but youth. In his youth Guillaume had quietly carried a great deal of ill will in his heart. A childhood seething with hurt and rejection, because he was a cripple, had made him proud and distant from his father. He'd hated his Uncle Marc, hated him for the cheap and mean-spirited ways in which hc'd treated Guillaume and his family in their early

years in the business, hated him especially for the way he'd treated Françoise. Uncle Marc resented Françoise. He bristled at the cost of Guillaume's college education, even though that'd been the deal. In exchange for Guillaume's education and his participation in the funeral home, Marc's only child, Jean Luc would get the family farm. Guillaume didn't think about these things anymore. It had all worked out. But, Marc was a bitter widower, and when Guillaume returned from Montreal with a bride, and such a bride, Marc fumed. Guillaume had forgotten all that.

What a bride. Even in his tortured tossing, Guillaume warmed at the memory. Françoise was beautiful and gentle and loving. He'd pinched himself at his luck and thanked God for His Grace. Nothing in his life was so pure a display of the power of God's love as this wonderful woman who'd found him. So, surely this could not be hell. Even here, wherever he was, he felt her tender kisses and concern. Was Guylaine really dead? Guillaume struggled with his wavering thoughts. He could not hold onto a thread that made any sense. Why would *his* daughter be killed? Where was the sense in that? In his drugged recollection of the day, Guylaine's deadly dash was weirdly mixed with Jean Luc's store and the purchase of hardware to hang Françoise's bird feeder. Winter was coming, and now his youngest daughter was dead. The birds would starve. He tossed, tangled in the sheets. Guillaume tried to set aside his confusion, wanting to think about music. Instead, there was Françoise. *His center.* Her small strong hands kneaded his shoulders. She whispered in his ear, but he could not make sense of the words.

In every infirmity there is some kind of gift. Guillaume believed this. He believed that the failure to find that gift was our greatest failing. He'd learned it from the love of those small hands. He was awash in memories, floating without edges. Guillaume's clubfoot had been his family's loss, their only son a cripple. In the manner of the day, they made little effort to address the problem. It was as it was—a shame, a quirk in God's plan. As a child Guillaume had tried to make his shoe fit with wads of newspaper, or padding from extra socks. His mother took his empty shoe to have the sole built up, to help ease the limp. Otherwise the boy was on his own. Guillaume developed a staggered gait, mobility at a price. Walking was a major endeavor. Yet his disability opened

15

doors to books and to music. It was the reason he went to college, where he met Françoise.

When he married Françoise her loving hands found the ache in it—his taut muscles, his posture twisted by the effort. Most nights Françoise massaged the spasms in his shoulders, pounding and kneading them to relax. Guillaume flourished. He stood taller. It eased his pain. Françoise insisted that he find a shoemaker. Custom-tailored shoes! A luxury for a poor man but she insisted on it. Correctly cobbled, Guillaume stood taller still, walked evenly, hardly needing the assistance of his cane. And, there was the gift of touch. As Françoise massaged his aching strained flesh the resentments melted with the knotted muscles. A grateful Guillaume reciprocated. Touch connected them. It became another form of communication. They developed their own language out of need, out of passion, out of love. Françoise had helped make him a whole man.

The nurse untangled his arm from the sheets and slipped on the blood pressure cuff. Guillaume rose to near consciousness when he felt the monitor tighten around his arm and it registered where he was. He struggled to open his eyes.

The nurse glanced up. "Mr. Maisonneuve, I just need to get some numbers, you rest. I'll finish up here in a minute."

Through heavy lidded eyes he saw the uniform and behind her, Françoise slumped over in the guest chair.

"My wife…"

"What's that?"

"Please, wake my wife and get her settled somewhere."

The nurse turned towards Françoise. "I'll take care of it. You just rest. Don't you worry, we'll see to it she's comfortable." She wrote on her clipboard, slipped the cuff from his arm and adjusted the rate on his IV drip.

The fog drifted back in, and Guillaume yielded. He could hear the nurse rousing Françoise. He sighed and surrendered to the shifting images of his unconscious. Françoise was safe. His breathing steadied.

Was Guylaine safe? Where was Guylaine? Again, the images—the shock and the white shirt. His restlessness returned, his frustration that he could not help her. His darling daughter— talented, loving, and different. He could see her but could not

16

reach out to touch her. Guylaine was further proof of his faith of God-given balance. Yes, she was an odd girl, but graced in her talents, gentle in spirit and loving. Guillaume turned his face to the pillow, and sobbed.

Someone sat down on the bed next to him. He felt the weight shift, the warmth next to his thigh. Guillaume struggled to open his eyes but couldn't. He felt fully alert, but couldn't lift his head or see. There was comfort in this visitor, warmth and solace. He heard Françoise's even breathing, now in the bed next to him. So who was sitting so still, so quiet with him? Through the covers he felt a reassuring hand on his forearm and he knew. *It was Guylaine*; it was her gesture. Since she was very little Guylaine had always reached out to touch him this way, an odd comfort from such a little girl. Guillaume sighed with relief. His girl was okay. Now, he could let go and surrender to sleep.

Chapter 5

Benjamin lifted his throbbing head and immediately lowered it *gently* back to the pillow. But, even that sent the inside of his head spinning. He wasn't sure where he was, but couldn't bear the light enough to open his eyes to see. The room was bright—he could tell that much. That at least meant he wasn't home in Toronto. He knew he wasn't at Guylaine's either. As he tried to roll over, his stomach lurched. Breathing shallowly, he put one arm over his eyes and tried to remember what had brought him here, wherever that was. Clearly, he'd been drinking and that alone was enough to tell him that *something* was seriously awry. Benjamin Levin was a level-headed, white-wine-sipping academic. His specialty was the influence of the invention of the camera on Impressionist and Post-Impressionist Art, with a special comparative emphasis on the various North American Plein Air movements of the Early 20th Century. Ben was *not* a drinker. He hadn't felt this bad since high school. He could barely breathe. There was an unrelenting pressure and an ache deep in his chest.

He lay there awhile and then slowly, gently shifted his weight, incrementally, his back more to the light. Covering his face with a cupped hand, he peeked out through heavy lidded eyes. The wall in front of him was pink. *Pink?* It was pink and yet oddly familiar. Just exactly *where* was he? He scanned up the wall and saw a faded Giles Vigneault poster, held fast by its corners with cracked and yellowed tape, and knew—he was in Red Wing, in Guylaine's old room at her parents' house.

Ben gagged. *Guylaine!* And now, cruelly, yesterday suddenly crystallized. Again, the image, played repeatedly, *breaking news*, his lover, her long black hair flying loose over a white shirt, running across the courtyard with her arms outstretched. Then stopped, shocked as the blood stained her chest before she collapsed.

His colleagues had called him into the faculty lounge when the footage ran live. There she was, standing in center screen as the newscaster intoned a story about the sculpture, its symbolism, and the ongoing siege. One of the protesters sprinted to the center of the courtyard and threw something at the RCMP forces dug in

on the west side. Shots rang out and the protester fell. Guylaine turned, saw the young man down, and headed in. The next six seconds were now history—the Canadian "grassy knoll." By then, of course, Ben was glued to the set, anxiously waiting for more information. Yes, *shot*, but alive? Hoping and waiting and, of course, subjected to the repeated image as they ran the footage every quarter hour. When the shooting had finally stopped, paramedics were permitted in, and confirmed the worst.

His buddy, Jerry, had brought in the bourbon after the first hour. They drank as they waited, but then Jerry had to go—kids at day care. Ben refused to leave, not until he knew for sure. He kept the bottle, too drunk to leave, too bereft to reach out. The faculty lounge eventually emptied, a string of nervous backwards glances from the tweedy professors as they carried this tragedy home. They had no protocol for something like this. The Department Chair *tried* to get Ben to go home with him, but Ben wouldn't budge from his station in front of the television. Later, bottle in hand, he'd wandered into his office. That's where Père Michel had found him.

Now a strange howl came from somewhere deep within him. He was curled into a fetal position, wailing, his body aching to the bone from the loss.

"Get up."

Benjamin stopped. He rolled over and squinted into the light.

"That won't help. Get up and drink this." Josette held out a steaming cup of coffee. Benjamin turned away.

"I mean it. I know this grieving business all too well. You do what I say, and you'll come out of it okay." She paused, "Come on Ben, I've been doing this my whole life. Right now there are people who need you, my *parents* need you."

She didn't need to say any more. He was recruited. It was a relief to have instructions. Ben rolled over and untangled himself from the covers. Still reeling from the hangover, he pulled himself up, and once seated on the edge of the bed, accepted the coffee.

19

Chapter 6

Ben came down the stairs, gingerly. He found Josette and Père Michel conversing quietly in French, over coffee and pecan rolls. Michel was formally dressed in his soutaine again, the fringed fascia straining at his waist. Except for the small television in the kitchen, the house was quiet. Ben refilled his cup and sat down with them at the long, harvest table in the kitchen.

Michel studied him. "You okay, Ben? You were in pretty rough shape when we brought you in last night."

Ben *didn't* feel okay. He didn't feel as though he'd ever be okay. He'd lost his center, and the hangover didn't help. He was woozy. His eyes filled with tears as he searched for an answer to the priest's question.

"Jesus, Michel, you should know better. How is he supposed to answer that?" Josette stood and retrieved the coffee pot and topped-off Michel's cup, snapping off the television as she passed it. "You're looking a little better, Ben. Can I get you anything? Breakfast?"

The idea of food made Ben's stomach roil. He shook his head and sipped his coffee.

The room fell silent. Then, Michel and Josette both spoke over each other. Each nodded awkwardly for the other to go first. Josette took the lead.

"My parents should be home by mid-day. Hélène said she'd drive them back from Windsor. Dad seems to be alright, but he's overwrought. They're keeping him sedated. Mom's hanging in. Ben, if it'll help, our family doctor can prescribe something for you. It's not a bad idea in the short run. Mom's refusing to take anything, but of course, Hélène has signed on for the meds." She shook her head.

"Please, Josette, cut everyone a little slack here." Michel reached out and put his hand on hers.

She pulled back, "Come on Michel, you know we're relying on her. She's supposed to be helping out, and there she is with her hand out for the pills, and she's *driving*, for Christ's sake."

Ben recognized this ongoing family theme. Hélène was *the delicate one*. Even Guylaine would complain sometimes that

Hélène shirked her share of responsibilities by coming off as being emotionally frail. Josette, the eldest, had little patience for it. But, right now, Ben found the familiarity of the old squabble strangely comforting.

Père Michel sighed, "Maybe we should just send your boy over to pick them up." He reached for another pecan roll.

Josette nodded, "I'll call him." She checked her watch, "Rene should be home from his shift soon."

"*I* could pick them up."

Both Josette and Michel looked up with surprise at Ben's offer.

"Really, it's how I usually cope anyway, helping out."

Michel nodded, "I can see that you'll fit right in." He looked at Josette, "I could go in with him and drive Hélène's car back."

"Works for me," Josette clipped, her jaw tensed.

Père Michel interceded, "Let it go, Josette. We can deal with Hélène later. Right now, she *is* helping."

Josette shrugged. She looked tired. "Sure. But first, we're going to need some ground rules. I don't think having the television on is a good idea when my parents are around. Dad doesn't need to see the whole thing, again. And, we need to hook up one of those answering machines they've collected, so we can screen calls."

"Screen calls?" Ben probed. "Won't they be friends and family?"

Michel and Josette exchanged looks. "It's not that easy," Josette started in, "This is a high profile event. I've already fielded six calls this morning from the Press, and *this* is an unlisted number. My parents cannot handle all that right now."

"Oh, yeah." Ben hesitated, looking for words, "Me, neither." He looked squarely at Josette, "So, what is the Press saying?"

"You know, they're all just asking lots of the same, stupid questions."

"No…" Ben inhaled and then held his breath for several long beats, "I mean about what happened." A single tear cut across his cheek. "Who did it?"

Michel stepped in, "It's all speculation right now. There'll be an inquiry, but they can't even start an investigation because the siege is still going on."

"Of course," Josette cleared her throat, "The Mounties are blaming the militants and the militants are blaming the Mounties."

"I couldn't tell from the angle," Ben whispered.

Josette leaned forward, "What was that?"

Ben continued, "I watched that news clip at least a dozen times. She came in at an angle, between the sides. You couldn't tell where it might have come from."

The three sat in silence.

Josette lowered her voice. "Maybe the autopsy..."

Michel tried to end the conversation, "It doesn't even matter, does it? It's tragic, and that's enough for right now?"

"Not for me, it isn't." Ben's face clouded with anger, "I need to know what really happened."

Josette caught his eye. "Me, too."

"Well, you two keep it to yourselves. Guillaume doesn't need to hear about it right now and neither does your mom." Michel's voice was firm on this point.

"What about the boy?" Ben pressed, "The kid that got hit before her?"

"He needed surgery. They say he's in serious condition, but expect that he'll pull through okay." Josette seemed to have all the details. Michel turned to her and gave her a hard look.

But Ben pushed on, "Has he talked to anyone yet?"

"They're not saying. But, Ben, Michel's right. There'll be time enough later for all this. Right now, it's about family."

He nodded.

Josette stood up, "If you want to drive, you have to have some breakfast. So, what'll it be?"

Ben wasn't really hungry, but Josette's piercing look made it clear he wasn't going *anywhere* on an empty stomach. "Just some toast would be fine, thanks." She turned to the counter, took the wire twist from the plastic bag and removed several slices of wheat bread.

The phone rang and Josette grabbed it. She listened for a few seconds then rattled off something in French that Ben didn't catch. She paused, and then hung up.

Michel laughed, "Well, that's one strategy for dealing with nosy reporters."

"None of them speak French, but we still are going to need the phone screened. They will catch on soon enough."

"They're in the linen closet, aren't they—the answering machines?" Ben asked, remembering the story. He and Guylaine had given her parents an answering machine, just one of their growing collection. "I'll hook one up." He stood, tentatively, and made his way out to the hall. Josette turned to make his toast. Ben returned and sat down with the answering machine, just as she placed the plate on the table. Between very small bites, Ben plugged the wires first into the machine, then the telephone and finally the wall outlet. He set the number of rings and tested it. He looked up, "What do you want to do for the message?"

Josette shrugged, "Well, I think it's obvious I should record something in French."

"Yes, and be sure to speak fast," offered Michel. "Let's give the edge to the Francophones."

Ben explained to Josette how to record the message.

Père Michel tapped his watch. "We've got to get moving, Ben. I'll ride over with you."

Josette pursed her lips, "Take the car from the business. It'll be more comfortable for my parents."

"Yeah, and *so* discreet." Ben disliked the idea of driving around in a mortuary Town Car. Guylaine had always hated it, and he'd picked that up from her.

"Beats the hell out of *his* Chevette," she said, nodding towards Michel. "I don't know why you don't get something with a little more room and, you know, *gravitas*."

"I'm a parish priest in a farm town, what should I drive, a Mercedes?" It was an obvious dig at Josette, who'd upgraded to a Mercedes. As manager of the local bank, she thought it set the right tone. They all laughed, this was old territory. Josette tossed Ben the keys to the Town Car. Then they climbed into Michel's blue Chevette for the hop into Red Wing to pick it up.

Ben took the wheel of the Town Car and navigated through the narrow village streets. At the outskirts, they were stopped briefly for a train at the railroad crossing, where the elevated tracks that Guylaine had always called *the high point* of the town, cut through the flat fields. Despite her jokes about its pancake topography, Guylaine had always loved Red Wing—its fields and

creeks. Ben remembered that once, on a visit, she'd pulled over and actually wept at the familiar sound of the red wing blackbirds that flocked around the reeds at the edge of the creek, between her parents' home and town. She called it *the ache of flat land*. Waiting for the train, Ben recounted all this to Père Michel, who smiled at Guylaine's familiar sentimentality. Where most were nostalgic about people, Guylaine connected to little details, the sound of birds, the way someone held a teacup, anything with music. They rode into Windsor in silence, for the most part counting their blessings as well as their losses.

Chapter 7

Ben maneuvered the Lincoln through the tight parking lot at Hotel Dieux, circling for a spot with enough clearance for the large car.

After cruising through the hospital lot twice, Michel pointed, "Take one of the handicapped spots." He fished through the glove compartment and found the disabled placard.

Benjamin screwed up his face. "I can't do that. We're not disabled."

"Not us," Michel shook his head, "The Maisonneuves, especially Guillaume."

Ben never thought of Guylaine's father as disabled, and yet clearly he was. Born with a serious clubbed foot, Guillaume's life had been shaped in many ways by the disability. To Ben though, he was a thoughtful, measured pillar of the community. Nothing happened in Red Wing that wasn't first brought to Guillaume for his blessing. He sponsored sports teams, underwrote political campaigns, was a member of the K of C and, above all, was the Choir Director for Saints Simon and Jude Church—Père Michel's parish. Guillaume's life-long love of music played out in his management of the choir, which had the most renowned and challenging repertoires in Southwest Ontario.

Ben pulled into the designated parking spot at the hospital's main entrance. Both men disembarked and strode inside. The lobby was crowded, but neither paid it any mind as they approached the information desk. Père Michel, looking official in his black soutaine, approached the candy-striper at the desk.

"We're here to pick up Guillaume Maisonneuve. Can you tell me what room he's in?"

The girl looked up at them suspiciously. She was unnerved by the cassock, but answered levelly, "I'm sorry, sir, I've been instructed not to give *any* information about that patient."

Michel stood taller. He was unaccustomed to not getting cooperation in this *Catholic* Hospital. "Excuse me young lady, but I am the Maisonneuves' parish priest, and I am here to pick them up. If you will just direct me, I'll be on about my business."

"Yeah, you and everybody else."

"Pardon me?"

"Father, *if* that's what you are, everyone over there in the lobby is here for Mr. Maisonneuve."

Michel and Ben swiveled simultaneously to survey the lobby. Reporters—about twenty of them, complete with cameras and video equipment. Some bore their station logos. Even some of the American networks were there.

"Well, *this* presents a new wrinkle." Michel mused, turning back to the candy-striper, "Do you think I could possibly speak to the Director of Admissions, or perhaps the Hospital Chaplain?" While the girl flipped through her directory, Pere Michel muttered to Ben, "Father Tony, the Chaplain here, is a good friend of Guillaume and works with the choir."

"And *your* name is…?"

"Father Micheal Beausoleil. We'll be needing the hospital's assistance protecting the Maisonneuves' privacy as we depart."

The girl picked up the telephone and mumbled in hushed tones. Then, smiling, she said to Michel, "Someone will be here in just a moment."

Ben regarded the opposition, some of whom were beginning to take an interest in them. "Let's keep it down a little." He elbowed Michel and nodded towards the reporters, for emphasis.

"Michel, mon ami! Comment ca va?" A booming voice filled the lobby as a dumpling of a man in a clerical suit approached." He grabbed Michel and gave him a great bear hug. "Et qui est-ce?" gesturing to Ben.

Ben marveled that this priest, and presumably the staff of the entire hospital, had happened upon the exact hide-in-plain-sight, French approach to the Press, as Josette had.

Michel turned and introduced Ben, "Ici mon ami, Ben Le Vin," he announced, bootstrapping an old Maisonneuve family joke about Ben's last name. Father Tony shook Ben's hand, then ushered the two of them through the swinging doors and into Admissions. Once out of sight of the hoard, Tony turned, "I'm glad to meet you Ben. Guillaume and Françoise have told me all about you." He lowered his eyes, "I'm so sorry for your loss." He embraced Ben, who was a little surprised by the familiarity. "And you, Michel, a sports coat might have been a little more *under the radar*."

"Sorry, I didn't even think about it."

"Where are you parked?"

"Disabled spot, right out front," offered Ben

"Are you in the limo?" Ben nodded. "Then we'll have to move you." He looked up at both men, "It's been hell this morning. We've never seen anything like it. They've been trying to sneak by us. One guy even came as a florist-delivery driver."

Père Michel queried, "Why do you think the Press is making such a fuss about this?"

Tony rolled his eyes, "Oh, I don't know. Good looking woman, taken in her prime? Canadian artist? Televised shooting, now that's a little out of the ordinary for Canadians. This is all over the news. They picked up Guillaume's admission on their emergency scanners. What are you doing to secure the house?" He cleared a spot and sat down on an admissions desk.

"Nothing, really. We never even thought about it." Michel was clearly out of his element.

"Well get on the horn. You might be followed out of here. It would be best if you could delay them finding the house, so watch your back." He turned to Ben, "You can pull the car past the big, liquid nitrogen tanks around back. There's a service entrance there. Just hang tight and try to look like a limo driver. I'll walk you up front and chew you out a bit about using the disabled spot, for show."

Michel was on the phone to Josette. They spoke briefly and he hung up.

"That girl's a true saint. She'll have Jean Luc put a chain and lock across the driveway. Ben, if it's there when you get arrive, the key will be in the mailbox."

Tony stood up from his perch on the desk. "Michel, they're waiting up on the third floor. I'll be out to the house in a day or so. I think I'll pull some duty with Guillaume getting the choir ready. This is family and we have a funeral to prepare." He turned to Ben, "We'll talk more at the house, for now just follow me and look guilty."

Père Michel took the stairs, leaving Ben and Tony to run the Press gauntlet, with Tony pointing and gesticulating like a gendarme. The ruse worked and no one took notice of the Hospital

Chaplain chastising a sheepish limo driver about improper parking etiquette. Ben pulled around back as instructed and waited.

For Ben, quiet moments were the hardest. Without the bustle his emptiness spilled over. Guylaine, the center of this fuss, was missing. She would have loved the intrigue, the *cat and mouse* with the Press. Ben wanted so much to hold her; he missed her smell. The warmth, and even the tensions of her family, accentuated her absence. His chest tightened and tears welled up in his eyes.

Suddenly, there was knock on the back of the Lincoln. Ben jumped in his seat. He was surprised to see that Hélène was there, in a wheel chair, with one leg extended.

"*Jeez* Hélène, what's happened to you?"

She waved him off wildly, "Silly Ben, this is part of the charade, so Père Michel and me can get to my car." She was clearly sedated.

He turned and saw Michel holding the service door open for Guillaume. Ben hopped out of the driver's seat and opened the doors for his in-laws. Ben reached for Guillaume's hand, but the old man just reached up and took the taller man in his arms. Guillaume held him, his tears flowing freely, but with a gentle strength. Françoise joined in the embrace and in its warmth Ben found a glimpse of Guylaine. He sighed raggedly and pulled away, "We've got to get moving. This place is crawling with reporters." He managed a weak smile and they all climbed into the town car. As they pulled away, they caught sight of an animated Michel wheeling an even *more* animated Hélène to her car, with a nurse in tow.

Chapter 8

It was a good thing he owned a hardware store. As soon as he hung up the phone, Jean Luc set to work. He found a length of old chain in the back—a new chain would've been a dead giveaway. He pulled a spray can of Rustoleum off the shelf and found a keyed padlock. He peeled opened the blister-pack and pulled out the keys. Sorting through the key blanks, he found matches, and then cut a dozen extra keys. He put one of them in his jeans pocket, and the rest in an envelope that he folded over and put in his breast pocket. He dropped the chain and paint into the back of the pickup, then gingerly loaded a casserole and cake carrier into the passenger seat—in typical small town fashion, his wife had responded to the news with a chicken-cheese-noodle casserole and a box spice cake. Jean Luc's biggest concern, about chaining off the driveway, was that it would make it difficult for neighbors to come by and drop off food. Jean Luc hadn't yet experienced the Press onslaught but later, when he did, he looked back to the driveway chain with smug pleasure.

Jean Luc was Guillaume's cousin. Their twisted fates should have driven a wedge between them. But somehow, as young men, they'd each realized that they were pitted against each other by outside expectations and, with the help of Guillaume's mother, they'd forged a bond closer than brothers. Whatever the challenge, they made it work, together. They celebrated each other's triumphs and pulled together in tough times. When Guylaine fell in that courtyard at Crowsfoot, it was like a knife into his own heart. He'd have taken that bullet himself to spare Guillaume the pain.

Jean Luc drove out to the big house and pulled up a bit into the lane that led to the house. He walked back to the fence line and hooked the chain to the fence post on the right side of the entrance. Then he pulled the chain over to the left side and secured it with the lock. Figuring that some might not expect, or see, the newly installed chain, he took a red handkerchief out of his pocket and scuffed it in the mud. He then threaded it through one of the links in the middle of the chain, and knotted it. He glanced over, and sure enough, Guillaume's pristine mailbox was neatly stenciled

29

"Maisonneuve"—like a homing beacon, signaling to every reporter in town. He grabbed the spray paint from the bed of the pickup and gave the mailbox a rough coat, taking care to cover the name. When he stood back, it looked a little *too* fresh. So, he scooped up a handful of gravel and dirt, rubbed into the fresh paint, and then rubbed some of it off. He couldn't help but grin, thinking how his work undid Guillaume's own fastidious maintenance. Finally satisfied that the mailbox now looked natural and anonymous, he cleaned off his hands on his jeans. He removed one of the keys from the folded envelope and put the rest in the mailbox. His work now done, he climbed back into the pickup and drove up the driveway to the big house to deliver the casserole, confident that Josette would reward him with a piping cup of coffee and some of that spice cake.

Chapter 9

The door slammed and Roger looked up, "Hey babe," he said, standing up, but Hélène kicked off her shoes at the door and walked straight through the room without acknowledging him. He'd been a member of the Maisonneuve family long enough to know that people weren't always themselves when someone died. Roger followed her upstairs and stuck his head in their bedroom just as she finished peeling out of her clothes and stepped into their bathroom.

"Hold on a sec. You okay?"

She scowled. "I don't know *how* I do it sometimes!"

"What's up babe?" This was clearly not just about losing her sister and Roger had wondered how this would play out. Hélène loved Guylaine, was proud of her successes, but they'd never connected very well. Guylaine was plainspoken, though Hélène always said she was blunt, and Hélène tended to be overly sensitive.

Right now, though, Hélène was simply angry. He knew that if he didn't tread carefully here, she'd be mad at *him* in a heartbeat. He reached out but she turned away, leaned in and turned on the shower. Something was a little odd about her timing but he knew who he was dealing with.

"Well, you can tell me now or just steam. Your choice."

"Oh," she sighed. She threw the last of her clothes on the vanity and stood there a moment, "I'm sorry. I'm just exhausted. I shouldn't let that fat old priest get under my skin."

Roger looked at her closely. She was still a good looking woman and Roger felt lucky in that department—a head-turner at an age when most women had settled, literally, into their roles as mothers. And, things between them had never ebbed but there was an edgy rhythm to her just now. Hélène stepped into the shower, pulling the curtain closed behind her. Roger considered his next move and finally went back downstairs to the kitchen and made a pot of tea. Nobody in this family had *ever* called Michel a fat old priest.

Waiting for the water to boil, Roger noticed Hélène's handbag on the counter where she'd dropped it in her charge

31

through the house. He walked to the bottom of the stairs, listening for the sound of the running shower. Then he stepped back into the kitchen and opened the handbag—right on top, an amber bottle of valium answered his question. He closed her bag with a click and left it exactly where he'd found it. He opened the cupboard and, after reflecting, selected the chamomile tea. The kettle whistled and Roger dropped in the bags filled the teapot. He assembled a tray with the tea, cups and a plate of shortbread, then headed upstairs to calm the beast.

He placed the tray on the nightstand and sat back on the bed, waiting. Some of his buddies considered him *pussy-whipped* because, in part, Roger went the extra distance for his wife. But, his marriage was vibrant, if occasionally dodgy. Hélène was certainly demanding but she was also generous, creative, a phenomenal mother to their boys and a good companion. Roger considered the extra distance well worthwhile. He thought some of his friends' wives were cows. Okay, so Hélène's creativity was a little *Hallmark*—she certainly wasn't Guylaine. But, she did flowers and home decorating for a living and brought in a decent income on the side. Roger was proud of her and learned to tolerate her chronic redecorating.

Roger peeked into the bathroom and was relieved at the transformation. Mellowed by the hot water, Hélène wrapped her wet hair up in a towel and pulled on her terry robe. But, her face was still taut as she continued mulling over her discontent. She relaxed a bit as she stepped into the bedroom, where Roger was waiting with the tray of goodies. Hélène melted—she slid onto the bed next to him while he poured her a cup of tea.

"So, ya going to tell me what's up?"

"Oh, it's just the stress of *everything*. Twenty-eight hours of my parents canonizing *Saint* Guylaine, lionizing Ben and hounded by calls from *Ms. Perfection* telling me what to do."

"*What?* Josette was controlling?"

Hélène glanced up at him, and then caught it. She let out a giggle. She reached for a shortbread and dipped it in her tea.

"You'd think she'd invented grieving and funerals. Where does she think *I've* been all my life?" She stood up, agitated. "And then Michel carries on about how *I* have to be present for my parents. And, where the hell was *he* last night? I was with my

parents the whole time while *he* was off chauffeuring Ben back here, like he even belonged!"

"Well, they've been together, what, at least ten years?"

"If you want to be family, you marry. Ben is nobody to us. Roger, he's not even Christian. And, I don't get the interest of a Catholic priest. Why is Michel even bothering with him?"

"Babe, that's a pretty harsh view. And, maybe that's one you should keep to yourself this week."

"Oh, I know! But it's even *worse* than before, and now Guylaine's some kind of martyred saint. Nobody even notices that she's unmarried and fucking a Jew. *This* from the famous sculptor of Catholic art! And now she's shot dead, probably by her former terrorist boyfriend, and we're all supposed to bow down and grieve like this isn't actually *God's will?*"

Roger held his breath. This wasn't going well. Peace was nowhere in sight, and neither was any sense of reason. "Just what *did* Père Michel say to you?"

Helene stood and paced up and down the length of the bed. "Jeez, it was like high school—'No drinking, No drugs, listen to your parents, attend to the needs of others.'" She peeled the towel off her head and tossed it over the headboard. It felt like minutes ticked by while Roger waited, quietly. Finally she stopped her pacing and sat down and poured another cup of tea. She turned to him, cross-legged on the bed and set her teacup in her lap. "I thought that priest was going to assign me to do ten Hail Mary's and reflect on all my sins."

There are times in every marriage that, despite loving one's spouse dearly, it's difficult to find a reason to like them. Roger finally let out his breath, "Maybe, like you've said before, everyone's not behaving so well because there's been a death in the family, even you. And, you said you were exhausted. Maybe we should just cuddle and take a nap for awhile." It was the best he could do.

"Great so *you* don't support me either."

Roger rolled to face her and upset the mug that had been precariously balanced in her lap.

"Jesus, Roger!" Hélène's lap was now soaked with tea. He reached up, grabbed her towel from the headboard and dabbed at her while she protested. She tried to get up, but he had rolled over

onto her robe, and just like a junk-yard dog that's run out of chain, she jerked to a stop mid-way. She snapped forward, hit her chin on his head, bit her tongue, and then collapsed completely onto the bed, weeping. Roger recognized his moment and pulled her to him in a powerful embrace. Spooning behind her, he rocked her gently in his arms while she sobbed. Hélène eventually fell silent and her breathing evened. Roger curled up even closer and inhaled the damp fragrance of her shampooed hair. He concentrated on counting her breaths as both of them slipped into a welcome, heavy sleep.

Roger woke, feeling Hélène stirring in his arms in the dark. The comfort had lasted only a few minutes, then, she jolted awake. She nudged him, "Roger, get up, we've got to go to my parents." She leaned over, untangling herself from his embrace.

He looked up at the glowing numbers on the clock—6:20. "It's okay, there's plenty of time."

"Roger..." Hélène was foggy—something was missing. "*Oh my God, Roger!* Where are the boys?"

It even took him a second to remember. "It's okay. They're spending the night at Marc's. Ginnie called and suggested it. I didn't know when you'd be home or what would be happening."

She shook her head, "Don't you think they should be with us? Shouldn't they see their grandparents?"

"Honestly babe, I don't see that a couple of pre-teen boys are going to offer much comfort or support. We should just head over, only the two of us."

Hélène flipped on the light. Roger winced and then caught sight of her. Her damp hair had dried, splayed out, just like a peacock's tail. Hélène looked like a punk rocker. He tried, but couldn't stifle his laughter.

"*What?*"

"Just go look in the mirror."

Hélène retreated to the bathroom with the damp towel and the tea soaked bathrobe. She flipped on the light and gasped. He heard the water run and then the hair dryer. Hélène came out of the bathroom looking like her normal self. "*Well? Are we getting up?*"

He rolled over and peeled out of his wrinkled shirt. Hélène went into the closet and selected their clothing. She came out and

handed him a fresh shirt and cardigan. They dressed in silence and headed down to the car.

As Jean Luc anticipated, Roger pulled up to his in-laws' driveway and almost drove through the new chain. There was a light rain falling and he nearly missed seeing the dirty, red handkerchief hanging from the center of the chain. He slammed on the brakes, jerking Hélène hard against her seatbelt.

"*Roger!*"

"Sorry babe, there's a chain across the road. What's up with that?"

"Oh!" Hélène remembered, "Père Michel told me to call first. It's security to keep out the reporters." Her upper lip quivered.

Roger stepped out to survey the situation, but the chain was securely locked. They could walk in, but they'd get soaked in the rain. He slid back into the driver's seat to find his wife weeping again.

"It's okay, babe. We'll just go back and call. I don't want you to get wet and catch a chill." But her sobs were relentless. "Hélène, What is it? They had good reasons." She was sobbing and gasping for breath.

"It's alright," but her sobs kept time with the windshield wipers, "It's just..." she sighed, "My sister is dead and *I'm* locked out in the rain," she shuddered again, "By my own family." It was cold, dark and raining. Hélène was inconsolable but Roger held her, rocked her in his arms in the dark car and dabbed at her face with a Kleenex.

Hélène had calmed considerably when the beams from approaching headlights swept across the interior of their car. Through the glare of the lights, Roger could see Jean Luc and his wife, Claudette, in their pickup. Jean Luc stepped out and stooped to Roger's driver's window, "Sorry Roger. I didn't have time to distribute the keys." He reached into his pocket, retrieved a key, and handed it to Roger. "Here, take mine. I'll just grab another one from the mailbox. Hi, Hélène. Okay, let's get you two in now, eh." The older man ducked through the rain, opened the lock and dropped the chain. Roger waved thanks and drove through. He squeezed his wife's hand. *Rescued.*

Chapter 10

After finishing the obligatory round of hugs and kisses at the back porch, everyone filtered back into the kitchen. With a forced smile, Père Michel took the opportunity to pour a round of tea to those remaining. He put a tray of cookies on the table. "Well, that didn't go too badly, eh?"

Jean Luc laughed out loud. "Jeez, are *you* diplomatic. You should be pouring stronger stuff. That girl is high-maintenance, bien sur." He lifted his mug as if for a toast. "Mes amis," his eyes flitted about the room and rested on Ben. Jean Luc paused and then continued in English, "May we celebrate the genius of Guylaine Claire without diminishing the contributions of the rest of us."

A brief round of applause acknowledged the wisdom of Jean Luc's toast. Françoise bent over her husband's cousin and kissed him on the temple. "Merci, si tout le monde comprends ce…" she shrugged.

"Oh, for Christ's sake," Josette winced at her language in front of a priest, "Sorry Père Michel." She turned to her parents, "You *all* pander to her. She shows up teary-eyed and you all go into overdrive to attend to poor Hélène. It becomes self-fulfilling," Josette rolled her eyes.

"Josette," her mother chided, "This is not the time to be harsh. We've all suffered a loss."

"Mère, this is not the first, or only, time we've been here. Jean Luc has raised more than one toast to our difficult one. But still, everyone caters to it and I think it makes it worse. It's appeasement."

Françoise put a hand on her hip, "How did we treat her different than anyone else, tonight?"

Josette shrugged, "If I go through it, it looks petty, but it adds up."

"So, risk petty, because I just don't see it. I only see a woman struggling with grief." Françoise put her arm around her oldest daughter.

"As are we all, Ma," she softened. "But everyone else had brought something to dinner. Most helped get the table together

36

and everyone else, including Roger, helped clean up and wash dishes. It's not like she doesn't know how, she's Miss Susie-Homemaker in her own home. But tonight, Hélène just sat and snuffled. We all shared Guylaine stories. There were tears but we were sharing the best of someone we loved. Hélène…" Josette threw up her hands, "She talked about the psychological impact on her boys."

The room fell silent. Françoise didn't have a response. It was an awkward moment.

Jean Luc broke in, "But that Roger, *he's* a trooper, you know."

"He sure is." Père Michel was usually the first to commend Roger. "The man is a saint." He looked sheepishly around the table and added, "Roger *does* give her balance."

"Can you believe it, his parents didn't teach their children French?" Françoise was shaking her head, mystified. "I mean, I love the man, he *is* our angel, but his folks had six kids, and with a name like Drouillard, not a one of them speaks the language."

Guillaume shook his head, "Françoise, you've been pondering that for, oh, about the twenty years they've been married. When Roger was coming up, French was a stigma. Back then, raising them up Anglais was considered a step towards success."

"But then, why give them all French names?"

Guillaume laughed and put his arm around his wife, "Who can explain the sense of names? And yours? Even Guylaine Claire's, eh?" There was a sparkle in his eye.

The phone rang and without hesitating, Josette picked it up. "Maisonneuve residence. She listened and nodded. "No, she *just* left. You could catch her at home any time now. Yeah, but I'd leave it up to her, you know. You should give her a call. Okay, maybe we'll check it out. Merci." She turned to the assembled group. "That was Ginnie, Hélène's friend. Tonight, there's a special airing of the program they did on the Crowsfoot sculpture. She wanted to know if she should let the boys watch it."

"I can't see any harm in it. It's actually a very sensitive piece." Ben nodded. "I always thought she should have participated in that. She trusted Estelle."

"Well, it *was* her agent who said, *no*," Guillaume recalled. "Speaking of whom... Michel, have you heard from Robert, at all?"

Guylaine's agent, Robert, and Michel had known each other since seminary. Both were refugees from terrible families and they'd become best of friends. So much so, that Michel was wounded when Robert washed-out without explanation in his second year. Robert disappeared for a couple years and then surfaced as an artists' agent and art buyer on the gallery circuit. One look at his effeminate new friends explained his hasty departure from *a life of the cloth*. But, he and Michel resurrected their friendship. Years later, Robert was Guylaine's savior and foster dad during some rough times in her teens. When her artistic talents emerged, Robert had taken her under his wing and groomed her for her successful career. The Maisonneuves accepted his lifestyle and loved him like family.

"I left word at his office. They said he's in Luxembourg. They'd already heard what had happened and were trying to make arrangements for his early return."

"I'd like to see it again, you know, the program." said Claudette. Everyone was surprised—Claudette was the opposite of her husband, Jean Luc. He was gregarious and she was shy. Though, when she *did* raise her voice, she was sincere and astute. "As I remember, it's really quite a tribute to Guylaine Claire and, in general, to the cause of peace and reconciliation. It's a message we should all remember this week."

Michel turned to the grieving parents, "She's right, it could be healing, but do you feel up to watching?"

Françoise and Guillaume looked at one another and then reached out to hold hands. Guillaume answered, "This is like Jean Luc's toast, it *is* a celebration of her life, and of our story. We'll cry, but we'd love to share it with all of you. When will it be on?"

The eight of them trooped into the living room and arranged themselves, as best they could, around the Maisonneuve's tiny television. Michel took charge of the *new-fangled* remote and fiddled with the rabbit ears until he was satisfied with the reception. Josette left the room and returned with several boxes of Kleenex from the linen closet. Growing up in a family that ran a funeral home, it was no surprise that her parents bought Kleenex

by the gross and that social entertaining often included keening and weeping. *Some* families just served popcorn.

The program started with a special introduction by Estelle Dumas, the reporter who had produced it originally. The elegant redhead sat in what looked like a comfortable study, facing the camera.

"This is a tragic week for Canada, and for the international art community, as well. In another senseless, bloody event between militants in the Native Peoples' Movement and the Royal Canadian Mounted Police, art and innocence are the victims in the crossfire. In an incident, achingly reminiscent the very subject of her award winning sculpture, Canadian artist Guylaine Claire was slain yesterday at Crowsfoot, the cultural center that was built to heal a nation after the earlier violence at Oka. Tonight, in honor of Guylaine Claire, we're airing our original program celebrating the installation of, and story behind, the Crowsfoot sculpture she created. We wonder when all sides in this ongoing feud will finally lay down their arms in the spirit of reconciliation."

Sheepishly, and with tears already coursing down her cheeks, Josette passed the Kleenex box. Then, seeing the pain etched in his face, she took a place on the floor next to Ben.

The original program started with Estelle narrating as she walked in the lush, courtyard garden at the Crowsfoot Center.

"In the 1990 siege at Oka, Quebec, Canada was shocked by the insensitivity towards indigenous claims and by the determination of the Mohawk Nation. When the siege stretched to 77 days, several deaths and the blockage of major traffic arteries leading into Montreal, it gripped the attention of Canadians and the world. Canada was mortified by the international spotlight on its historic oppression of its native peoples. Yet some in Canada blamed the Mohawk Nation for its militant response to the expansion of a golf course on allegedly native lands. Mostly, the incident illustrated the cultural disagreements that have been festering for centuries. Following the debacle at Oka, several non-profit foundations funded the Crowsfoot Cultural Center here, outside Rockland, just a stone's throw from Ottawa and just over the provincial border in Quebec. Oka was doubly troubling since it revealed that the intolerance of Indigenous claims was not

limited to the English speaking government in Ottawa. Quebec, itself a font of civil rights and language claims, comes second to none in discriminating against its native and Métis populations. Crowsfoot was intended to heal the wounds of history."

The background faded to an architectural model of the Crowsfoot facility, her narration followed: *"Based on the designs of traditional longhouses, the museum, cultural and teaching facilities were located in a series of buildings arranged to create a central courtyard."* In her voice-over, Estelle described the facilities and their cultural and design significance. She described the pride that Canadians felt when this Center rose from the wounds at Oka to restore faith in the Canadian spirit of compromise and accommodation. The scene shifted to show the art, historic and cultural exhibits in the various Crowsfoot buildings, where indigenous arts, language and history would be invigorated by new classes and events. The view then returned to the courtyard.

"All that remained was an artistic statement to be created for the courtyard, something that spoke of the collective of Canada's indigenous groups and the healing efforts rising out of the pains of Oka. An international competition was launched to find a centerpiece that would be the inspirational heart of the facility. Applications came in, not only from Canada, but from around the world, with written narratives of the submissions as well as maquettes, the models of the sculptures, themselves." The camera panned the numerous miniature sculptures—elegant statements, realistic and abstract, featuring the typical symbols representing native heritage.

Now the camera turned to Estelle Dumas. *"One submission stood out for its special relevance to the Oka environment. A young Canadian sculptor, herself of Métis heritage, submitted a sculpture depicting a scene from her own family history that spoke to the Canadian yearning for reconciliation. Guylaine Claire, a quarter-blood native and French-Canadian descent, produced a proposal that spoke of her own grandmother's experience with cultural healing. Guylaine Claire's grandmother, Claire, was a young Cree from outside St. Boniface. As a very young girl, she came into the town during the troubles in 1884—the Louis Riel/Gabriel Dumont resistance. Claire had been rejected by her*

40

family and tribe for converting to Christianity. She wanted to serve Jesus Christ and to heal the divisions tearing her world apart. She presented herself to the St. Boniface parish, but was rejected there too, because of her illiteracy and limited French language. Disillusioned, she wandered the streets of St. Boniface, only to find herself on the outskirts of the village during one of the undocumented massacres of the local Métis, by the hired security forces of the Hudson's Bay Company. In the face of unimaginable and senseless violence, the young woman set to work, ripping strips from her skirts and bandaging the wounded, Métis and Anglais, alike. Lucien Trottier, at the time a wealthy French trader, witnessed Claire's selfless acts and was moved by her altruism and courage. Following the conflict he escorted her back the St. Boniface parish, where, as a well-known member of the community, he insisted that this pious and angelic spirit be taken into the parish house.

"More than twenty years later, the newly widowed Trottier returned to the parish house, to search out the woman who'd so impressed him. Claire still worked at the church as a domestic. Trottier decided to woo and marry her. Years later, the couple was blessed with a daughter, Françoise, the mother of our Crowsfoot sculptor."

The camera now panned the elegant and sensitive bronze sculpture, installed at the Crowsfoot Center. Estelle circled the piece, continuing the story: *"The piece, submitted by Guylaine Claire, was of a young native girl, recoiling from the violence while bravely attending to the wounds of three souls around her, two Métis and one uniformed Anglais. The judging committee's decision was unanimous."* The camera now cut in close to show the sculpted image of the braided native girl, shrinking from the shots over her head and tearing bandages with her teeth while attending to the sufferings of the injured. *"The sculpture is realistic, but exaggerated in its elegance, and poignancy much like Picasso's painting of* Guernica *or Rodin's* Burghers of Calais*. It is quintessential interracial rapprochement."* The camera focused on Estelle, her hand resting lightly on the shoulder of the young girl in the sculpture.

"Today, no one doubts the wisdom of the committee's decision. Visitors to the center are taken aback by the harsh

beauty of the work and its tremendous emotional impact. The Center has devoted an exhibit to the writings and personal effects left by visitors at the sculpture site, attesting to its resonance. A simple bronze plaque explains the history that led to the sculpture and its continuing significance, given disputes like Oka. It is a moving and healing statement."

The program continued for another ten minutes on the distinctive architectural and symbolic aspects of the Crowsfoot facility, but nobody at the Maisonneuve house was watching anymore. There wasn't a dry eye in that living-room, with family members reaching out to one another, squeezing hands and holding shoulders to support each other in the face of beauty and loss.

The originally aired program concluded. Then Estelle returned with a closing statement. *"It is our loss as well, and our hearts offer solace to the family of the artist. We won't show you the footage of the tragedy. We've seen it more than enough. But, we can't help but see history repeating itself. Our Guylaine Claire was at the site to protest its use as a backdrop for yet another Canadian standoff. She decried the blasphemy of her grandmother's image at the epicenter of the siege, a symbol of peace conscripted to a site of racial intolerance. While it's easy to judge her and the wisdom of her choices, it's impossible to miss the repeating symbolism of Guylaine Claire, launching selflessly into the fray when, once again, hatred butchered the innocents around her."* Tears stained the cheeks of the journalist as she bid the audience goodnight and asked that they reflect on the message of the artist's work, and life, during this time of national grief.

Jean Luc, keeper of the remote, clicked off the image and the room was silent. Ben sat on the floor with his face buried in his hands. Guillaume and Françoise sat next to each other on the sofa their arms around each other, tears flowing freely.

Claudette, flustered, apologized, "I am so sorry. I didn't realize how hard that would be."

But Françoise put a hand up and silenced her. "I wouldn't have missed it for anything."

Everyone, Ben included, gestured their agreement. They rose and filed out, exchanging goodnights, each touching and consoling

the others. As the last of the guests departed, Michel and Josette stepped out into the night to head for their respective cars.

Josette turned to the priest and said quietly, "This is bigger than we knew. I think we're going to have to beef up security."

Chapter 11

The phone rang incessantly. Françoise didn't even bother to screen the calls. She was overwhelmed by the volume, and simply unplugged the phone. Josette came in early with an armload of groceries. She smiled when she noticed that the windowsills, all around the house, were lined with tomatoes in varying degrees of ripeness. Josette knew that it was a good sign if her mother was attending to these little details. After unpacking the groceries, Josette took a bag upstairs and, quietly opening the door to Ben's room, where she set it inside. She'd felt bad because the poor man had been in the same clothes for days. So she picked him up fresh underwear, a couple of shirts and a new pair of jeans. She turned to go, but was stopped by Ben's voice.

"It's okay, I'm not asleep."

Josette came back into the room. "How are you doing?"

"I don't seem to sleep much. And, my chest aches." He rolled over to face her, "I miss her with every breath. The program was hard to watch, but it actually helped."

"Yeah, I feel the same way." She sat down on the other twin bed, leaned back and sighed, "Wow, this place is… like, stuck in a time-warp."

Ben laughed. "Yeah, I don't think anything's changed in here since Guylaine was seventeen. We always stayed in here when we visited, and we laughed about it. Go over and close the closet door."

"What?"

"Close the closet door and you'll see."

Josette reached over and swung the door closed. On the back was another music poster, this one of Renee Claude. Josette laughed, "Who even remembers *any* of these people. Giles Vigneault and Renee Claude!"

Well, Guylaine had to tell me who they even were. You can imagine that French-Canadian rock and roll didn't figure heavily into the cultural life of a boy from Ohio. She insisted on played some of the music for me, and translating."

"Anything good?"

Ben reflected. There was one song I really liked. Guylaine used to hum it all the time under her breath. It seemed to be a kind of Canadian anthem."

"Can you hum the tune?"

Ben attempted it. Josette nodded. "Oui, I recognize it. That's a lovely song." She sang softly, "Mon pays, ce n'est pas un pays, c'est l'hiver, mon jardin ce n'est pas un jardin, c'est la plaine, Mon chemin ce n'est pas un chemin c'est la neige, mon pays, ce n'est pas un pays, c'est l'hiver."

"Yeah, that's it. She loved that song. What does it mean?"

Josette hesitated and, tipping her head back, recounted, "*My country is not a country, it is the winter. My garden is not a garden it is the open plain, my road is not a road, it is the snow, my country is not a country, it is the winter.*"

"That's beautiful."

"Any others?"

"Pardon me?" Ben spread his hands and shrugged.

Josette pressed, "Are there others? You know, other songs that had special meaning?"

"There were dozens. The woman lived for music. She breathed it. She'd take a song and play it over and over while she was working on a piece, because the song had a special emotional tug that she wanted to capture in the art."

"That's funny. You know a whole different Guylaine than me. I was nineteen when she was born. I'd already married and moved out. My memories are all of her being just this tiny, little thing. And, she was such an *odd* child. Later, I got to know her when I helped her with her financial affairs. It was uncomfortable at first, but then I really got to know her. And, over the past twenty years, I'm really glad we made that connection."

They sat quietly remembering. Then Josette patted the bed to get his attention, "Try to think about the music though, we'll need to put something together for the funeral service."

"There was another song. It was from an opera. It went like this," Ben hummed a few bars.

"It sounds familiar, but we'll have to ask Dad. *He's* the opera buff. Guylaine got it from him. They'd spend hours together listening to Dad's scratchy, old LPs. Dad would listen quietly, his eyes closed while Guylaine twirled in the center of the room. I

swear, I thought the kid was retarded." She laughed. "When she got tired or dizzy, she'd curl up in his lap and they'd just listen."

"What's going on with the funeral?" Ben was relieved because of her familiarity with these official details.

"Don't know yet. The problems are whether, and when, they'll release her body. When there's a criminal investigation, they have to do an autopsy. Who knows?" She was an old hand in the funeral business.

"Any word on what really happened?"

Josette paused, "You mean, who did it?"

"Yeah."

"Not a peep. Not yet anyway." She lowered her voice, "And it's not likely that anyone's going to step forward and accept responsibility. So, we may never know."

Ben rolled over, facing away. "I don't think I could handle that."

Josette nodded, "I know, but since there is government involvement, I don't expect fast or accurate."

Ben pursed his lips, "Yeah, I guess I see what you mean." He paused, "What's the deal with Hélène?"

"Oh, I shouldn't complain so much. She's just a drama queen, is all. Everything's fine as long as it's about *her*. This goes back a long way. She's always had a lot of jealousy over Guylaine. This will be really tough on her."

Ben looked perplexed, "How so?"

"It's harder to grieve if you have unresolved issues. You still feel the loss, but it's all mixed up with anger or whatever. I feel lucky because I had a good relationship with Guylaine later on. So, while I grieve, I don't have to work through any anger or jealousy. There's no real unfinished business. I think Hélène always felt eclipsed by Guylaine, and that's *her* unfinished business."

Ben nodded knowingly. "I guess I may have some of that."

"But you loved her, we all knew that, and I think for you, it'll come out okay."

Ben's hands smoothed the covers on the edge of the bed. "Guylaine had a funny take on Hélène, I never really understood it. It was like she fully embraced her, and understood all the little

weirdnesses. I found it particularly strange because Guylaine was, herself, such an odd fit."

It was Josette's turn to be confused, "Maybe that's it. But, what do you mean, or what did Guylaine mean, by *Hélène's weirdnesses*?"

Ben hesitated, "Oh, you know. Always needing what she didn't have, but not appreciating what she did."

"Like what?"

Ben sat up and leaned against the wall. "Everything—time, attention, influence. Guylaine thought that Hélène never learned how to find her place in a situation, so she wasn't comfortable. It was like, if she wasn't the center of attention, she some how wouldn't exist. Guylaine thought *that* was why she took on the whole religious thing."

Josette reflected on this. "You know, I suppose it's wrong, but you don't think about your little sisters that way. You're so busy charging forward with your own stuff, you never even think that *they* have stuff of their own."

"You remember when Hélène couldn't conceive?"

"How could any of us forget *that*?" Josette rolled her eyes.

"Yeah, I know, but that was Guylaine's point. It was always about something Hélène *couldn't* have, like something was being withheld from her. Then Hélène would make it *everything*. More tellingly, she made it everything for all of us, too. Guylaine just thought, if you couldn't do it, you did something else, or at least you did something else, in the meantime."

Now, Josette felt she needed to defend her, "Still, you have to admit, she *is* a great mother."

"Yeah, and Guylaine thought so, too. She got a lot of pleasure from that because it came out so well. Do you remember the sculpture?"

Josette nodded, "That little bronze Madonna and child? Oh that was so beautiful. And, *what* a waste."

"But, Guylaine didn't think so. She thought the whole thing was actually funny." Ben smiled, remembering it.

"Funny? That'll take some explaining. After all that whining, she finally conceives. Then, Guylaine gives her the most beautiful sculpture on the planet, and Hélène hides it in a closet. *That's* funny?"

Ben chuckled, "Robert was livid when she wanted to give that sculpture away because *he* wanted it. It was incredible—that Madonna *was* Hélène, the curve of the brow, even that cowlick in the front. And, one breast exposed, she was nursing the infant Jesus. The piece was sensual and it captured something universally fulfilling about the intimate connection between mother and infant. That sculpture really nailed Hélène and had a religious theme, too." Ben closed his eyes, remembering, "It was the ultimate compliment, *and* the ultimate celebration of her pregnancy. But, to Hélène, I think it was too revealing, not in a sexual way, only in the sensuality of it. A few years later Guylaine offered to exchange it for one Hélène would like, but she was offended, even then. In the end, she wouldn't display it, but couldn't give it up either."

Josette laughed ruefully, "You know what she does now? She's crocheted a little blanket for it and she takes it out at Christmas, and sets in under the tree like a crèche. But *now,* it's got this little throw concealing the breast *and* the baby!"

"I know. Guylaine thought that was hysterical. It's the old *mustache on the Mona Lisa* syndrome. Here she has something beyond value, and because she can't make the connection, she reduces it to some... some seasonal decoration with a modesty panel. Guylaine thought it was funny *and* heartbreaking at the same time."

Josette shook her head, "It's just a waste, if you ask me."

"Guylaine thought it was perfect. If a piece of art is *so* compelling that you can't look at it, but can't look away, you've hit a nerve. The piece has found its home. It will find fuller appreciation sometime in the future, but right now it speaks secretly to Hélène. That's the gift.

"I'm glad all of her art doesn't find such a *constipated* audience."

Ben laughed. "Me, too. She never gave such a personal piece to family again. She made them, but they were strictly for her personal collection."

After a long silence, Josette softly asked, "Ben... did she do a piece of me?"

"Yup. A couple, but one in particular. We can go later this week and get it, if you want."

Josette started crying, quietly. "I'd really love that." Ben's eyes filled with tears, too.

"Josette, do you know Estelle Dumas, personally?"

"A little, of course. She did the Maclean's article, and I had a hand in that. Why?"

"We may need her. Well, *I* may need her."

Josette nodded. "I've been thinking about it since last night. You might be right about that. After She did the Crowsfoot program, she wanted to do a more in-depth biography. Guylaine thought the idea was silly, since she was only thirty-four. Maybe now is the time to reach out. I'll have to get it okayed by my parents."

Ben nodded, acknowledging that hurdle. After a minute he added, "Guylaine added a funny twist to the Madonna story. You know, when Hélène had her second boy, Daniel, he was a gift of a child, considering all she had to do to conceive the first time. But, Hélène was actually disappointed. Yeah, Guylaine laughed then, too. She said that the next sculpture would be another Madonna, but this one disgruntled. The title would be, *I sorta had a girl in mind.*"

Josette laughed out loud, then caught herself. "Don't tell my mom that one." She sat up on the bed, "Hey, there's some fresh clothes in that bag. If you need anything else, let me know."

"Thanks Josette, you're a brick."

"Well, at least till I crack. And, we all do, sooner or later. I'm hoping it's later for me, because of my parents."

"If I can help, let me know."

Josette sucked in her breath, raggedly, "The stories help, you know. The songs and the little bits about her life. They *all* help, a lot." She sniffed and stood up. "I've got to get coffee brewing. It's morning in Red Wing, ya know." With a quick smile through her tears, Josette headed downstairs.

Chapter 12

Jean Luc was at the kitchen table, coffee already in hand. "Josette, I was just telling your mother that I think we need some kind of plan."

Josette poured a cup for herself and leaned back against the counter, looking back and forth at her parents for a clue, "So, okay, a plan for what?" She looked around. The table and the counters were stacked with food. Françoise was putting casseroles and soups in the refrigerator.

"The town is crawling with reporters. They're *everywhere*. Someone told Claudette there was even a reporter up at the cemetery looking for leads." Jean Luc shook his head and took another sip of his coffee.

"But, so far they haven't found us here," said Guillaume. "You'd think the easiest thing would be to just come up and knock on the door."

Josette laughed. "Well, not so easy as you'd think, now that Jean Luc has done a little cosmetic work."

Guillaume and Françoise looked puzzled.

Jean Luc flashed Josette a look, "Uh, well, when folks started talking about the Press, I doctored up your mailbox a bit and put a chain across the drive."

"Exactly *what* did you do to my mailbox?" Guillaume was always meticulous about his mailbox, a stainless steel model, which he kept at a high shine and on which he had proudly stenciled their name and the street number.

Jean Luc looked down at his feet, "I just made it look a bit more… you know, French-Canadian. I did it for *your* protection." Josette turned her head away, giggling.

"*What?* You painted it? Years I've kept it up." Guillaume turned to his wife. "They've vandalized *my* mailbox."

Françoise elbowed her husband, "We'll get you a new one. Good God, Guillaume, your cousin here owns the hardware." She stole a glance at Josette to stop her giggling. "But that chain certainly explains why it's been so quiet around here. I was wondering why there were no visitors, and after a death in the

family." She clucked as she smoothed the Saran-wrap over a bowl of potato salad. "So then, all this food was delivered where?"

Jean Luc smiled, "To the hardware, of course. The back room was full of it. A bit of a dodge there too, because it hasn't been lost on the Press that the name on the sign, in front of the store, is *"Maisonneuve's Hardware and Farm Supply."*

"So where's the dodge?" asked Françoise.

"My clerks are telling anyone who enquires that I'm a distant relation, and if they want to talk to family, they should contact the St. Pierres or perhaps the Parents."

All of the Maisonneuves howled at that, leaving Ben, who'd joined them, in confusion. He looked like a teenager in his t-shirt and new jeans. They fit, but he'd lost his usual stuffy, professorial look.

"I don't get it," he admitted.

"Just look in the phone book," Guillaume pushed it to him. "It's not a total lie, but not too helpful either. My two living sisters are married, one to a *St. Pierre* and the other to a *Parent*."

Ben rifled through the pages, stopping first at Parent, and then flipping to the S's. "Oh my god, there must be two hundred Parents and there's a page and a half of St. Pierres," Ben looked up at the broad grins around the kitchen.

Jean Luc said, "Those St. Pierres, I swear, they're like rabbits, eh."

Françoise added, "The cemetery won't help, either, all the Maisonneuves are buried here on the old homestead." She chuckled, "We're hiding in plain sight."

"Someone will tell though, maybe not from town, but maybe someone in Puce or Tecumseh. We're too well known. I should probably stay out of the bank for a while." Josette screwed her face up.

"Josette, what could be wrong with that? You haven't taken vacation in years."

"You've got a point, maman. I can work around it, we've got some loans to settle, but with the phone, maybe I can get Giselle to handle most of it."

"I should hope so. You're sister's passed, what do they expect?"

"Mom, I'm the boss, I'll make it work." Josette was just doing the juggling in her head.

"How will people come see us?" Françoise screwed up her face, concerned about the proper funeral protocol. As leaders in the community, *and* the owners of the main funeral home in the area, Guillaume and Françoise had buried members of almost every family in town. People would want to pay their respects. She surveyed the counters, and there was already a lot of food.

"We'll work it out," Guillaume assured her, "So far we don't even..." his voice began to break, "We don't even have our daughter yet." He covered his face with his hand, leaning on the table.

Françoise took his hand, lowering herself into the chair beside him. Quietly, almost just to him, she said, "We can do this, we did for Lucille, and with God's grace, we will for Guylaine Claire, too." Since this recent tragedy, it was the first anyone had mentioned the daughter they'd lost under the ice, almost thirty years earlier. The room fell silent.

Ben cleared his throat. "There's a sculpture *and* a headstone."

Françoise looked up, "Pardon?"

"Guylaine did a bronze for her own headstone. I don't know if you set those right away or not. My people wait a year. But, up in Oakville there's a sculpture and I know she wanted to use it."

Guillaume regained his composure, "And, did she have *other* plans, as well?"

"We didn't discuss it that much, we obviously didn't expect *this*. But, the last time we went to Paris, we went to Père Lachaise—it's a lovely cemetery. She felt that the French had a correct sensibility about graves. She loved the sculptures. When we came home she spent a few days on it. She showed it to me when it was cast. I remember thinking how simple it was, so elegant, and I hoped that I'd never to see the day it was used," he dropped his eyes, "And you know Guylaine, there'll be a pile of notes, in her casting journal. It will have the complete installation instructions."

"This *does* help." Guillaume nodded. "It's better when the family, or the departed, I have a clear vision. This way, we can give her what she wanted." Françoise, still holding his hand, was nodding with tears on her cheeks.

Guillaume added, "Did she tell you *where* she wanted to be buried?"

"Why, here, of course. Right next to her sister, by the river. I don't think she ever contemplated anywhere else."

Guillaume breathed a sigh of relief. "Thank you. I've been agonizing over this. I just want our girl home, but we have to respect her wishes, and yours, of course," he nodded to Ben. "But, it just feels right for her to come home, here to the family plot." Guillaume squeezed his wife's hand.

"Papa," Josette added quietly, "He knows about some music, too. We need to think about this in advance, because the schedule will not be ours."

Josette poured more coffee while Ben and her parents talked about Guylaine Claire and the music. Ben hummed the tunes and Guillaume nodded, recognizing them, one in particular caught Guillaume. Ben valiantly *tried* to hum the soprano piece, but Guillaume recognized it immediately.

Tears came to his eyes, "Ah, the Aria, Cantilena. It's from Brazileiras." He dropped his head and his tears fell freely onto the kitchen table. "This one, it's perfect."

They were good selections and they would need a soloist. Guillaume and Françoise had ideas, as well, and some songs for the choir. Jean Luc made some suggestions, too. Josette watched silently as the healing magic of symbolism stepped in to weave them together in Guylaine's absence. And, these quiet, orderly plans helped to put their loss in a safe place, a place that suspended her, and them, in love.

Chapter 13

Père Michel had a bad feeling as he locked the chain behind him and slipped back behind the wheel. It was still overcast from last night's heavy rains, and now, the temperature was falling. He rubbed his hands together to warm them, *and* to rub off the mud. Good thing today he'd opted for a clerical suit. From the passenger seat in the Chevette, Father Tony looked skeptically at the aging priest, now muddied from fiddling with the lock and chain.

"I don't know, Michel, if you *really* need to go through all that. And, after that goofiness at the hospital, have reporters really been that big of a problem?"

"Town is *swarming* with them. They're asking questions, everywhere."

"Yes," Father Tony continued, "But just what would happen if they found the Maisonneuves? If you don't run, nobody can chase you."

Michel thrust the little car into gear and pitched forward along the rutted road, the kilometer or so to the Maisonneuve house. Past the house, the sky over the lake looked threatening. Maybe the weather explained his feeling of foreboding. "Come on Tony, these are the same buzzards who showed the shooting round the clock, for *three* days, in the name of news. They would have ambushed the family at the hospital if we had let them. Have you witnessed anything resembling compassion, or even a little respect?"

The younger priest paused, "Well I'm just not sure it's worth turning the family into prisoners, is all." Tony had made his point.

Michel pulled around back where Hélène's boys where tossing a football. The two ample priests extricated themselves from the tiny car.

"Hey, Père Michel," waved the older boy. Donald, the spitting image of Roger, was friendly but stayed where he was, tossing the football from one hand to the other. His little brother, Daniel, hadn't yet reached the age when he'd be too cool to run over for a hug. He buried himself against Michel, who returned the embrace, happy to be reminded that these were really great kids.

"How are you boys doing? This is my friend Father Tony. He's going to help out with the choir. Are you two sure you don't want to join?"

Both boys lined up and extended their hands, "Nice to meet you Father Tony," said Donald. Daniel shook hands too, but didn't say anything—he just kept nodding his head, up and down. Michel was impressed. In this day of lapsing manners, Hélène's boys always presented well.

Father Tony, in a friendly way, pushed the point, "So what about that? Would you be interested in joining choir?"

"No, Thank you, sir." Donald said, his eyes focused on the ground. Daniel just covered his face.

"Why not?" pressed the younger priest, sure he already knew the answer.

Donald stood silent, but Daniel gave up the game, "Choir's for *girls*."

Both priests laughed. Tony tousled Daniel's hair and added, "Yeah, well, tell that to the Mormons." The boys just looked at him blankly. A few raindrops fell and they all turned towards the house.

Father Tony heard it first—what he thought was the low drone of a large insect. Looking side-to-side, his gaze finally settled towards the east. Then Michel heard it too, but distracted by the boys, dismissed it until he noticed Father Tony looking out over the lake, his hand shading his eyes. The buzz kept building, and now had the boys' attention, as well.

Père Michel, more to himself than anyone, asked, "What's that sound?"

Father Tony, spotted the two dots that were growing rapidly as they approached, pointed and said, "It's coming from over there."

"I bet it's the helicopters again!" Donald cried out, clearly excited.

Both of the men looked at the boy and almost in unison asked, "What helicopters?"

"The ones from earlier. They were going back and forth, really low. It was *so* cool!"

The priests looked at each other— they were in the open, fully exposed and whatever this threat was, the Maisonneuve

home was the closest refuge. Instinctively, they started to shepherd the boys towards the house, glancing skyward. The shapes of the two aircraft were now distinct and the low drone soon became a rhythmic pounding. In his haste, and with his attention drawn to the sky, Michel almost trampled Daniel, who had slowed to watch the in-coming helicopters. Keeping his voice even, he urged the group, "Hurry along, everyone. We should get inside as quickly as possible."

"I've got a pretty good idea what they're looking for, and I don't think *two priests,* in the yard, should be what they find." Father Tony's jaw was set—he had the look of a cornered animal, his eyes scanning his surroundings, determined to escape.

Père Michel wore a slightly panicked expression, his head swiveling from side to side as though he expected another helicopter to suddenly appear from a different direction. It felt as though the Maisonneuves' were actually being hunted—their pursuers relentlessly scouring the country-side, and now, he and his small flock were in the cross-hairs.

They scurried across the yard, finally reaching the relative safety of the covered porch. Ascending the steps, Father Tony quickly ushered the boys inside. Michel couldn't help but stop and look up. The helicopters speed had slowed, even as the noise of the churning blades, and their turbine engines, increased. He could now clearly see one of the "hunters" leaning out, video camera in hand, surveying the terrain through his view-finder, in search of a target. Shaking his head in disgust, he turned and followed the others inside, unconsciously slamming the door behind him.

In the kitchen, the two Maisonneuve sisters were cooking. Françoise was going through the mail when Father Tony rushed in with the boys, followed by a visibly flustered Père Michel. Work in the kitchen stopped as they all listened while the helicopters briefly hovered, over the house, then flew off in their relentless search.

The old priest grumbled angrily, "I can't believe the *nerve* of those people!"

Françoise looked up, "Some of them came to the front door earlier. I didn't even think. I opened the door and there they were, with microphones and cameras, practically barbing their way in!"

She was still a little rattled. "If Josette hadn't stepped in…" She let that hang in the air.

"So, what did you do Josette?" Father Tony asked.

"I yelled at them, of course. They were behaving like children, so I shamed them like children."

Guillaume stepped in from the living-room, "She was great! They skulked away like bad, little boys. I don't think we'll be seeing *that* footage any time soon."

Tony and Michel exchanged looks. "I should have bet you on that." said Michel.

Guillaume stepped over and gave the priests a hug. "Thank you for coming."

Father Tony pointed up, "Well, there is good news. Since they now know where you are, you can stop hiding." Tony looked around the room. "It's time to pick your Press and exclude the rest."

Guillaume put his arm around his wife and turned to his daughter, "He's right you know. Josette, we need to get in touch with that woman, the one who did the interview and the television program."

"Estelle?"

"Yes, she did a wonderful job with the magazine interview. If this story is worth telling, she's the one to tell it. We already trust her."

Père Michel sighed with relief. It was the right move. They'd all been talking about it, but holding off because Guillaume and Françoise might have found it unseemly. The Maisonneuve family took the personal business of grieving seriously. Guillaume was not one to bend his principles to accommodate the morbid interests of outsiders. In an odd way, Michel was relieved by the day's invasion of privacy. It had so upset Françoise that Guillaume was now reaching out for creative ways to protect his family.

Josette put her paring knife down and washed the smell of onions off her hands. She turned to her father, and taking his face in her hands, kissed him on the forehead. "Merci Papa. It's not our usual way, but it's the right thing to do now. I'll give Estelle a call." She pivoted back to her onions, where she and Hélène were chopping and mixing.

Père Michel poked his nose into the cooking, "So, what are we making?"

Hélène laughed and smacked him lightly with the back of her wooden spoon, "*We?* Josette and I are making tortières."

"Mmmm. But, isn't that an odd choice? It's not exactly the holidays." Tortières are the traditional French-Canadian spiced pork pies.

Hélène explained, "No, but they're always well received and can pull together different types of food. Guylaine Claire loved them." Hélène often called her sister by her full name. She poured blended spices into the meat and onion mix.

Josette added, "We have tons of food that our friends, neighbors and a lot of folks from town have generously provided, but we needed something for an anchor, so all the different elements can fit together."

Père Michel looked over at Josette, "So, you're on board with this?"

"Michel, you know better than to question Hélène when it comes to food. She's a genius." She held up her hands, knife aloft, "*I* just chop."

Michel was pleased—that Josette was learning to hold her tongue—and to see the daughters working together. He waved his hand at the preparations, "And since you're obviously cooking for a crowd, exactly who is going to eat all this food?"

Françoise answered, "This evening we will entertain mourners and friends. The chain will come down for twenty minutes at 6:30. We will host our friends until 9:30, when, again, the chain will come down for twenty minutes. Our dear Jean Luc has spread the word and made all the arrangements." Guillaume nodded his assent.

The healing continued. The Maisonneuves were pulling together for strength, reaching back out to community, even beleaguered by the Press, and in the face of tremendous loss. Michel was always humbled by the strength of love in this family. Quietly, he lowered his head and silently offered his private thanks for this blessing and for his inclusion in it.

Father Tony put his hand on Guillaume's shoulder, "We should talk about the choir and the music. I'll need your help."

Guillaume put his hand on the priest's, "Yes, of course. Please come into my study, I have all the music set out and we can discuss the arrangements." The two stood and filed out.

"Et, tu?" Françoise said to Michel, "Aren't you going to help with the choir?"

"Me? What do I know from music?" Michel reached over and sampled from one of the bowls on the kitchen counter. "I'm here to supervise the kitchen."

The sisters laughed and Françoise stood and took up a knife to join them.

Hélène called out as the boys headed back outside with the football, "Don't get all dirty, we'll be needing your help with serving tonight." The boys rolled their eyes, but nodded assent. Michel watched as Josette took the interruption as an opportunity to slip away and make the telephone call to Estelle Dumas.

Chapter 14

Josette wiped her hands with the dishtowel and looped it through the refrigerator handle to hang dry. Françoise was wiping the counter and Estelle filled the kettle with water for a pot of tea. As they each finished her task, the three women settled around the kitchen table.

"I'm exhausted," reported Françoise. "I have just enough energy for that cup of tea. Then, I'm off to bed."

Josette laid her hand over her mother's and gave it a squeeze. "We did good tonight, Maman."

"Yes, and Hélène was a peach."

Josette nodded, but was not as sanguine. It wasn't lost on her that her sister always managed to be overwhelmed by a situation, and to leave *just* before it was time to clean up. It rankled her to have Hélène make such a display out of grieving for Guylaine. It seemed disrespectful of her parents, in particular. She chided herself for being so petty—Hélène had, after all, spent the afternoon with them cooking for the gathering. Josette didn't mind the scullery work, but she hated to see her mother doing it. Under any other circumstances the ladies of the town would not have permitted the bereaved to host and clear up after such an event, but good intentions were trumped here by a locked chain and the Cinderella hours set by Jean Luc and approved by the family.

Josette was relieved by the gathering. The family was starting to feel isolated, out at the farm. They felt confined by the presence of the Press in town, and pressured to stay at home because news could come at any time, by telephone. They never spoke of it, but ever present was the possibility of "the call." The provincial police had undertaken the inquiry, because the Mounties were involved in the shooting. Oddly, it was not the outcome that held sway over the Maisonneuves—it was the anticipated release of Guylaine Claire's body. No funeral could commence until she was brought home to her family. Until then, they were in a kind of limbo, days filled with minor errands while everyone virtually hovered over the phone. But, tonight had felt more normal. Josette's reverie was broken by her mother's voice.

"You got up to speed quickly, Estelle. I cannot thank you enough for all your help. Did this evening provide you with any… material? Things you can use?"

"Oh yes, it was great. Just about everyone had a story they wanted to share about Guylaine. I'll need some help sorting out all the names, but my notebook is bulging." Estelle lowered her voice, "and, Françoise, thank you for introducing me like that. People are much more open when a family member introduces you as Guylaine's *official biographer*."

Josette let out a laugh, "Well, I don't think it hurts any when *you're* serving the drinks."

"Yeah, that was Father Michael's idea."

"The man does know his parish," smiled Josette.

Françoise's brow furrowed. "Really dear, you're going to have to call him Père Michel. And, with a name like *Estelle Dumas*, how is it you don't speak the language?"

"Maman," Josette chided, "You cannot continually challenge everyone, with a French given-name, on their linguistic prowess!" She stood up to pour the water for tea and carried the pot back to the table, dangling three cups by their handles in her other hand.

Françoise turned to her daughter, "I just that I don't understand—if one's family doesn't speak the language, how do they expect to preserve the culture?"

"My mother was Spanish, my father from Provence. We were raised in Germany, with Spanish as our first language and German as our second language." Estelle's explanation was perfect.

Françoise shook her head, "Ah, the mother's tongue for the children and the language of the country of necessity. A pity for your father, though." Françoise forgave her geography. "What did your parents do that they lived in a foreign land?"

"My father was a journalist, my mother a textile designer." Estelle submitted willingly to the vetting.

"And you have sisters and brothers?"

"One sister and two brothers."

"Where are they?"

"My sister is in British Columbia, one brother in Hong Kong and the other is in Madrid."

Françoise continued with her *interview,* "And your parents?"

"My mother now lives in Madrid, near my brother. My father passed when I was fourteen."

"Ah, such a loss in your tender years. My condolences." Françoise' head nodded knowingly here. Josette smirked that her mother had unearthed the obvious explanation for the loss of the French language. Josette poured the tea.

"Thank you," said Estelle, but it wasn't clear who she was thanking. She settled back and sipped her tea.

Françoise leaned forward. "I was never permitted to learn my mother's language, only French was spoken in our home. And, I didn't learn English until college—and then more when I moved here."

"But college was not so common a choice for a young woman of your day." Estelle was impressed.

"Well, I was sent to college with the idea that I would be a nun. I went to Montreal, but in my second year, I met Guillaume. It was then I learned I had another calling."

Estelle leaned forward, "So, was it love at first sight?"

Françoise laughed, "Not at all. I actually disliked him at first. He was very studious, always knew all the answers. That I could forgive, but," Françoise confided, "He came to every class early. I didn't know why, but that annoyed me immensely."

Estelle looked puzzled.

"I can't explain it," Françoise continued, "I made an effort to come a little early, but every time he was already there, with his books spread neatly in front of him."

"Just tell her why, Maman." Josette urged.

"He and I were at the top of our classes and I became very competitive. I thought he was pompous, and there *I* was, guilty of the sin of pride. One day our mathematics professor wanted someone to solve a problem at the board. He called on Guillaume, who refused. It would have been an opportunity for him to shine, but Guillaume turned it down. So the professor called on me and, of course, I did it. Afterwards, I had to ask him why. But, when I did, he was mortified, you could see on his face, he dropped his eyes, he stammered. Finally he looked up at me and said that it was because he was a cripple and that he tried to avoid any display of his infirmity. That's how he put it, *'any display of my infirmity,'*

like it was his fault. Mind you, I had never seen him out from behind his desk."

"*That's* why he came early." Estelle winced with the recognition of it.

"Yes, back then he limped terribly. They didn't have all the fancy orthotics they have now. His clubfoot had always been a source of shame for him, a tragedy that, for many years, had split his family. And, there I'd been judging him, not knowing the facts. I felt so mean spirited that I wanted to run in shame, but that would only have compounded my sin. So, my penance was to get to know him." She looked up at Estelle, "You'll soon see that to know Guillaume, is to love him. Before long *I* loved him so much that I knew I surely couldn't become a nun." Françoise folded her hands on the table.

"To this day, my father says that mathematics was his luckiest area of study." Josette looked tenderly at her mother.

"And mine too," Françoise smiled.

The kitchen was quiet and they could hear the stereo in Guillaume's study playing the songs he and Tony were selecting for the service.

Françoise turned to Estelle, "So you see, you never know— this morning you were just another reporter and now," she patted her cheek, "You're like family. We feel we're so lucky to have you as our emissary, to tell Guylaine's story and to protect us from the rest of that rabble." Françoise took her hand, "I'm so glad that Josette was able to reach you. This is such a blessing, to have you with us."

"Honestly, I was in Windsor trying to reach *her.* I knew that Guylaine Claire's story was here, with her family. I was very touched that you wanted me to tell your story, and to tell it as family."

Françoise nodded.

"Is *that* what you said?" demanded Josette, "You invited her as *family*?"

Both Françoise and Estelle turned abruptly to Josette. Estelle jumped to Françoise's defense, "She was very genuine, very sweet. She said 'I hope you'll join our family and tell our story.'"

"In front of Hélène, eh?" Josette started to giggle. "Well, *that* explains a lot."

Now the joke was dawning on Estelle, she smiled broadly and turned to Françoise, "Tonight, while I was talking to Jean Luc, I think it was, Hélène tapped me on the shoulder, handed me a stack of dirty dishes and said, 'Welcome to the family.' I didn't give it much thought at the time—I just helped with the dishes."

Josette was laughing, "I saw it but didn't understand what was going on. *Now* it makes perfect sense." She added, "Sometimes there are ripples in our family, but we'll smooth them out for you."

Françoise shook her head—she was not amused

Estelle held up her hand, "Don't worry about it. Let me assure you, it's not the first time I've seen friction between family members. I can be very diplomatic. But, thank you for the heads up."

Josette was still smiling, "Mama, I am exhausted. I think Ben and I have some planning to do tomorrow but I'll try to get back early." She leaned over and kissed her mother on the cheek, and turned and to Estelle, "If you're ready to go, I'll follow you out and unlock the chain."

"There's no need for you to do that," Françoise stood, reached into the spice cabinet and removed a small envelope. She pulled out a key and handed it to Estelle, "You should be able to come and go as you please."

Estelle graciously accepted the key, "Merci," she said, bowing forward. "When I get back to my hotel in Windsor, I'll contact my editor, who'll *leak* that I have an exclusive with the Famille Maisonneuve. That should ease some of the pressure. Tomorrow though, I'll need a recommendation for somewhere closer to Red Wing, to stay."

Françoise didn't miss a beat, "Don't be silly. You'll stay here, of course. How can you be our family historian, without being here?"

"I don't want to intrude, Françoise. These are difficult times for a family. Nearby is good enough."

"No, I insist. We have three empty bedrooms here. You'll just stay with us. I know Guillaume will want that, too."

Estelle turned to Josette for support.

Josette shook her head, "Don't try to fight French-Canadian hospitality. It's supposed to be bad luck or something." Josette turned and headed for the door.

"Wait, I'll walk you out." Josette waited while Estelle grabbed her handbag and rushed to give Françoise a hug and kiss. The two women then headed out into the dark, October evening.

Chapter 15

Ben came downstairs dressed in his own clothes. He'd discovered them laundered and neatly folded on the other bed. Though he hadn't been aware of not feeling himself in the clothes Josette had bought, being back in his own again, was a relief. He felt a little more adult.

Waiting for news was beginning to wear on him. Ben needed something to do and had half a mind to call the authorities to check on the progress of the investigation.

He made his way downstairs and found the kitchen empty. He poured himself a cup of coffee and sat at the table. It was quiet, and he wondered if this was how his new life would be, without Guylaine. In the bustle, he sometimes broke the grip of his loneliness. It reminded him of summer camp when he was a kid—suddenly all of your routines were gone, but it was the same with everyone around you. You just moved with the crowd and it came out alright, even fun along the way. Guylaine's family was wonderful, embracing, but this was a journey, not a destination. Here, it would not come out alright. He couldn't visualize what the best outcome would be and he couldn't change the visualization of what already was.

Guylaine would have taken these feelings and translated them into wax or clay. But, he was an academic—his thought processes did not easily absorb the personal. He looked at his hands and wished they could offer some transformative insight. He marveled at Guillaume, who was otherwise ragged with this loss but found so much comfort in music, even in the process of selecting the very music with which to bury his daughter. Ben could see Guylaine in that, in how music often seemed to be her first language. Françoise had a deep faith and the ability to pull meaning out of her daily duties. But, Ben was stuck. At night, in that twilight stage before sleep, he was flooded with the sense of her, her scent, the way she shifted her weight in bed next to him. How she'd pull the covers tight around her like a cocoon or how her long hair spilled off her pillow and tickled him. He was passing *through* Guylaine in a way that, if he tried to stop—to hold onto the sensations, he was either jerked awake to the

emptiness or he slipped into the oblivion of sleep, and lost her there. He wanted to drift in the sensations, to hover forever and keep her there, with him.

Awake he was tormented by fleeting images of art that tried to capture grief. He thought of the tombstones that Guylaine had loved so much at Père Lachaise in Paris, the ones that captured the essence of the deceased or the torment of those left behind. There was one he'd thought was melodramatic—a sculpture of a draped figure leaning against the mausoleum, one arm raised to the grated window. Now, the memory of the two of them, holding hands in the spring air, touring the *monuments to loss*, tore at him. That sculpted melodrama did not touch the now, airless space in his chest—the ache of wanting to understand.

His head was full of images, famous paintings and sculptures of death or grieving. Was this the torture of the art history professor? So many of Guylaine's own religious sculptures drew on that theme. He was reminded of her *myriad pietas*—Mary tenderly holding the draped body of her beloved son. This had been one of her best selling images. She'd sculpted it repeatedly, never replicating the details, each one a full-blown exploration of some new facet of grief. These were the gentle reminders of his sorrow. More often, he would awake with a start to the image of Guylaine in the courtyard, with the stain on her shirt flooding across her even before she realized why she'd stopped. This scene had crystallized and he connected it to a familiar image, Goya's seminal *Third of May*—a man in a white shirt, arms outstretched awaiting execution by a firing squad. In that image he felt the pang, the pointlessness and the trapped-in-time feeling of the loss. Over the past several days, he'd come to loathe that painting.

Outside Ben heard a car pull up. He wiped his eyes and stood to greet those arriving. He walked to the back porch and peered past the line of windowsill tomatoes. Père Michel and Jean Luc stepped out of the pick up, their faces grim. Ben's knees went weak. Bad news, maybe, but what worse news could there be? Ben realized he wasn't ready for the results of the inquest. He lowered himself to the table before Michel and Jean Luc let themselves in.

"Morning," was all he could muster.

Swinging open the cupboard and pulling down two coffee cups, Jean Luc opened the conversation, "So, how are you holding up Ben?"

Ben just nodded. He saw that Père Michel's face was taut, his jaw clenched and eyes almost wild. It was alarming to see. Jean Luc poured the coffee and set one in front of the agitated priest.

Ben struggled to catch his voice, "Michel?"

Jean Luc was now busy rummaging, his head buried in the refrigerator. Without looking, he volunteered, "Give him a minute, he'll be okay once we get some sugar in him." Closing the door with his foot, he wheeled around with a plate of leftover brownies and cupcakes, placing them in the center of the table.

Michel spoke, "Jesus, Jean Luc, you can't smooth over everything with a plate of sweets." He sipped his coffee.

"That's not what Françoise says." Jean Luc grinned, "She says whenever there's shock or loss, apply sugar. She should know, eh, she *is* in the business."

"What's going on, Michel? Jean Luc?" Ben was pulled out of his stupor.

In spite of himself, Michel reached out for a brownie. "Someone broke into the church early this morning. They tried to steal the Patron Saints and the Stations of the Cross. They didn't get what they came for, but they did a lot of damage."

"We were concerned about security here." Jean Luc added.

No one had thought of this. With Guylaine Claire dead, and with her work and life all over the airwaves, thieves were now after her sculptures. Horribly, the chief victims would be the churches that had supported her over the years with commissions.

Though Ben was appalled by what had happened, he couldn't help but feel relieved that it wasn't bad news about Guylaine. Even to an outsider, stealing from a church was low. But, the result seemed unlikely, "I don't get it, why weren't they successful? I mean, how hard could it be to steal her sculptures from the church?"

Now Jean Luc laughed, "These aren't *De Prato's*. Guylaine was always concerned about liability. She made these Stations of the Cross for Père Michel after one of the old, plaster ones fell and injured a child during communion practice. It wasn't for nothing

that her uncle was in the hardware business. Her sculptures are always *seriously* attached."

Père Michel nodded as he swallowed, "Yes, and most of the damage is to the walls. They used a crowbar, but still couldn't pry them from the walls. Saint Jude has some nasty gashes, but we can get him fixed." The sugar was kicking in. Père Michel was recovering. "Mostly it's just a shock to have a break-in and theft from a church." He shook his head in dismay, but the wild look was gone. "Where are Françoise and Guillaume?"

Ben shrugged, "I don't know. The place was empty when I woke up. They can't have been gone too long, the coffee was hot." Now, Ben reached for a cupcake.

"Ben, do you know to reach Estelle?" asked Père Michel, "We've got to get the word out and warn the other churches."

"That could be a mistake." Ben shook his head. "Putting this out, over the airwaves, could actually bring about more thefts. You know, copycats."

"So, what? We don't even warn them?"

"No," Ben explained, "I'll call Cathy at the foundry and ask her to go through the records and contact all the churches that Guylaine did work for. She should be able to reach most of them by the end of the day." He picked up the phone.

Jean Luc interrupted him, "Eh, don't you think you should tell her to beef up security at the foundry and Guylaine's place?"

Guylaine lived and worked in an old cannery that she'd converted to a working, production foundry, mostly for her religious work, and a series of apartments. Ben lived there too, on weekends and during the week he stayed in Toronto to be closer to the University.

Ben nodded, "I don't think it'll be too much of a problem, I wouldn't want to wrangle with our foundry guys, but I'll mention it." He reached for the phone and dialed the foundry number.

"Cathy, it's, Ben." He paused and listened. "I know. I'm sorry I've been such a wreck. I was calling to warn you about the possibility of theft from churches or the foundry. We need to get the word out. I didn't even think about what might have been happening there." Ben sat nodding, absorbing a torrent of words, so anguished that Père Michel and Jean Luc could hear it. Jean Luc cringed. Ben didn't even try to interrupt. He felt ashamed that

he hadn't connected with Guylaine's second family—her foundry and artist friends at the compound. They too were suffering. Finally, when the tinny voice on the other end softened, Ben spoke.

"Okay, I'm here in Red Wing. I'll be up later today. Just hold everyone at bay till I get there. No that's alright, it's a corporation, I can sign. No, Cathy, just hang tight till I get there." He paused, nodding. "Okay? Yup, before close of business. Uh huh. If you compile a list of clients, I'll draft a quick letter, today." After another pause, "It's okay, I'm on my way. See you in a couple of hours." Ben gently replaced the handset and sighed.

"What's happening up there?"

"I dropped the ball, Michel. The foundry has been inundated, reporters, mourners, wackos and even creditors. She says there are flowers a foot deep at the loading dock. The employees are devastated and are being hounded as they go to and from the complex. And, some of the creditors are threatening to pull accounts and put them into collection because of Guylaine's death. They need my help." He turned to Jean Luc, "Is there a truck I could take? There's stuff there that has to come back. Some of it is pretty big."

"Sure. Could the F250 handle it? He didn't wait for an answer, "Whenever you're ready, you let me know."

Voices came from the back porch. The Maisonneuves and Estelle marched up the back steps and into the kitchen, their cheeks pink from the chill and exertion. As soon as they entered, they felt the tension.

Michel snapped, "*Where* have you been?" He immediately regretted his tone.

Françoise shot back, "We've been gardening and cleaned up the graveyard."

Guillaume put his arm around his wife protectively, "What have you heard. Is it about Guylaine?"

Ben, already standing, gestured at Père Michel, "No. Michel can bring you up to speed. I have to get ready to go to Oakville. He went upstairs to pack, but when he reached his room he realized he'd brought nothing with him but the clothes he was wearing—there was nothing to pack. His ears rang with the sting in Cathy's voice. They had no choice but to share their grief.

Alone it compounded. It was a relief to be needed. Ben sat down on the bed, covered his face and sobbed.

Downstairs, Père Michel and Jean Luc recounted the break-in, their voices rising in agitation that carried upstairs. Ben listened as Père Michel described the damage and got himself worked up all over again. Everyone was indignant at the desecration of the church. Guillaume fumed at the insult of it. He wanted the damage repaired immediately and quietly, afraid the funeral would become more of a media circus. Françoise and Guillaume lamented their own failures to connect with Guylaine's foundry. They were adamant that Ben should not go alone to Oakville. Françoise suggested Josette. Then, Ben heard her making the call. He smiled at the earnest concern for his welfare.

By the time Ben gathered his wits and reported back to the kitchen, everything was settled. Ben and Josette would take the truck to Oakville and Toronto. The Maisonneuves would sit tight, Guillaume to work on the music with the soloist, Françoise to cover coordination. Estelle was torn, but Françoise assigned her to go, to cover the scene at the foundry and to watch over Ben. Françoise announced she'd be working with Hélène to plan the post-funeral reception.

With a plan of action now in place, Michel could relax. He apologized to Françoise for being worked up. She pushed the plate of baked goods in his direction and everyone laughed. Jean Luc finished his cupcake and headed out to get the truck. Twenty minutes later Ben, Estelle and Josette were out the door, headed to Oakville.

Chapter 16

Jean Luc pulled up in the F250, ready to trade Josette for her Mercedes. Josette came down the porch steps and handed him her keys, looking nervous. Earlier she'd asked Ben if they wouldn't be more comfortable if she drove her car, but he'd just insisted they needed the truck. "Don't sweat it Josette, I won't hardly race her around at all." Jean Luc laughed. He nodded at the truck, "Key's in it."

Josette lifted one eyebrow, "Am I *that* transparent?"

"Like a window, but don't worry. So, who's gonna drive?"

"I am assuming Ben is, but I can if I have to." Josette was no stranger to work vehicles—she'd been driving hearses, trucks and tractors her whole life.

"I know you can, but whoever does, needs to know that the parking brake sticks a bit. You need to jiggle it to get it to release. Should I show you?"

Josette flashed him a look. "Whose daughter do you think I am?"

It was true. Guillaume had always been a wiz with engines and things mechanical and all his girls knew their way around the shop. *Even* Hélène. Jean Luc could only smile. He turned and folded his lanky frame into Josette's car, just as Estelle came down the steps with her backpack. Josette noticed and barked at Jean Luc to wait up, realizing she'd left her stuff in her car. Ben joined them and the three climbed up and slid across the long vinyl seat stretching the width of the truck—Ben driving, Josette took the middle and Estelle perched on the outside. Guillaume and Françoise came out onto the back porch and waved them on their way. They'd all entered a new phase now; there were things to be done. Françoise clasped Guillaume's hand in hers as the truck and the Mercedes pulled away.

They rode in silence for a while, odd companions on an undefined journey. Only Ben really knew their mission, and he was being pretty tight-lipped. Josette realized that she hadn't been to Oakville for several years. Usually Ben and Guylaine came down to Red Wing to visit. Josette had helped Guylaine with the financing for the Oakville purchase—since it wasn't a standard

deal, the bank was uncomfortable with the loan. Guylaine had proposed taking a defunct cannery and converting it to a home for herself, a studio, foundry and rental spaces. Lenders, uncertain about the prospects or resale value of such a venture had needed convincing. Once the deal closed, Guylaine wasted no time in renovating her personal space into an amazing home. Josette had assumed she'd live like a student, or starving artist, but Guylaine had come there to live. A gourmet kitchen, rambling living and entertainment quarters on the first floor had a modern, almost designer appeal. Josette was surprised by the bold vision it took to transform industrial into habitat. Artistic aesthetics grabbed you, along with a sense of humor about design, and about herself, that Josette hadn't previously seen in her little sister. She'd smiled quietly at her décor comparisons between Guylaine and Hélène. Like Hélène, Guylaine never tired of personalizing her home turf.

Ben snaked the truck through the county roads out to the 401. The three of them lost themselves in the flat landscape—farmers' fields and woodlots cutting straight lines into land that welcomed a break from monotony. It was a relief from the jarring events of the day. This was Guylaine's landscape. She loved to come home to recharge. The truck's ride was stiff and the two women perched unsteadily on the hard springs of the bench seat. Ben melted into his role as the driver.

Bouncing along in the truck, Josette realized she was looking forward to seeing what improvements had been done. Then, she swallowed her tears, reminded that her sister would not be there this time for the usual tour. Guylaine's absence snuck up on her in bits. As adults they'd grown to know each other largely through Guylaine's business interests. Since Guylaine was not one to call and chat, Josette had relied on art and her remodeling for clues on Guylaine's emotional state. Though no artist herself, Josette was early seeing Guylaine's talent. She was the first in the family to recognize and embrace Guylaine's gift, and to recognize that her voice was in her art. When Josette could zero in on recent works, she had somewhere to connect, and then she and Guylaine could talk. Josette loved seeing how her sister could process raw emotional states into phenomenal sensual sculptures. In her own realm of form, line and volume, Guylaine was confident and centered. Outside that, she could be scattered and distant. A family

story could distract or confound her, until she found a way to integrate it into her own language. Nothing demonstrated that linkage more powerfully than the sculpture of their grandmother at Crowsfoot. They'd all grown up with the story of how Grandmère Claire had met Lucien. It was their family's romantic saga of innocence and heroism. When the sculpture was unveiled, Josette saw in an instant that Guylaine had found so much more in their story—it spoke to the entirety of Canadian history. That one scene encapsulated the spark of human decency surviving in brutal, frontier times. It captured transcending racism while acknowledging its ugly footprint in the Canadian psyche. In it Guylaine suspended judgment and shared her love and mercy for her family and for Canada. The sculpture was intensely personal in a way that touched everyone.

Ben made the sharp turn leading to the on-ramp, jostling Josette from her thoughts. Estelle pulled her jacket around her, from the window's chill. Josette leaned forward, adjusting the controls to kick up the heat.

"Thank you. With the day so clear, you don't realize how chilly it is." Estelle wrapped her scarf an extra loop around her neck.

"Temperature's been dropping for a couple of days," reported Ben, "More like what you'd expect this time of year."

Josette was distracted, "I guess we need to head up to Toronto, too. You can pick up some of your own clothes when we get there."

"I was counting on it. I'll need something for the funeral and some warmer stuff, in general." Then, looking to Estelle, "Is there some protocol to this. I mean, are we supposed to include you or let you observe objectively?"

"Well, I'm not sure there *are* rules. So far it's all been pretty informal, and that seems to be working. I may interrupt for some background stuff, or just make notes and follow up with questions later. I think we can play it by ear." Estelle was looking tired.

"Can we ask *you* questions?" Ben was sincere.

Estelle leaned forward to peer around Josette. "Sure."

"How did you swing that interview with Guylaine?"

"Well, I was pretty pushy, wasn't I, Josette?"

"I wouldn't say *pushy*, but you certainly were persistent, and persuasive. I had to really twist Robert's arm to get that moving." Josette smiled at the memory.

"Why *was* Robert so opposed?" Estelle looked genuinely perplexed.

"Well, it was Guylaine, after all." Josette looked at her as though that, in itself, answered the question.

Estelle seized on her ambiguity, "Okay, so there is a question—everyone seems to have this baseline assumption that Guylaine was 'odd' or 'strange' or something. But, in our interviews, I never got that. We met three times, once at her studio, at a Pieta installation and then for lunch. I never had any kind of problem with her. I didn't need to edit heavily and, if anything, it was so long. I had to take some good things out. Otherwise, the interview was pretty much as it was in Maclean's magazine. So, what's the deal?"

"Wow," was all Josette could say.

Ben explained, "It's not that she couldn't be articulate. Guylaine had an unusual sort of shyness. If she wasn't at ease or if the topic wasn't comfortable, she could come off as spacey. When I first met her, and she wanted to make a point, sometimes she'd gesture or draw strange forms on paper to make sure I understood. At first, it came off as weird. And, there was another language in there, one of shapes and forms and sometimes tones. Once, very early, before we were very close, she came into my office to ask a question about something in my lecture and slide presentation. Once I understood it, I thought it was a very good question. I showed her an image from her textbook, to illustrate the point. She flipped a few pages to another picture which, amazingly, I understood was a follow up question. We went back and forth, just flipping to different pictures of artworks in the textbook. It was a conversation, but there were almost no words. I hardly knew her at that point, but *that* visual encounter got my attention. I started going into the studio classes to check out her work and it was there, too. Like another language. She was way beyond the rest of her class in terms of what she produced. Her drawings were good, but her sculpture was extraordinary. She couldn't paint to save her life, yet from our... I guess you'd call it a discussion, I knew she

understood painting It just didn't interest her as a means of expression. So, I'll admit, she *was* different."

Estelle reached for her notepad. "Was that when your relationship started?"

"No, not at the time, but it was when I first noticed her as someone special in the arts program. Other faculty members talked about her. It's not very often we'd have a student who already had a paying career in the arts. So, you have to understand that when you interviewed of her, you were communicating about something of interest to her, and that helped. But, you didn't notice anything awkward or strained?"

"Well, she seemed somewhat shy. The point of the Maclean's interview, naturally, was that she'd won the award for the sculpture at Crowsfoot. So that was the opening salvo. I suppose that was a topic with which she was particularly comfortable. I'd checked her background before we met. I was impressed that she'd won other awards and had works in some major museums and galleries. I was mostly impressed with her business success. For a sculptor, especially a woman, that's quite a challenge and she had the successful line of religious sculptures. What's really amazing is that she'd done all that without much notice from the art world, generally."

"Robert loved her, so it's no criticism," Josette defended, "But he was always leery that her odd *language* rhythms would give the wrong impression. He didn't want her to give that interview, or any interview, for that matter."

"Did you ever see the program I did on the Crowsfoot piece?"

"We watched it the other night," nodded Ben, "It's one of the reasons why we called you."

"I really wanted her to participate in making that program but, as you know, Robert wouldn't hear of it."

"Didn't want to push his luck, after the Maclean's deal," said Josette.

"You know that for a fact?" asked Estelle.

"Well, Guylaine mentioned it. She was a little uneasy about the camera, but Robert, he was *adamant*. Actually, I think the piece worked beautifully. Without her, the focus was on the piece and not on the artist."

76

"I'm not complaining, but it would have been nice to have some footage of her. Since Maclean's, I've wanted to do more to chronicle her. I feel vindicated, and more than a little cheated, too." Estelle shook her head. "I don't understand the reticence."

"That's because your interview went well," Ben answered, "That wasn't always the case. Believe me, Robert had good reason to be protective."

"What could've gone wrong?"

"Well, an artist's career is always on the line. Not *everyone* hit it off with Guylaine, so well. She'd been burned before. Can you imagine the impact of a bad interview?" Ben's tone was protective. Josette flashed him a warning look.

"What's this really about? Come on you two, if I'm to do the piece, I need to know the whole territory, *and* the motivations." Estelle had found the first obstacle, and with her most cooperative sources. Josette and Ben exchanged glances. Josette gave him a warning shake of her head. They fell silent as the truck flew by the exit for Chatham. Estelle sat quietly, letting the silence do her work. Unlike most interviewers, Estelle wasn't nervous about this kind of silence.

Ben finally broke, "Josette, we might as well put it out there. We won't find a more sympathetic ear. As a professor of Art History, I'm uncomfortable with the idea of family secrets trumping the full truth." He turned to Estelle, "There are things about that *other* interview that shaped Guylaine forever. After that, she totally distrusted the Press. I think because of it she never came forward with the full story about Paul Labute. You can see where that's got her, now." His eyes filled with tears. Estelle made notes, and Josette pursed her lips.

"Josette can correct me, if she wants. She knows the story better than me. When Guylaine graduated from the University of Windsor, a local journalist wanted to do an interview. Her work had been featured several times in the Windsor Star. Each year the Art Department did a student show and opened up the LeBel Building to the public, and Guylaine's work was always positively reviewed. So, when she graduated, this guy wanted an interview. She was already successful. He pitched the, *local girl makes good* angle…"

Josette cut him off, "Don't make excuses for him. He never had any intention of writing a positive, or even honest, article. Robert was right to try and stop it from the start." Josette looked conscripted into the story. She turned to Estelle, "He butchered her. We had to go to the Star and threaten litigation to have the *so-called* interview pulled. It wasn't an interview it was an indictment." Josette's jaw was set, her neck tense.

"How bad could it be? As an interview, wouldn't the information have come from Guylaine?" Estelle asked naïvely.

"*Jesus.* He made it all up. Guylaine met with him and showed him her work. But, he was pushy and argumentative through the whole thing. Guylaine just curled up like a sow bug…"

"A *what?*" Estelle was confused.

"A sow bug, a rolley-polley, an armadillo bug, you know those pill bugs that can curl into a little ball. Anyway… It was hostile and Guylaine couldn't deal with it."

"Oh, I see."

Josette finished the story, "Guylaine hardly said a word. The article suggested she was not the sculptor, implied she was a front for someone else. If not that, he said, she must be an idiot savant, an artist on autopilot. Guylaine was mortified. We were livid."

"The interview was a career killer, end of story." Ben face flushed with the memory. "The ink wasn't even dry on her degree and this guy was out to destroy her. We offered him a second chance to interview her, with Robert attending, but he wasn't interested. *He* already had his story. Robert knew someone on the Star's editorial board, but still, Guylaine had to hire a lawyer. It finally ended okay, but it left her bruised and wary. After that, she wouldn't give interviews. She said that her work spoke for itself."

"Well, I guess that explains the warm welcome when I called. Is there a copy of this so-called interview somewhere?"

"Sure, but I wouldn't want it in her biography." Josette insisted. "The *idiot-savant* line really hurt Guylaine. All her life she was a little… *different*, and he tapped right into that hurt. He made it seem as though her talent was somehow freakish, and made her less than she really was."

"I'd still like a copy. Not to include it in its entirety, but enough of it to explain why she came off as a recluse. It's strange because she was wonderful with me."

Josette shook her head, "Must have been because she connected with you through the Grandma Claire sculpture. What did you end up leaving out of the Maclean's interview?"

"The discussion of the Lucille sculpture, I just couldn't get it into the allocated space and, hmmm, the stuff on Jensen and some stuff about her mixed feelings about the church. I felt it would be alienating."

"*Lucille* sculpture?" Josette asked, "Did she do a sculpture of Lucille?"

"You'll see it when we get to the studio," Ben said. "It's a newer installation. What's the Jensen part?"

"Well, when I spoke to Josette before the interview, she said if we got stuck, I should ask about the pins on Guylaine's lapel. At one point it did get… strained, so I complimented her on the pins, and it really loosened things up."

Ben chuckled, "You mean the kingpins? Josette, what a great idea."

"I felt a little bad about that," Estelle admitted.

"You shouldn't have, it wasn't like you tricked her or anything. It was a really great interview." Ben added, "It's too bad it didn't make it into the interview, it would have been a nice touch."

"That's what I feel bad about, Guylaine started to tell me about the pins and then, once she was talking freely, I steered her back to her own work. I didn't get the whole Jensen story, so I couldn't include it. I felt like I may have short-changed her in the process."

Ben nodded, "It's not that big a deal, just that it is so quintessential Guylaine. She learned about the pins during the summer, after her first year at Windsor, on a trip to Europe. She had planned to go to Paris, parts of Italy, and some of the Museums in London. It was a sculpture tour. When she got to Paris, she loved it. Not just the museums, she fell in love with Paris, itself—the cemeteries, all the public sculpture, and the sensibility of it. While she was there, she went to an antique store and saw a tiny enameled, silver pin. You might know the piece, red and silver, with a crown on the top. She was crazy about the design and asked the shopkeeper about it. He explained that it was a commemorative, birthday item for King Christian of Denmark,

on his 70th birthday. The shopkeeper explained that Denmark was under German Occupation at the time, but Christian quietly resisted, in his own way. He rode his horse in Copenhagen every day, as he always had. He still went out, without guards and mixed among his people. The Germans couldn't control him, but they did respect him. It was said that when the order came down that the Jews had to wear the Star of David on their arms, Christian rode around with the Star of David on *his* sleeve, too. He sent the message to the Danes that they could not be broken and that their integrity was not for sale. The Danes never were accomplices to the holocaust, in the way the French were.

"The pins became a symbol of Danish nationalism and pride. They were inexpensive pieces worn by everyone in Denmark. The shopkeeper who told Guylaine that the story of the pins was French, but Guylaine said that he seemed wistful, almost jealous, that the Danes had had a leader with such spine and conviction during those hard times."

Estelle agreed, "You're right, it *is* a great story. I wish I'd pushed to get it in."

"But it's more than that. You see, Guylaine had been attracted to the pin even before the story, so to her, the pin achieved the very goal of art. It was itself beautiful and simple enough to carry the weight of all that meaning in a tiny little pin. To her the pin was a reminder of the true purpose of art. She assumed that Georg Jensen was the designer, but he had died before the occupation. The pin was actually designed by someone named Malinowski, under the Jensen name. Guylaine cancelled the rest of her summer plans and went instead to Denmark. She spent the summer learning about Jensen and his work in Danish silver. She wanted to understand the European version of the Arts & Crafts movement, and came back inspired. She was disappointed when she learned that Jensen wasn't the actual designer of the King Mark pins. But, she decided that the dedication that continued in the Georg Jensen line, right up to that simple pin honoring their King, and keeping their integrity, was a good conclusion—a tribute to Christian and to Jensen."
Remembering, Ben was moved to tears.

"Wow. Did she wear the pin a lot?"

"Almost all the time. And, she has dozens of them. They're on every one of her jackets. She thought of that pin as a reminder to be true to the spirit of her art. Guylaine was hooked on symbolism."

"That's why I told you to ask about the pin," added Josette. "Guylaine could be so intensely articulate about things that carried personal meaning for her, and those pins sure did."

"I feel like I really missed an opportunity there. I would have loved to hear *her* tell it." Estelle frowned.

Josette consoled her, "Maybe it's just as well. That story is intense, but the interview was about the Crowsfoot sculpture. You could have lost some of that if you'd added the King-pin story. It's good background, but I wouldn't change a word of the interview as it was printed in Maclean's."

"Estelle, your interview meant the world to Guylaine." Ben was solemn. "You made it possible for her to occupy space on the publicity side of art. Otherwise, she just didn't feel she spoke that language. That's why you're with us, now."

"Thanks."

They rode quietly for a while. Past London, a few miles north, the landscape lost its flat, farmland look and gave way to rolling swells, its contours plowed with corn and pastureland dotted with cattle.

"Guylaine loved this drive. She savored the different landscapes between Red Wing and Oakville. She felt that the tamed, but still rural Canada, was not well represented in Canadian Art. The *Group of Seven* got the wild stuff, but nobody saw this. As a sculptor, she felt challenged by landscape."

Estelle shifted the topic, "So, Ben, when did you and Guylaine actually get together?"

"Which time?" Ben sighed. "Guylaine and I met during her first year at Windsor. She was a student and I was an untenured professor. There was interest, but nothing came of it. We talked a lot. She was taking more Art History courses than she needed and I don't think that was because of an academic bent." Ben grinned.

"Were you dating?"

Ben hesitated, "Those weren't exactly dating times, back in the seventies. But, we were friendly. Midway into her second year,

I'd suggested travel, like the Europe trip, and we were closer than most faculty/student relationships, but not dating."

"When did that change?"

Ben squirmed. Even over the road noise, Estelle could hear the seat springs creak, as he shifted his weight.

"Really Ben, *solely* in the interests of Art History, you need to come clean on this." Josette was smiling ear to ear. She looked at Estelle, "The family has never heard *this* story."

Ben reached up, adjusted the rear-view mirror, and took in a deep breath. "When Guylaine came back from Europe, she'd changed. She had developed an interest in Arts & Crafts era philosophy and art. That was my area of specialty, so she took the additional classes. We shared a certain aesthetic. Guylaine began to develop an internal artistic vocabulary. A lot of art students never do, they reject history. But, not Guylaine. It was wonderful to watch. By the end of second year she'd taken all of my classes. I felt a little bad because I'd enjoyed her as a student and would miss her. I was afraid we wouldn't see much of each other after that. In her third year, she began dropping by during office hours. She wasn't taking any of my classes, so it was clear the nature of her interest had changed. I was certainly interested, but wary. Dating students didn't exactly put you on the tenure track."

"So, *she* pursued you?" Josette laughed.

"*Doggedly.* I didn't know what to do. I tried to keep it the light side. Later that year the Department Chair, a decent enough fellow, came by for a visit. He said there were budget cuts on the horizon and that while my position, as it stood, was probably safe. I shouldn't expect anything more permanent in the next few years. I was crestfallen—I'd hoped to be able to stay on in a career position. The non-tenured track didn't pay much, and with no long-term potential *and* no job security, we were just a step above student teaching-assistants. I decided it was time to put out resumes. But, that freed me up with Guylaine and we started seeing each other towards the end of the year. As usual, she went away for the summer, but when classes started back up in fall, we were an item. I was shopping for another position and it was Guylaine's last year anyway. I fell for her much harder than she did for me, but I assumed there was a commitment there."

"Ooh, I hear a broken heart in there. What happened?" Now, Estelle's interest went beyond professional curiosity. This story was becoming personal.

Ben shook his head. "I'm not sure if I'm the one to tell this part of the story. When she graduated, Guylaine made a trip out west. She wanted to see where her mother had grown up, and she ended up not coming back. I'd secured a job at the University of Toronto and the plan was that she'd travel, and then join me. But, she just didn't come back. She'd hooked up with Paul Labute and that was that." Ben was visibly upset. "Maybe you should talk to Père Michel about this. From where I was sitting, Guylaine just disappeared for two years. Then when she finally came back, I wasn't interested in starting it back up. She moved to Oakville and started taking classes at the University of Toronto. It took awhile, but we reconnected and we've been together since." He fell silent and finally turned to Josette, "Do you know any more of this?"

Until now, Josette had been quietly sitting back, taking in the conversation as if it were a tennis match—her head swiveling from side to side, following the action.

"Some," she said, "But I think the best source would be Père Michel. Estelle, it wasn't just Benjamin that Guylaine walked away from, it was all of us, everything. She got involved with militants in the Native Community and she virtually disappeared. The only one she kept in contact with was Robert—she continued to work, and he was her agent. This went on for two years, without a word. My parents were beside themselves. Then one day, Guylaine waltzed back into Red Wing. It was a Saturday afternoon and she showed up at the church—for *confession*, no less. So, you need to talk to Michel." Josette sighed, "I've never really wanted to know any of this stuff, but I'd had hints from Guylaine and Michel, from time to time. There are some sensitive issues here, for my mother, and we'll have to tread carefully."

"Did your mother and Guylaine have problems?"

"No. I know that during her walkabout, Guylaine dug into my mother and grandmother's history. Michel hinted that this would hurt my mother, so Guylaine didn't talk about it. I never pushed."

"Does that strike you as odd? Daughter, sister, lover disappears for two years and nobody knows why?"

"We got her back, and that was enough for me." Josette was firm, "I had no reason to pursue it. I was angry with her because Guylaine hurt my parents, but I was dealing with my own life—I was a single parent with two sons who were about to become adults, finances for their college, finishing up my own degree. It was a busy time."

"And, Ben, you never dug to the bottom of it?"

"I've found out a little, but this was painful for all of us and we just gingerly rebuilt. I knew about Labute and his reputation. But, I didn't see the attraction and I was hurt. Maybe when you get the story from Michel, I can add something to it. But, my story is not the complete one."

"Okay." Estelle made notes while they rode in silence. "So where's Robert now?"

"Should be back anytime," Josette said. "He was in Europe when... well, he wasn't easy to reach. But, he'll be able to add a lot. They go back a long way, to when Guylaine was sixteen or so." She paused, "He's an old friend of Père Michel."

"Do you think he'll cooperate, on this?"

"He'll fall in line with Père Michel, though his first allegiance will always be to Guylaine. After that, it'll be Michel." Josette was exhausted. Unburying her family secrets was proving to be as difficult as burying her sister

"So, how did your family first connect with Père Michel?"

Josette rolled her eyes, "He was our parish priest."

"Is he this close to all his parishioners?"

"No, but we ran the local funeral home, so there was more contact."

Estelle was worried that she'd crossed a line. "Josette, I'm not criticizing, just asking. Père Michel seems like family. That's not a bad thing, but usually there are ties that bind. Was he always your parish priest?"

"Josette laughed, "Oh, God no, we got him when he was wet behind the ears. Father Tobin had left."

"So, what was special about him?"

Josette tilted her head back, remembering, "For one thing, he spoke French. Father Tobin was all English and, in my opinion, he was a jerk, to boot. So, along comes this young priest and everyone was skeptical. I was just a little kid, but the adults were

all taken aback—Michel was a *baby* priest. *What* was the Diocese Thinking? But he spoke English *and* French, and that was huge. At first, he did masses for both groups but over time, pulled us all together through choir and other stuff. It's funny now that there was ever such a division. Mass was in Latin anyway, but there was still a schism, and he brought it together."

"So, the reason Michel become family, is language?"

Josette reflected. "I think we just adopted him. And then, he adopted us. We were brought together by tragedy."

Estelle lowered her voice, "Because of Lucille?"

Josette's eyes widened with the memory *"Oh my.* Later, yes. But, there was a terrible accident, just after he arrived at Saints Jude and Simon. He was in over his head and my parents stepped in to help. After that, like a puppy, he was ours."

"What happened?"

"When they were building the *401,* they had to build all these overpasses for the county roads. And, they had these huge, flat-bed trucks with big bins of sand, for mixing concrete, that were held to the truck-bed with chains. One of those trucks sank onto the unstable dirt, next to a new overpass, and it tilted over. Not enough to flip the truck, but enough to put a lot of stress on the load. Then, the chains on one of the bins snapped. It tipped over and slid off the truck, landing on a school bus that was passing by on a road below the work site. Somehow, it just sliced open the roof of the bus, and the sand poured in. They never knew what hit them. There was hardly any damage to the bus but everyone inside *drowned* in the sand. There was a driver, and fourteen children. One family lost all their kids in that accident."

"Jesus!" Benjamin exhaled, "How does a town deal with that?"

"Père Michel didn't really know anyone yet. He didn't know what to do. My mother stepped in and walked him through it. He was stunned, so he sat in the parish house and waited for the grieving to come to him. Mom kicked his butt. She got the names and addresses and sent him out to see the families. Then she and dad arranged a grieving mass for the community. The funeral home was overwhelmed so we had to share facilities with Tecumseh. With my parents' help, Père Michel stepped up to the plate and connected with all of the families. Most were French, but

they now had a priest who spoke their language. It was a terrible time, all us kids knew kids who'd died. It was too strange, too random. Mothers wouldn't let their children ride the buses, even though that made no sense, whatsoever. Père Michel visited them all. Anyone and everyone traumatized, he made the rounds. In the end, he was *our* parish priest. Had he failed, they would've had to reassign him. But, he came through and comforted the community. *That's* when we adopted him."

"That's an incredible story. Did it have an impact on Guylaine?"

"Only as a story. She wasn't born yet, but it was a part of the local lore, for years. It brought Père Michel into our lives and that had an impact.

"Your parents saved him. Well, as a priest, anyway." Ben spoke softly.

"Yeah, but it's a two way street. Later, when Lucille died, Père Michel more than returned the favor. My father was devastated by the loss and *we* were the funeral home. So, Père Michel reached out to Tecumseh and arranged for Lucille's funeral there. It was the sweetest, most tender funeral I've ever seen. Père Michel carried my parents emotionally for months after that. I was a young wife with little boys and a soured marriage. There wasn't much I could do. Without Michel, I'm not sure what would have happened. He was there for my dad, and he gave my mother the strength to be there for him, too. He'd adopted us right back." There were tears on Josette cheeks but she seemed unaware of it. Sometimes the past floods back and we have the presence to put it together anew. Josette was feeling a profound new love for Père Michel and it helped carry her past all the losses.

"I don't know how your parents can cope with this—*two* daughters. It seems unfair," Estelle lamented.

"I think it speaks to their faith. They are far more accepting of life's unfairness than I am."

Ben slowed down and signaled as he exited the highway.

"Where are we? Why are you getting off here?" Josette wanted to keep the momentum going.

"It's just Morristown. We need gas. This truck really burns through it." They pulled into a Mobil station and Ben hopped out to pump the gas at the self-service Island. Josette and Estelle went

inside the mini-mart while he scrubbed and squeegeed the windshield, and checked the oil while the tank filled. He hadn't done any of these things when they'd started out and he chastised himself for not being more conscientious. The school bus story was still in the back of his mind.

Estelle came out carrying a bag of assorted chocolate bars. Ben helped himself to a Hershey bar while Estelle peeled back the wrapper on a Caramilk. Josette joined them and couldn't help but laugh, as she picked out an Oh Henry from Estelle's collection.

"It's true what my mother says, emotions are easier to handle with sugar." Josette took a bite and scrambled back up into the truck. They'd talked all the way so far and they were all exhausted. It was an odd day that opened with a burglary at a church, and, soon would close with a homecoming at Guylaine's.

Ben finished his Hershey bar, and threw the wrapper into the trash. He climbed back into the driver's seat while Estelle clambered back in, next to Josette.

Leaning forward to start the truck, Ben said, "Estelle, can I dictate a letter to you while we drive?"

"Sure, what is it?"

"We've got to get a letter out today to try and calm the vendors and creditors at the foundry."

"We shouldn't have too much trouble with that," Josette added, "I speak banker." They all laughed.

Great. I promised Cathy I'd get it to her her. The foundry staff is going to need help and support, too." Ben frowned. "I let it go too long."

As they drove towards Oakville, the three of them composed the letters and planned the steps that would ease them into the next stage, past their losses.

Chapter 17

Françoise sat quietly in the living room letting the long shafts of afternoon sun warm her on the sofa. She hadn't had a quiet moment since that afternoon in the garden. For the time being, everyone was away, either attending to the choir or heading to Oakville. Finally, she could quietly reflect. Even now, the fact that Guylaine was gone, didn't feel real. Françoise took this time to pull out the photo albums and select some pictures of Guylaine to display when... well, that was the challenge. There was no protocol here. No body, no funeral in sight, no normal rhythm or tradition in which to share the loss and celebrate the life. Her eyes filled with tears. Françoise had dedicated more than fifty years to burying the dead of Red Wing and she'd never experienced such a fractured, attenuated passage.

As they aged, Françoise and Guillaume had grown even more entwined, like old vines. She could not have contemplated that her husband would endure this loss so well. He loved all of his daughters but over the years each had encapsulated some special gift—Josette's competence with compassion. Hélène, well Hélène was a good daughter, attentive when alone with them and the best parent they'd ever witnessed. Guillaume had identified with Guylaine's unbridled creativity and vision. In particular, the sensitivity of her religious sculptures took his breath away. They evoked the same upwelling in him, as fine music. Guylaine's lifestyle was a puzzle to both her parents, but once, when they'd attended the unveiling of Guylaine's largest pieta at St. Anne's, Guillaume had taken Françoise's hand and whispered, "Sometimes I worry, but you can see the light of God shines out through her work."

When Lucille died, trapped under the ice, Françoise thought Guillaume might himself die under the weight of his sadness. Lucille had been their tomboy, the daughter that tagged after her dad when he tinkered with motors or tended to projects around the house. Her death had stolen his light, his inspiration for so long that she wondered if he would ever recover. When Françoise first heard the news that Guylaine was gone, her heart was seized with fear that this, too, would be the end of Guillaume. Indeed, the

initial shock *had* leveled him, but Françoise was heartened that since then he had been growing stronger. She mentioned it to him, getting into bed the night before, how she had worried so. Guillaume had taken her in his arms and whispered, "I am no longer a young man. I am at a point where my faith must carry me, and I carry my losses forward." He kissed her and added, "My heart breaks for Ben and for the loss of her talent. But, I am selfish enough to know that when my time comes, our two daughters await me. For now, it's my duty to deliver her with dignity and grace, to follow her wishes and to honor Ben in dealing with this loss. I pray he can shoulder this and live a full life."

Françoise had wept in his arms, and marveled at his wisdom and faith. As for herself, she was not so sure. She saw much pain in the world and at times it tested her convictions. Perhaps *his* faith alone could carry her, as well. At least for now, in the darkness, in his arms. Françoise was awed that life had given her this path, not an easy one, but with so many satisfactions. Who would think that an orphaned crossbreed could have come so far and landed in such loving arms?

She rifled through thirty years of pictures. Guylaine was in the image of Françoise's mother, Claire. She was always her bronze child. Guylaine had her grandmother's straight, shiny black hair; she was the Indian in their tribe. Unsure, Françoise held the photos outstretched. How *does* one pick from the photographs of a life to find exactly the ones that will live in the memory of the survivors? How does one pick the one loving image that would undo those horrible last moments, replayed repeatedly on television over the last week? Secretly Françoise was both proud and, at the same time, horrified by those last seconds. Guylaine had rushed into the fray when the young man was shot. It was not lost on Françoise that Guylaine, in the shadow of her own sculpture commemorating Claire's similar dedication, had come to the aid of someone under fire. She also wondered whether it had been her mistake, extolling the family history to her children in a way that would shape their decisions so indelibly.

There was tapping at the back door, and Françoise started from her reflections. She set the photos aside and retreated to the kitchen to peek out at whoever was interrupting her private

afternoon. Given the events of the day, Guillaume had made her promise not to open the door to strangers.

Jean Luc stood at the top of the steps, facing away from the door. Françoise unlatched it and stepped out onto the porch. "Come in cousin, *vite*, don't let the cold in."

He turned and smiled. "Or the Press, either, eh?" Jean Luc climbed the steps, kicked off his boots at the top landing and followed her in.

"Coffee?"

He looked at his watch, "Better not, my sleep's already messed up, but a cup of tea and a cupcake would do."

Françoise smiled and put on the kettle. "Come sit in the living room, the sun is so nice this time of day."

He followed her in and took a seat in the sun, at the end of the sofa. Looking down at the photos spread around where she'd been sitting, he nodded, "You looking at pictures?"

She sat down again, and tucked her feet up under her. "Oui. It's tough to choose."

"Does this mean you heard?"

"No, not a thing. I'm just keeping busy. What about you? Run out of hardware to sell?"

"Naw, the staff is standing guard, so they sent me home. I ran into Guillaume and Michel and that little guy… you know, the priest"

"Father Tony?"

"Yeah. Guillaume was worried about you being out here alone, you know with the reporters and the church deal and all. Thought I could drop by for a cupcake or something, you know, keep you company."

The kettle whistled and Françoise hopped up to make the tea.

Jean Luc, in his stocking feet, padded after her into the kitchen. "Claudette was pretty shaken-up by the break in. Seems just wrong, stealing from a church."

Françoise pulled the teapot down from the cupboard. "Herbal?"

"Yeah. Better safe, you know."

Françoise poured the water and set up a tray with a couple of plates and cups. She added a plate of brownies and cupcakes to the tray.

"Here, let me get that." Jean Luc lifted the tray and bowed for her to lead the way.

"So, is Claudette worried about the house, and all? You're in the book, under Maisonneuve, aren't you?"

"Yeah, but we've got a fancy alarm. I think it's just the shock of it. It really bothers us that it could be someone from here, you know, someone who knew Guylaine did the statues. What's the world coming to—robbing churches and shooting artists? We're pretty shook with all that's happened. I don't know how you and Guillaume hold up through it all." He poured her a cup and one for himself then, reached for a brownie.

"I'm not sure either some times, but it's not like there's much choice. We do have the advantage of having done so much of it."

"Well, Claudette was just crying and crying this morning. We both had a special soft spot for Guylaine. She said she thought not being able to have kids might be kinder than losing two of them." Françoise nodded. It had always pained her that Jean Luc and Claudette had never had children. It was sweet that Claudette thought first of Guillaume and her, discounting her own losses.

"It's okay Jean Luc. We don't have any regrets and we don't question His Will." She paused, tears spilling from the corners of her eyes. But, it was comforting to sit in the sun and just accept the feelings. She reached for a brownie and dipped it in her tea. "It means a lot to me that you and Claudette cared so much for Guylaine. Some *did* find her peculiar."

"Well, she *was* a funny kid. I think Claudette liked the challenge of connecting with her because of it. Later, when Guylaine started sculpting, she'd call me up and ask hardware questions. She got famous so fast, she seemed embarrassed not to know some of the technical stuff. I was so flattered, she felt okay to call me." He took a second brownie. "You know, she didn't talk much but, well, it's a funny thing but Guylaine was always really there." His face showed that he wasn't sure how to express it.

"I know what you mean," Françoise assured him. "She communicated a lot while just being there. Guillaume always said music was her first language and maybe he was right, like when music when taps into your feelings." She fell silent enjoying the warmth of the sun. Then, thinking about the contrast with Hélène, her face clouded.

Jean Luc saw her mood change. "See, there you seem fine, and then you go get that troubled look. Been doing that for days, you know. I'm guessing it's about Guylaine, or Guillaume. So, what's up cousin?"

"Oh, just I can't help but feel that all this isn't going so well for Hélène. She's pretty angry. If anyone should, *I* know that a death in the family spells emotional upheaval, but sometimes that girl is a mystery."

"I told you, high maintenance." Jean Luc grinned, "It's not like she doesn't have her talents—she's decorated half the homes in town. She's got great boys, Roger loves her, but with all that, she's got an edge to her, eh? So, what's it about this time?"

Françoise shrugged. "Seems she's not so crazy about Estelle being around. I don't know. Jealous, maybe. I *think* I understand, but really, Jean Luc, Estelle's a godsend, right now and we need her."

"Sure, it's just the fuel injection thing."

"Eh?" his remark went completely over Françoise's head.

Jean Luc laughed, "Oh it's something between Claudette and me. Just a theory."

"Well?"

He leaned forward to explain. "You remember when gas was real expensive back in the seventies, with folks whining and carrying on? Well, the engineers tinkered around and came up with fuel injection, and suddenly, cars got better mileage. While some folks saw a shortage, others just reinvented the supply."

Françoise still didn't get it. She quietly sipped her tea and waited. Her blank look told Jean Luc he hadn't been clear.

"It's just that some people look around and see a shortage. Others just make room for more. You and Guillaume have always opened your hearts to everyone. Every time you do, your world gets bigger. But, Hélène sees that there's only so much to go around. So, when other people get it, she feels that there's less for her."

The sun slipped in the sky and the room slid into twilight. Françoise tipped her head back and nodded. She got it now. "You ever tell Guillaume that one?"

Jean Luc grinned, "Naw, just something between me and Claudette."

"Can I tell him?"

"Yeah, sure. It's not patented."

She laughed. "Fuel injection." Guillaume will love it. "So how come I got two fuel injected daughters and one… what, a carburetor?"

"Maybe it was just harder coming up after Josette." He laughed again, "She'd be a tough act to follow, eh? Thing is, it doesn't matter how and there's nothing you can do, but it helps to know—then you don't have to be mad or hurt, it's just not fuel injection."

"Jean Luc, you've somehow managed to explained one of the great mysteries of the universe. Guillaume will have a good laugh."

He leaned over and switched on the lamp and checked his watch. "You gonna be okay here, alone?"

"Oh, of course. Hélène will be by in awhile, I'll be fine."

"Okay, cause I'd like to help closing the hardware. With the break-in and all, I want to make sure the deposit gets into the night drop, okay. Everybody's just a bit nervous."

"Well thank you Jean Luc. It was sweet to come by."

"It's nothing. Just thought I'd check up on you and ruin my dinner." Grinning, he picked up the tray and carried it into the kitchen, with Françoise close behind.

Pulling on his boots he said, "Now, don't open that door for strangers, and keep the porch light on."

"Thank you Jean Luc, and don't you worry, I'll be careful." He nodded and headed out into the evening.

Chapter 18

Ben pulled up to the old cannery. It was already dark and a light rain had started to fall. The steady beat of the wipers had lulled Josette and Estelle into an easy silence. As he turned into the driveway, his headlights reflected off the chain-link gate closed across the entry. Someone had woven yellow caution tape through the fence wire. Ben couldn't remember ever seeing the gate rolled closed.

The cannery was a large red brick, U-shaped building. The foundry and sculpture studios ran along one leg of the U and a small gallery was at the tip of the other, flanked by small apartments. Guylaine's living quarters, the only two-story section of the building, made up the bottom of the U. Both the foundry and the gallery had loading docks. As an operating cannery, the workers' parking lot had filled the inside of the U, but since Guylaine had owned it, the lot had been converted into a smaller parking area with a central, courtyard garden. Tonight, access to the lot was closed off and Ben was reminded of the problems in Red Wing. He backed up and parked on the street at the foundry's loading dock entrance. Guylaine's business office was tucked in the back corner of the foundry and getting in to see the staff was his first priority.

"I can give you the keys to the apartment, if you like. I need to connect with the staff." Ben held up the letters they'd drafted earlier.

Estelle rubbed her eyes, "Actually, if you don't mind, I'd like to join you. I'll need to get to know the staff, and this might be a good time for an introduction."

"I'll come, too. Maybe I can help." Josette reached for her jacket and started pulling it on. Estelle wound her scarf around her neck tightly against the chill. The three disembarked into the cold night and approached the building. The exterior lights across the back were not turned on. Ben remarked that it was odd that the motion sensing lights, installed at both the gallery and foundry entrances, were not working. Most of the building was dark—the gallery and apartments looked deserted. At the back of the foundry they could see lights, but the garden was dark. Ben climbed the

steps at the end of the foundry loading dock and checked the door. It was locked. Estelle pointed to piles of flowers at the base of the loading dock—hundreds of bouquets of flowers, burned and limp from the crisp, November evening. She snugged her collar up tighter around her neck and wished she'd brought a camera.

Ben knocked on the glass door. After a moment, he rubbed his hands together against the cold and rapped on the glass again. The light over the door came on and then it slowly swung open.

"We've been waiting for you." Cathy stuck her head out and warily surveyed the surroundings. Quick, get inside."

The three filed in behind the slight figure of Guylaine's office manager. Without speaking, she led them past the equipment and the over-head crane to a small office and conference room at the back. Inside, the two foundry workers, Marc and Bill, were sitting at a slab of granite suspended on a pair of sawhorses that served as the company's conference table. There was a bottle of red wine and an assortment of plastic cups on the table. Once in the light, Cathy turned around and warmly embraced Ben.

"I am so glad you're finally here. We haven't really known what to do so I gave the others the week off. The phones have been crazy, cops were everywhere and people have been coming by for days. They want to talk, they leave flowers and some just sit and cry on the steps outside. We're keeping the lights off to try and quiet things down. We..." Cathy sobbed.

Ben reached out and gathered her into his arms. "Okay, it's okay. We'll get through this." Still holding Cathy, he turned to Marc and Bill, "I'm so sorry. Père Michel picked me up and spirited me off to Red Wing. I didn't think to call."

The two lumbering men, enormous next to Ben, joined in the hug. Josette joined them, too. Estelle, still an outsider here, hung back.

Marc slapped Ben on the back. "S'okay, man. How are *you* doing?"

Ben shook his head, "well, as you can imagine, I've been better." He paused and his voice caught, "But Guylaine's family has been great." Josette swallowed—these first words from Ben were a tribute to her family. Her gratitude registered on her face.

Bill reached over and embraced her. "How are your folks with all this, eh?"

Tears ran down her cheeks. This was Guylaine's second family—for years they'd joked that Guylaine's employees at the foundry were her children, her support network through thick and thin. "As well as any of us. It's tough, just waiting."

"Any word?" Bill was diplomatically evasive.

"Not yet. Françoise and Guillaume are suffering with the delay." Ben shook his head.

The group hug broke up and Marc noticed Estelle, waiting in the shadows. He nodded in her direction, "So, who's your friend?"

Josette stepped up, "Jeez, I'm sorry, that was rude of me. This is Estelle. She's a reporter and she's helping us." Cathy dropped her eyes. Bill and Marc glanced at each other and kept their silence. Josette continued, "Estelle, these are Guylaine's closest creative partners and friends. Cathy runs the entire operation and Bill and Marc run the foundry." The two men were huge and well-muscled—a matched set of brothers. No one spoke.

The silence stretched to the point of discomfort. Ben finally broke it, "Maybe you remember Estelle, Estelle Dumas. She's the woman who did the Maclean's magazine interview with Guylaine."

Recognition flickered across their faces. Cathy's eyes met Estelle's. "Didn't you also do the television special about the Crowsfoot installation?"

Estelle nodded.

Cathy reached out and took her hand. "You must forgive us. Our experience with reporters over the past few days has been terrible. I think your work is very good. I know Guylaine respected you and I saw that program the other night. It was wonderful. I loved that you let the sculpture speak."

Bill offered Estelle his hand. Finally Marc reached out as well, and nodded. Cathy grabbed a handful of plastic cups and poured wine for the newcomers. Everyone pulled up chairs around the table.

Ben spoke first, "So, what's really been going on, up here?"

Cathy sighed, her slight figure slumping in the chair, "We were all here that day, the whole staff. Rosemary called and told us to turn on the television…"

"Oh shit." Josette broke in, putting her hand to her head, "We forgot Rosemary."

Estelle looked puzzled. Cathy explained, "Rosemary is Guylaine's best friend. They go way back to Windsor. Rosemary's an artist, too. She'd heard the radio and called, hoping they were wrong and that Guylaine would be here. We turned on the television and, well, you know the rest." Ben gripped her shoulder. "It was bedlam after that. The police arrived and just bullied their way in. They rifled through our files and busted the courtyard door to Guylaine's place".

Bill added, "Bastards wouldn't wait—we couldn't find the key."

Ben looked traumatized. It never occurred to him that anyone would've forced their way into their home.

Marc reached around and gave him a reassuring squeeze. "Don't worry, man. We didn't let them mess it up. We stood guard."

Looking at the two of them, Josette laughed, each of the brothers was well over six foot tall and weighed in at over 250 pounds a piece. "Yeah, you might be the only thing that'd keep them in line."

Cathy giggled. For the first time, the image of Marc and Bill marshalling the cops through Guylaine's quarters occurred to her as funny. "And, the reporters were right behind them. We had nothing to tell them, but they kept badgering us. None of us had ever met Paul Labute. We knew about the siege at the sculpture of course, but we were in shock. We decided to let the office staff go home—told them to take the week off and snuck them out through the apartments. The tenants are laying low, and some of the smart ones up and left town. So, it's just us three holding down the fort." She passed the wine bottle.

Ben reached into his pocket and pulled out the letters they'd drafted during the drive.

Cathy took a moment to read them and nodded, "Yeah, this should do it." She first looked at Ben and then at Josette, "You know, the weirdest thing is, a lot of orders are coming in."

"What do you mean?" Ben drained his cup.

"I mean, every little church in Canada, and beyond, has decided to upgrade their devotional sculptures. I don't know what we're going to do, but right now we have enough work to keep us busy for a year. I mean, at what point do we strike the molds?

"You don't, of course" Josette looked certain. "If I recall, the foundry is its own separate corporation. The rights are held by the estate, but if there are orders, there is no reason not to fill them."

"We'll have to see her will, what she wanted. That's what decides it." And that was it. Ben's voice left no room for discussion. "In any event, you do what you need to do for now, I'll see that everyone is paid." He poured another glass, empting the bottle.

"Maybe we should order a pizza or something," Josette offered. "We've been driving all day, and we should feed these folks for staying late for us. That's assuming you haven't eaten."

Marc reached for the phone. "Well, *I'm* game. While we wait, maybe we can put out these letters and answer some questions, eh."

Two bottles of wine and a couple of pizzas later, the group surveyed their efforts. Almost two hundred letters were hand addressed and neatly stacked for mailing the next day. Buoyed by the news of all the new orders, Josette had modified the letters to emphasize that the foundry operation had orders to fill and was still open for business. They suggested that those, who already had Guylaine Claire sculptures, improve their security. Not only would these letters mollify creditors, they might also bring in additional business to cover the costs of operating for whatever period it took to wind up affairs. Ben was reminded that numerous livelihoods hung in the balance. This crew was not emotionally, or financially, in any position for sudden unemployment. He was touched by their dedication and their sense of preserving Guylaine's legacy. Estelle helped with the mailing and the brothers took turns regaling her with funny stories from the foundry floor. Marc told her that Guylaine and he had taken an advanced sculpture class together and she'd hired him from there. She had told him she'd hired him for his smile but his size, as a foundry man, didn't hurt. As the operation grew, she'd turned to him in frustration one day and asked if there were any more like him at home.

Bill grinned, "That's when I joined the group."

Cathy had known Guylaine back at the University of Windsor. She, Rosemary and Guylaine had been a trio of trouble in the Art Department. Fuelled by Rose's twisted sense of humor, the three had been the devils of the LeBel Building.

When they finished with the mailing, Cathy turned to Estelle and Josette, "Come see the gallery, then we'll take you to see Lucille and then you can settle in."

All six crossed the now darkened courtyard to the gallery. Ben was surprised to see that it was spotless and set up for a show. Just the week before it had been filled with packing materials and supplies stacked up along the walls. In the interim, the staff had cleaned and organized a tribute to Guylaine. When they switched on the lights, he paused at the entry and could not keep himself from weeping, as he leaned against the doorframe. The pieces they'd selected spanned Guylaine's career.

Displayed, as they entered, was a series of single figure sculptures that Guylaine loved so much that she'd never been able to sell them. Some were abstract, some amazingly realistic, each depicted an elderly woman seated in an upright, ladder-back chair, wearing a housedress with her hair swept up and pinned in a practical twist at the back of her head. A large bowl, partly filled with sliced apples, rested cupped in her lap. Just beyond the edge of the bowl her hands were occupied with a paring knife peeling an apple, the long peels spilling into a pile between her feet. There were eleven of these sculptures in all, in various mediums. Guylaine had dearly loved her paternal grandmother and had captured her repeatedly in this most familiar pose.

"Oh," Josette's voice caught in her throat, "It's her Nana series. I'd completely forgotten about these." She walked down the row touching the sculptures that had always stolen her heart. In one simplified, abstract version, Guylaine had carved her grandmother in white marble as an elongated figure, seated tall in her farm chair, her features only suggested in the spare white stone. Her head and face small, rendered in the sparest of shapes— cheekbones, forehead and hair offset by the line of her chin. Her form also gently suggested—collar bones through her dress, sharp elbows tucked in. The sculpture spread towards the base, forming a pyramid of apple peelings, her dress and the pile of peels forming the wide base of the bottom of this elegant triangle. Another, a smaller one in bronze, with more detail, playfully showed Nana seated, buried to her knees in a pile of apple peels. Yet another, in carved walnut, was an abstract reduction of shapes—the curve of her spine, twisting into the chignon, the

triangle of her arms resting on the rim of the bowl of apples. Most were elongated in a Giacometti view, that, only now, Josette realized represented the foreshortened view of a tiny granddaughter.

"These are incredible." Estelle's hand brushed the smooth polished surface of speckled, black granite. "This is your grandmother?"

"Yes," Josette nodded, she was standing in front of a patinaed bronze, strikingly realistic, with a dimpled, almost hammered looking surface where, if you looked closely, you could see Guylaine's fingerprints in the bronze. "Nana died when Guylaine was in college. When she was little, my grandmother looked after her. They had a special connection. For years, whenever Guylaine had time, she'd do a Nana sculpture. Sometimes she'd do one before undertaking a major piece. Nana was like her touchstone, she brought Guylaine back to center."

Ben was transfixed. "I have two of these, small ones, back in Toronto. Where'd you find all of these?"

"You'd be surprised at all the stuff in the basement." Marc stood in the center of the room, obviously pleased with the effect. "We picked stuff that was personal—we wanted to show Guylaine's private work, not just the religious things."

Beyond the Nana series was a set of semi-abstract pieces. At first they appeared just to be flowing shapes. Looking closer, it became clear that the sculptures represented the negative space between figures. The first, a set of three in smoothly carved walnut, were horizontal "figures" or at least the spaces that would exist between figures, a nude couple, sleeping, first back to back, then spooned together and finally with the man facing his partner, who was lying on her back, his arm draped over her. The accompanying plaque identified this series as, *"Entre Nous."* They were sensuous and discreet, mind-bending in the way that the viewer had to look at the solids and fill in the spaces with the missing nudes. Ben looked a little embarrassed, and Estelle guessed, by his reaction, that he had been the male model for these. She grinned.

Ben caught her glance, "She never asked me, and we never actually posed for these." Now, blushing, he stammered, "She did

them from memory. I was always too embarrassed to let her show them."

Estelle chuckled, "Too late for Canadian modesty, now they belong to Art and History."

Just beyond the walnut carvings was a highly polished bronze. Its visual reflections were distracting, but again the sculpture was of the negative space between two figures, this time engaged in coitus. It was stunning, sensual and fully rendered and, at the same time, the smooth reflective surface confused the observer and the negative/positive space conversion concealed, in full view, the intimate nature of the subject.

This time Ben laughed. "She could never show this. She was afraid that it would be the end of the production work. What church would buy its Stations of the Cross from the sculptor of a piece like this?" They all laughed, breaking the tension. The work was so sensual that it tended to make people a little uncomfortable with its beauty; it left them feeling exposed, even as it was stunningly arousing. "Guylaine said that the way to *see* this piece was to close your eyes and touch it. That way you're not distracted by the reflections." Everyone nodded, but nobody stepped forward to try.

Next, along the interior wall were a series of wall-mounted sculptures, body parts in various activities. The first was a life-size set of a man's hands, in a dark bronze finish, one holding a coffee cup and saucer and the other holding a spoon heaped impossibly high with sugar. The sugar was done in white epoxy, a tower of sugar piled, maybe two inches tall. The title plaque read, *"Sweeter in Summer."*

Ben snorted, "This was a senior class assignment. Students were told to illustrate a concept revealed by the title of the piece. Guylaine had a humorous take on humidity."

Another piece was mounted close to the ground, again in a dark bronze finish, above there were two hands from the elbow and just below them, a foot held on the horizontal, heel towards the wall. The hands were poised, applying a band-aid to the heel of the foot. On the ground next to the foot was a roller skate, also in bronze. The title was, *"Enthusiasm."*

A third bronze, like the Nana series, showed a woman's hands in the act of peeling an apple, an impossibly long piece of

peel dangling, its thin ribbon of peel so delicate it made you forget this was a bronze.

"Jesus, these are good," Estelle mumbled. "These were all here?"

"Yeah, in the basement. And, there's more," said Marc, "But this gallery's too small."

In the center of the room was a full-sized bronze of a swimmer, crouched like a spring, waiting for the starting gun—her muscles taut with the tension of the moment. They stepped around her, giving her wider berth at the front, as though at any moment she would launch herself into the water. Above it, mounted high on the wall, in bronze, was a long split-hull of a racing shell, topped with an undulation of arms and hands wrapped around a row of oars which extended out over the room in a near-perfect alignment.

They circled around the swimmer and the last work, before they came back to the Nanas, was a larger-than-life marble of a seated nude, leaning forward, toweling her hair dry. She was plump, not like a Rubens, but like a Maillol, taking up space and yet somehow, there was a smallness to the intimate moment.

Josette gasped.

"It's almost too much. Each one of these really needs its own space."

Bill nodded. "We tried to get as many in as we could, but leaving some area around each. Can you believe that some of these were unclaimed commission pieces?"

"They'll probably try to claim them, *now*." Josette said, harshly.

Cathy added, "We produce and cast these sculptures, working alongside Guylaine every day, and we know we work with a talent. But, when we assembled these, we were just awestruck. It's taken us three days and when we'd put the last ones in, we sat and wept. We don't even know why we did it, but we needed to... to honor her and to show that she was more than just that footage we've all seen." Marc put his arm around her.

"You're the first to see it. So, what do you think?" Bill looked tentative.

Ben embraced him. "It's perfect. It brings us to what she was, who she was, to us."

"Well, it's been hell, here," Cathy continued, "We had to pull the gate closed. There've been mourners and attempted break-ins. The reporters never stopped calling. Did you see the flowers?"

"Yeah, some of them, in the dark." Estelle answered.

"All the while, we just kept setting this up," Cathy gestured at the room. "It's kept us together and sane."

Josette wandered the room, touching the sculptures, marveling at their beauty.

Bill approached her, "Have you seen the sculpture of Lucille?"

"No."

"It's so incredible," Cathy said, "It is so telling, because this one, Guylaine did for herself. This was her vision. It was such an experience placing this piece because it shows the breadth and depth of how she connected with her world. There were a lot of technical problems, but Guylaine knew exactly what she wanted. You need to see it." Bill took Josette's hand and led to the door.

Everyone followed Bill, Cathy turning off the lights as they left the gallery. They walked along the portico that shielded the apartments from the courtyard garden and came to the inside entrance of Guylaine's home. There was a ragged, jerry-rigged piece of plywood instead of a door.

"I'm sorry. I'll have it replaced tomorrow. The cops cut the door with axes." Bill was shaking his head. "We were looking for the keys, but by the time we got back, they'd hacked it to bits." He unlocked the makeshift door.

Inside, it was warm. Ben reached for the lights in the kitchen entry. Bill looked at Marc and motioned with his thumb, pointing upstairs. Marc nodded. Bill slipped past them and into the living area. It took Ben a moment to realize Bill and Marc were setting up the lighting—to best show the Lucille installation. Ben stepped back to watch them give the tour.

Marc turned to Estelle, "Do you know the story of Lucille?"

"I know that she was Guylaine's sister, that they were very close and that she died under the ice on Red Wing creek."

Josette nodded and added, "She was our family's tomboy and the apple of my father's eye. Lucille always pushed the limits. Hélène and I never had a toboggan, and never wanted one. Lucille did. She had the balls, the hockey sticks and the skates. You name

it, she had it. That day she was skating by the water intake by the treatment plant. It's set where there's a little eddy, just past the bridge and the wind keeps it clear of snow. But, the water is always moving because of the intake, so the ice tends to be thin. Of course it was posted with warning signs, and a fence, but kids have always just ignored them. It was the saddest day, when they brought her home. I thought my dad would break into pieces."

Marc turned to Josette, "This way." He turned the corner into the living-room and started up the stairs. Where there had once been an oak railing, was now a galvanized, steel pipe. A chain-link fence behind it spanned all the way to the second-story ceiling above, topped along the ceiling with razor wire. The open railing on the living room side was also a chain-link fence, angling to follow the staircase. At the landing level, before the stairs turned right, there was a yellow, *DANGER—KEEP OUT,* sign on the fence. Josette saw it and sucked in her breath.

Marc nodded at her recognition. "Yeah, that's the actual sign. Guylaine stole it from the site a couple of years ago." Next to the sign there was a gap in the mesh fence, its edges curling slightly in towards the upper landing, it's high spots and the edges of its chain links polished to a smooth, black sheen as though from the passage of many small trespassers. Near the top of the split hung a child's hat, caught in the weave of the fence's mesh. Estelle followed, noting both the installation and Josette's responses as history caught up with her.

Josette paused before turning at the landing, "Ben, I'm not sure I'm going to like this." She looked back down to him for reassurance.

"Parts are hard, but when you've seen it all, it's worth it." He smiled, "It's okay, Josette."

She swallowed and stepped up past the landing to where the loft flooring began to be visible. The painted, plank floor gave way to a white, powdered surface, like snow swirled by the wind on ice. Josette reached through with her finger to see if it was loose, but the "snow" was firmly adhered.

Marc looked to Bill, "It seems we got that right, eh? Everyone checks it."

Josette laughed nervously, "I feel like your guinea pig. Who else has seen this?"

Marc and Bill looked at each other and shrugged. Bill volunteered, "Other than the staff, Rosemary and those cops, I think just Ben." He paused, "There were a lot of cops."

Estelle said, "I was here eight months ago before it was finished. Everything was all torn up. This is all new." She was amazed. "It doesn't look new." The chain-link mesh had a weathered, powdery-grey look. The hand rail had an oxidized look, too, except along the top, where hands would have worn it smooth and dark.

Bill watched her, and smiled, "You have no idea how hard we worked on that. Guylaine wanted it perfect."

Josette proceeded up the stairs and stepped around the end of the fence to the upper landing above the first flight of stairs. In the corner the snow was a little deeper, but there was a section, about two or three feet, that looked like mittened hands had cleared the snow from the rippled, icy surface. A soft glow emanated from the ice. Josette walked over and gasped. She dropped to her knees and touched the surface. Her warm hands left moist imprints on the lightly frosted, Plexiglas surface. Below several inches of "ice," indirect, bluish light revealed the angelic face of a young girl, her long brown hair swirling in the water around her. One mittened hand was pressed against the underside of the ice, the other hand, bare, with the fingers just gently touching the ice above her, in almost a wave or a salute. Her face was peaceful, slightly smiling, with her lips parted just enough to see the glint of her teeth. Her brown eyes smiled up in recognition. Her parka hood was pushed back, and its draw strings floating, framing the face. Beyond that, the image frosted and the body was obscured. Josette put her hands to her face and sobbed.

"It's beautiful, but too sad." Josette wept.

Estelle came up behind her and put her hand on Josette's shoulder. Looking down into the ice, the sculpted portrait of Lucille was stunning, ethereal and elegant. The face had the pink cheeks of a ten year-old skater but in the blue illumination, she looked chilled, maybe distant. Her fingertips touching the ice were grey-blue.

"Look again Josette, she isn't sad—she's stunning." Estelle lowered herself to the floor and put her arms around Josette.

Josette, looked up and around at everyone. "How could she want this here, here in her bedroom? It's heartbreaking."

Ben answered, "Not to Guylaine, she never got over losing Lucille. This way she kept her close, and, when you see the rest of it, maybe you'll understand." He walked over and held out his hand to Josette.

"There's more?" She wiped the tears from her cheeks with the back side of her hand. She looked back down at Lucille's sweet, smiling face, then turned and took Ben's hand. He helped her up and led her back downstairs.

Ben explained, "The same sculpture continues, down to the breakfast nook below."

Bill went ahead and flicked on the lights in the breakfast nook that was tucked in the *L* of the kitchen, underneath the upper landing. There, above the table, almost floating by the ceiling was the slight figure of what appeared to be an angel in flowing robes—its wings spread almost the width of the ceiling, partially obscuring the view of the shoulders and head. You could barely make out the swirling hair, smooth profile and hands, reaching up to the illuminated ice, above. Peeking out from the flowing angel's robes were the skinny legs of a ten year-old, clad in snow pants and white figure skates.

Guylaine had her angel, Lucille, watching over. She had transformed what had been a family tragedy into a happy ending.

Josette slumped into one of the chairs. "It's incredible. Too beautiful for words. I think *I* can handle this, but I don't know if my parents could. But, I see it, I see Guylaine in it and that's beautiful, too." Tears streaked Estelle's face.

Ben looked from face to face and saw the expectant looks of the sculptor's assistants. "Guylaine couldn't have asked for a better reception. She wasn't sure if her parents should see it, but it healed something in her to create it. She did want Robert and Père Michel to see it. Mostly though, *she* loved it." The two foundry men nodded and nudged each other in brotherly appreciation. Bill gave Marc the thumbs up sign.

"It's late. It's been a long day and we should let you folks settle in." Cathy was suddenly aware of the late hour. Josette turned and put her arms around Cathy. "Thank you." She turned to

the oversized brothers, "Thank you for everything, for the gallery, and for this," her arm raised to the angel Lucille, above them.

Cathy was beaming. "I think I can speak for all of us—your reaction has made it all worthwhile." She dropped her eyes. These were such emotional times for all of them. "We've made up the bed in the guest room and the pull-out in the study," glancing at Ben, "We assumed you'd want to stay upstairs. It's just as she left it." Cathy checked her watch and assuming the role as a mother hen, waved the boys ahead of her. "C'mon, let these folks get some rest. They stepped back into the kitchen and said good night. On her way out the door Cathy added, "You know Guylaine, there's nothing in the fridge. We'll bring you some goodies in the morning."

Josette looked up at the skate clad angel. "It's amazing, just amazing. Ben, if you'll give me the keys, Estelle and I can grab our things. It's been a long day and I know *I* need to rest."

Ben reached into his pocket and handed over the keys to the truck. As the women went off, Ben ascended the stairs. He sat on the bed and pulled off his boots. Pulling the covers back, Ben climbed into bed fully clothed, and exhausted. He buried his head in the pillows, into her scent and for just a moment, as he slipped into sleep, he felt her arms around him and her hair against his face.

Chapter 19

Françoise heard the knock, and made her way to the back door. Guillaume was away with Jean Luc and Claudette. She hoped that this wasn't reporters—she wasn't up to the task of warding them off this morning. A light rain was falling from dark clouds and Françoise was struggling to keep her emotional equilibrium. At the bottom of the stairs she could see Officer Bill Campeau. He was more than just their local cop. Bill Campeau and Guylaine went way back, to childhood. He'd been central to the events that, indirectly, led to her development as an artist. Françoise was momentarily embarrassed, and then alarmed— perhaps Bill had information on the investigation. Françoise wished that Guillaume was with her, now.

She stepped down the steps and opened the locked storm-door.

"Good morning, Mrs. Maisonneuve." He nodded his head in respectful acknowledgement.

"Bill." She waved him in and led him up the back porch steps. Inside she turned to face him, "So, any news?"

"Sometimes, no news *is* news, eh?"

"Should I call Guillaume?"

"No need. I've been pressing... well, trying to get the department to keep me in the loop. They know I have a connection with your family. Sometimes that means you get the inside scoop. But, this time, I think it means they're circling the wagons."

Françoise looked puzzled. "Circling the wagons?"

Bill chuckled, "Sorry—too many TV westerns. It's just that it seems like my superiors are *not* giving me information. I'm thinking they're concerned about a lawsuit."

Françoise shook her head, "Then they don't know this family very well—we wouldn't sue. And, you can tell them that."

Bill nodded. "I wish it were that simple. I heard this morning, in the locker room, that the department was going to issue a *White Paper* on the inquest."

Again, Françoise didn't understand. She looked at him blankly.

"Usually, a White Paper means they're going to take their sweet time about the investigation. They'll wait until it's no longer in the public eye."

"Such idiocy." Françoise wiped her hands on the dishtowel, "Can I get you some coffee, Bill?"

"Sure." He was taken aback by Françoise's blunt assessment. She poured two cups and looked up at him, "Cream?"

"Oh no, I wouldn't trouble you. Just black is fine."

"No trouble."

Bill smiled, "I think most cops drink their coffee black cause it's just easier."

Françoise and Bill took their cups and sat down at the kitchen table.

"I don't really care whose fault it is, you know." Françoise looked directly at him. "I've been in this business long enough to know that searching for fault just takes you farther away from the one you've loved. Better to just own the loss." She took a sip from her steaming mug.

Bill nodded, "Well, you may be the only one in Canada who feels that way right now. I wish we could bottle that attitude and sell it."

Françoise furrowed her brow, "Does this mean that they won't release her body? Because that's going to be a hardship. The family needs to be able to deal with her death." She sighed, "We *need* a funeral."

"Well, there's *has* been an autopsy and, while they aren't releasing the results, they've brought in a forensic expert in to review it. As soon as that's done, there shouldn't be any reason to hold things up any longer. Were you and Guillaume going to follow-up with an independent autopsy?"

"Good God, *no!* Some folks do that?"

"Sure. Even… sorry I don't remember his name—Guylaine's, professor fella?"

"Ben, Ben *Levin*." Françoise took care to correctly pronounce his last name. "Could *he*?"

"Well, they been together a long time now and I think, under Ontario law, there's some common-law rights, there."

"Oh. I hadn't really thought about it, that way. You're probably right." Françoise paused and reflected on that. It would

certainly be a shock for Hélène. Maybe Guylaine and Ben really *were* married, after all. She smiled, then scowled, "I can't imagine he would, but if he did, might that slow up her release?"

"Could. But, if you all worked together with a request, we might be able to get somewhere. Maybe if you submitted something, you know, with a lawyer or maybe Père Michel."

Françoise sighed, "I didn't know it was all so complicated. Usually with an accident, Guillaume handles the police part."

"This is different, and it's way beyond me. Hey, I'm just a glorified traffic cop." Bill dropped his head. "I wish I could be more help on this, but I'll give you any information they give me."

"That's fine, Bill. They're good suggestions." Françoise wondered what Michel would say. She looked up to see Bill crying.

"I loved her you know."

"I know. We all did. It's okay."

"Yeah. But, I mean all the way back from when we were kids. I always loved her. I was heartbroken when you sent her away. I thought it was *my* fault. And, by the time she came back, she was an artist. I felt like my chance had passed."

This silenced Françoise. Some chapters never closed. She now chose her words carefully, "We didn't handle that so well, but it all worked out. I certainly can't say I'm unhappy that Guylaine found her talent."

Bill let that in. "No, I guess not. I'm not sure whether or not there was a place for her in Red Wing, but she *was* special, eh?" They both sighed and lifted their coffee mugs. Françoise was amazed—she would never have guessed that Bill had a lingering bond with Guylaine—and admitted, to herself, that you never knew what kind of impact you might have, on anything.

Bill drained his cup. "Mrs. Maisonneuve, if there's anything I can do, you just let me know, okay?"

Françoise nodded, looking around the kitchen. She was poised on an undertaking of her own. Two full bushel baskets of green tomatoes had been waiting on the counter. The pressure-canner sat on the table along with onions, brown sugar and raisins. She paused, "Well, what you *can* do, if you've got a few minutes, is give me a hand with these tomatoes."

Bill looked around the kitchen and realized she was serious and well, he had offered. "Sure." He smiled, "What're we making?"

"We're making green-tomato chutney. The recipe was in *The Windsor Star*."

Bill slipped out of his trooper's jacket and rolled up his sleeves.

Chapter 20

The rain had started. After a beautiful, clear morning, the clouds had rolled in with a light rain. But now, the storm hit with a fury. Guillaume, Père Michel and Father Tony dashed from the car to the back entry, covering their heads with outstretched jackets. They stamped their feet on the mat and, then thinking the better of it, the three portly men each bent down and removed their shoes in the narrow entry. Off balance, they bumped each other, and steadied themselves, hanging on the railing, laughing in the process.

Father Tony caught a whiff of the vinegar edge of the chutney, and called up to Françoise, "Whatcha got cooking, Françoise? Smells like something died!"

Père Michel gave him a quick elbow and rolled his eyes. Tony winced. Not even noticing, Guillaume was first to step into the humid kitchen. Michel followed on his heels, with Father Tony bringing up the rear. The kitchen was hot and steamy. The table and counters were lined with jars of the richly spiced, brown and green tomatoes. The enameled pressure-canner was steaming and rattling on the stove, the rest of the pots and canning tools piled in the sink. The air still hung with the bite of vinegar. Françoise and Bill sat opposite one another at the table with mugs of tea and a tray of brownies sitting between them. The chicken-shaped kitchen timer ticked on the table.

As the three older men filed in, incredulous at the volume of jars, Bill stood to greet them, with an outstretched hand. His professional demeanor was entirely undermined by his appearance and Father Tony began to laugh. Père Michel, studying Bill, succumbed as well. Bill looked puzzled. Guillaume struggled to keep his composure but, looking Bill up and down, sank into one of the kitchen chairs and chuckled. Bill looked down at himself. He was in still in full uniform, sleeves rolled up above his elbows. His eyeglasses were speckled with chutney and he was wrapped tidily in an old-fashioned floral bib-apron with yellow, rickrack trim. The butt of his sidearm peeked out, its holster, protruding above the apron ties. It *was* ridiculous. Bill looked up with a broad grin.

"Protect and Serve, eh?" He laughed, "But, not necessarily in that order. And, you've got to admit, the yellow and green flowers go nicely with the uniform." Bill struck a fashion pose.

Père Michel wrapped his arms around the officer in a warm embrace. Guillaume reached out to shake Bill's hand. He looked over at his wife, who looked tired, even frazzled, but happy. A flood of relief and love for this officer, and for all the love in Red Wing, washed over him.

Françoise stood and put on the kettle for another pot of tea. She looked relaxed and laughed with the others. All day, Bill had just been Bill. But now, he was amongst the men, and wearing that apron, she could see the humor. The timer rang and, without word, Bill and Françoise stepped over to the stove. Françoise flicked off the gas, while Bill lifted the lid and reached for the canning tongs. The steam rolled up and filled the kitchen. Still, neither spoke as Bill carefully lifted the wire tray of jars from the hot-water bath. With the tongs he gripped each jar and gave it a shake. In turn, Françoise took them from him with a kitchen towel, quickly rubbed each one dry and placed it, upside-down, on the kitchen counter. The men watched as the pair emptied two layers of pint jars from the canner. Françoise reached over and re-set the timer.

Father Tony applauded. "That was like watching a ballet. And, *what* a production!" He waived his hand at the rows of jars lining the kitchen counters.

Now, encouraged by their audience, Bill removed his apron and bowed. Then,Françoise turned on the oven, made a quick turn and stepped over to the refrigerator. She opened the door and stared at the assortment of casseroles left by their friends and neighbors. Bill was already gliding over to open the oven. She made her choice and had peeled off the Saran-Wrap cover of a large, Pyrex dish. The casserole went in and Bill deftly swung the oven door closed. Their performance ended with Françoise making a quick pirouette, lifting the tray of brownies and placing it on top of the refrigerator.

She turned, "I hope you gentlemen are hungry. I picked Claudette's famous, sausage and potato casserole for dinner."

They all murmured their assent.

Father Tony turned to Bill, "Do you have any news for the family?"

Bill began to recount what he'd told Françoise, many hours *and* many jars of chutney, earlier that morning. Guillaume stood, quietly wrapping his arm around his wife. Père Michel noted that they leaned into to one another. There were times when he was embarrassed to witness these intimate moments, but tonight it built his faith.

Looking at his wife, Guillaume raised his eyebrows, "Salad?" She nodded. He pulled out her chair. She hesitated but Guillaume nodded for her to sit. Françoise squeezed his hand and settled in at the kitchen table while Guillaume went to the refrigerator and assembled the salad at the counter.

Père Michel sighed—he felt blessed to witness the tiny healing moments of the people he loved. Françoise and Guillaume, shattered only days before, were able to find each other and that was the beginning of healing. For the first time since he'd listened to that horrible radio announcement, Michel could see the path forward. Bill was recounting the position of the Provincial Police and Michel turned his attention to the details.

The timer rang again. Françoise started to stand, but Bill motioned her to stay put. He walked over to the counter and turned over the last jars of chutney. Almost immediately the lids snapped—*plunk... plunk*. Sealed, each in turn.

Françoise beamed, "I love that sound. The end of summer." Everyone smiled.

Bill finished his up-date, "So, a little subtle pressure, combined with reassurance that the force has nothing to fear from the family, *might* speed matters up."

Guillaume looked to Père Michel. Michel looked to Tony and nodded. "We need to talk to Ben, but I think we may be able to muster an *official presence*. Bill, you just find out who we should contact."

Bill nodded.

"We just want to bring her home." Guillaume spoke from the counter, where the salad was taking shape in the bowl before him. He turned, "We need her *home*."

Everyone nodded.

Françoise turned to her husband, "How is it going with the music?" Guillaume just rolled his eyes and turned back to his salad.

"C'mon Guillaume, most of it is going well." Father Tony turned to Françoise, "But, the soloist. She's not right. We need to start over on that."

Françoise winced. "And she's Hélène's friend, eh? C'est difficile."

Guillaume shook his head. "It has to be right. I'll find the right voice, and Hélène will have nothing to say on the matter." He set down the bottle of dressing down hard on the table.

"What about Guylaine's friend, Rosemary?" Michel asked, "I remember she had a lovely voice."

Guillaume's face slowly brightened. "Ah, yes. They went to art school together. I remember once, Rosemary told a story about Guylaine, sculpture and music. That woman is very funny. She sang part of the story. If she can sustain that voice, she'd be perfect!"

Michel smiled. He wondered if anyone could be good enough for Guillaume, for his salute to Guylaine Claire. But, if connections were an important part of the story, Rosemary was connected.

Father Tony tried to reassure them, "Everything else is coming together wonderfully. The orchestra has really come along. If we find the right voice for the solo, it will be perfect." With his eye on Guillaume, still tossing salad, he turned quietly to Françoise, "The selections are so poignant—I think it should be recorded. It's a stunning Requiem." He paused, "Françoise, talk to him. Guillaume doesn't agree with me but it's too beautiful to just let it be lost in the moment."

Françoise nodded and looked to Michel. His eyes met hers and her decision was made. She would make the bid to Guillaume in their quiet time together.

Bill spoke softly, "Once, back in high school, when we were close, Guylaine tried to explain to me how she felt about some beef at school. It was really a dumb thing—the vice principal was cracking down on some disciplinary problem. First she hummed a tune and then she danced. It was crazy, but amazingly beautiful. I understood exactly what she was trying to say, but it was wordless. It changed me, but I could never have explained it. Sometimes, as a cop, I've thought about that day and wished I could tap into that deeper sensibility. I've wanted people to

connect in a way that got around the words." He sighed. "So, if your music does that, record it and share it. We sure could use it.

Guillaume stopped prepping the salad and put both hands on the counter. No one spoke. In that moment the decision crystallized for him. He sighed.

"Alright, Tony. You win. If we find the right soloist, you can bring your recording people. I can't argue with that."

The air filled with the aroma of the hearty casserole. Père Michel's stomach growled loudly. He blushed. Françoise laughed and opened the oven, flooding the room with the full, smoky-rich aroma. When she thought no one was looking, Françoise stuck a finger into the corner of the casserole, checking to see if it was hot enough. Seeing it, Père Michel laughed to himself. Françoise pulled on oven mitts and delivered the steaming dish to the table. Guillaume followed with a huge mixed salad and two bottles of store-bought dressing. Père Michel got the plates from the cupboard, then the flatware from the drawer and placed them at the end of the table. Father Tony passed them down. In a few moments, dinner was ready to be served. Then, they paused, looking to their priest.

Père Michel bowed his head, and silently gave thanks for the meal, and his adopted family, before nodding and gesturing the others to begin. It was the privilege of the Parish priest, to embrace more than just the food before them. Françoise took the plates and ladled out generous portions. Mostly silence reigned as they settled into the meal.

When the plates were finally cleared, Michel started up the conversation. Looking around the kitchen, he counted at least forty pints of green-tomato chutney. "Françoise, you and this young man have certainly been busy, today!"

The two canners exchanged smiles.

"Oui, it was a big job. But, I'm glad of it. I hated to see all those tomatoes go to waste."

"And Bill, how'd *you* get roped into this?" Michel raised an eyebrow and grinned.

"Just offered, and she took me up on it. You should be careful what you say, eh?" He smiled at Françoise, "But I don't regret a single minute of it. It was great."

She interrupted, "You be sure to take some of that home for you and Margie, now. And, some for your folks, too."

Bill nodded, "Yeah. But, I'm not sure my wife or mom'll know what to do with chutney. Never heard of it, before today."

Françoise explained, "It was in the Windsor Star—*green-tomato chutney*. And, on account of the mild fall, folks have lots of tomatoes left in their gardens."

Bill looked up at her. "I wouldn't have guessed it. It's pretty strong stuff but the flavor's pretty good. Maybe you can tell Margie how best to use it."

"It *is* good." She turned to Guillaume, "It's really good with meats and rice. When I first thought about making it, I checked with Guylaine. She said it was Indian food. That made me think of my Maman, and I decided to give it a try."

The room fell silent. One by one, Françoise's words sunk in. No one looked at anyone else.

Françoise looked around. Her guests' eyes were fixed firmly on the table or their hands. "What?"

Finally, Guillaume addressed it. "Mon chore, did you make all this chutney because you thought it was it was *Indian* food?"

"Sure. And, because I had so many tomatoes. I've felt it's long past time for me to connect to my native roots. Why?"

Guillaume swallowed. "Françoise, did Guylaine ever use the word *Indian* to refer to her heritage?"

"What do you mean?"

Père Michel couldn't stand to watch Guillaume suffer this. "Françoise, Guylaine never used the word *Indian*. She said "native" or "indigenous" or "aboriginal.""

Françoise looked confused.

Père Michel continued, "Did the Windsor Star say chutney was Indian food?"

"Sure, chutney, they said so."

"Françoise, Chutney *is* Indian food—From India." Michel peered at Françoise to watch her reaction. He glanced around the room at the neat rows of pints and pints of chutney.

Guillaume gently put his hand on Françoise's leg.

She looked at them blankly. Then, stunned, she looked at the jars. She remembered the late, afternoon sun streaming across the garden on the day she and Josette gathered the tomatoes. She

117

thought about the phone ringing. She searched her mind to remember *exactly* what Guylaine had said the day before that, about chutney. 'Indian food'. Sure.

Françoise sat and soaked up the totality of it. She missed her youngest daughter, and the reaction Guylaine would have had to this misunderstanding—dozens of pint-jars of misunderstanding. Françoise threw her head back and *howled*. She slapped her thigh and laughed till her sides ached, tears running down her cheeks. Guylaine would've loved this.

Chapter 21

Estelle smelled the bacon. Rolling over, she opened her eyes. She'd been sleeping on a pullout sofa in a small office. She heard the murmur of hushed voices mixed with the smells of breakfast, coffee and bacon. She sniffed again—and maybe biscuits. She took a deep breath and flopped over onto her back.

It was Guylaine's personal office—small and orderly. In a niche, on one wall, was an array of elegant crucifixes. Estelle reached over and pulled the curtains open for better light. There were eleven of them—small, carved ivory Christ figures, mounted on wooden crosses that were themselves mounted in elaborate gilded frames. When she looked closely, she could see that the ivory Christ figures were exquisitely carved. The tallest was about eight inches, running down from there to about four inches. Even the smallest of them had incredible detail—sinuous muscles stretched in agony and tiny elegantly carved hands and feet pierced with miniature nails of ebony. Each was adorned with a delicate crown of thorns. Individually, each was spectacular but cumulatively they were, perhaps, too much.

These were obviously antiques and, based on the ornate frames, Estelle guessed they were probably French. She marveled at the sensitively rendered figures, their ivory skins yellowed with age and luminous. Some of their expressions were serene, others grimaced with pain. Together they were a study of the faces of the passion play in the culminating narrative of Christianity. Estelle wondered at the superfluous display of religious ardor. One, maybe two of these would have served the purpose. Why so many, when the beauty, the sincerity, of each was undermined by the excess? There was no other decoration in the room. Estelle felt she had a lot to learn if she was ever going to understand Guylaine Claire.

The desk was covered with photos and drawings, mostly of posed figures. Guylaine's handwritten notations punctuated the pictures—with arrows to specific angles or planes of body views, a sculptor's language. Estelle opened the desk drawers, revealing tidy files. She knew she was snooping but reasoned it was a *necessary evil*. She chuckled, rifling though the folders. Almost

everything was pictures. The files held titles like, *Athletes, Ears, Hands and Feet. Shoulders (crouched), Shoulders (extended)* and one marked *Pietas*. Ever the consummate researcher, Estelle giggled at a funny world where one's reference files contained images and drawings of body parts.

On the corner of her desk pad, Guylaine had left a chunk of Plasticine that was twisted into an elongated woman's neck, rising from rounded shoulders, head slightly turned to the right, chin down, and hair pulled into a chignon. It was an idle maquette— perhaps a three-dimensional doodle she'd made while talking on the phone. Estelle was enchanted with the idea of an absentminded moment emerging into this moving fluid form. She thought back to her interview with Guylaine, when she had glimpsed just a sliver of a life unbounded by words. Estelle, as a writer, was fascinated by an artistic sense that worked outside her own definitional parentheses of language. Guylaine was as free a spirit as she'd ever encountered. Not a woman without worries, but whose concerns reverberated more to the rhythms of heart than Estelle's. Guylaine was more connected to the immediacy of her feelings. It was the first time Estelle wondered whether communication, and the effect of language itself, might create distance. She sucked in her breath, suddenly aware that her resonant consideration of this notion came at the cost of personal tragedy. She picked up the Plasticine and ran her fingers along the line of the neck, the subtle indentations suggesting the line of the spine.

A soft knock at the door startled her.

"Estelle?"

She set the modeling clay back down on the desk. "Yes, I'm up. Come on in."

Josette poked her head in the door. "We've got breakfast if you're interested. Ben's looking to get an early start, so he sent me to nudge you."

"Sure, I'll be right down. Smells great."

"It's somewhat of a tradition, around here. Ben's always made a big breakfast. Everyone's here"

"Do we have an agenda, yet?"

"When you come down, we'll figure it out." Josette closed the door behind her. Estelle rose, stretched and pulled on her

clothes from the day before. She closed up the sofa-bed and reluctantly suspended her reverie to join the rising buzz, coming from downstairs.

"I hope you're hungry," Cathy called up as Estelle's feet hit the first landing, "Ben's outdone himself, this morning."

"Hey, I'm not the one who did the shopping," Ben countered, "As usual, you bought enough to feed an army."

"Yeah, well," Cathy winked at Estelle and nodded in the direction of Marc and Bill, "Wait 'til you see these guys eat."

Estelle stared over at the mounting pile of food around Ben at the stove. True to her nose there were pancakes, bacon, eggs and biscuits. The brothers were loading up their plates, proving Cathy right. Ben nodded smugly.

"Coffee?" Cathy held out a mug to Estelle.

"Thanks." Estelle took the cup, served herself a modest plate, and trailed the brothers to the breakfast nook she'd seen the previous night. Guylaine's skating angel hovered overhead. When she took her seat, Estelle saw Bill and Marc bow their heads momentarily in silent grace, before digging in to the mounds of food on their plates. Estelle paused. She was both embarrassed and touched by this quiet and simple act of piety. She was a bit reluctant to start eating without giving thanks, but not comfortable with the idea of reaching into her own past for the rituals of prayer. These two, beefy guys pushed the buttons of her beliefs, testing her assumptions.

Bill looked up, "So, what's the plan for today?"

Josette and Cathy joined them, sliding their plates across the table and scooting in along the back wall into the antique, church pew that served as table seating across the back of the room.

Finally, Josette answered, "I think we've got to split up today. Ben's got to get back to Toronto and there's plenty to be done here with the business. I thought I'd stay with Cathy and help her sort things out."

"What about us?" Marc gestured to his brother.

Josette smiled, "I think it's going to be business as usual for you two. I understand there are still orders that need to be filled. As long as that's the case, there's casting to be done. It's still about product."

Cathy added, "We've got dozens of orders for Stations. So, you can do the calculations and just keep casting."

Bill nodded and reached for the syrup. He looked satisfied. Estelle thought she saw the relief hard work would bring—they kicked around how to prioritize orders, and whether bronzes or resins should be given priority. While they discussed shop efficiency, Estelle's eyes and mind wandered. The pew, the women were sitting on, was an oak, carved, gothic affair, with quatrefoil crosses on the ends. A brass plaque still indicated the row number. She smiled at the recurring church themes throughout the eclectic home. On the short wall at the end, separating the nook from the kitchen, Guylaine had hung an assortment of odd items that could only be described as *catholic kitsch*. Even the light-switch cover was a plastic gilded scene of Jesus as the shepherd of lambs and children. There were two, turn-of-the-century, sick-call boxes made of oak—one complete with a glass fronted diorama of a painted-plaster pieta. There were several brass, or bronze, holy water fonts filled with keys. Interspersed, and tying the collection together, were plastic rosaries in every color. Grouped together, they had the festive look of New Orleans Mardi Gras beads. *Tasteless religiosity.* Estelle was sure there was a story there.

Cathy continued, "Josette and I are going to go through the basement. There's a sculpture down there for her, but I'm not sure exactly where."

"I'll show you, but there's lots to see down there," Ben said. He turned to Estelle, "You may want to stick around and explore. So, you have a tough choice—you can follow me, or dig through the artist's archives."

"Do I get to take a peek, first?" Estelle was torn between a day alone with Ben, and his memories, or the chance to root around in the basement. Ultimately, she knew that the opportunity for an interview surpassed rummaging, but there was draw in the idea of lost treasure in dusty storage.

Ben poured himself another cup of coffee. "Sure. We can all go down and at least get Josette's piece. That way, you'll get a peek, and then you can decide."

Marc grunted, "That place is really a mess. It'll take you all day *just* to get your bearings." With the efficiency of a front-end

loader, he scooped up the last of his breakfast, and washed it down with coffee. "We'll be in the foundry. So, give a shout if you need help moving stuff."

"Doing a pour right away?" Cathy asked. "We wouldn't want to interrupt."

"Naw, we've got a lot of organizing to do first. You won't be interrupting." Bill picked up his plate, along with his brother's, and headed into the kitchen.

Cathy explained, "Pouring bronze is exciting, but dangerous and difficult work. We don't stop, if we can help it."

Bill returned and signaled to Marc. As he got up to go, Marc said, "If you find what you're looking for, let us know, eh. Don't try to move any bronzes, they're heavier than you'd think." Bill nodded and the two hulks departed, filling the doorway on their way out.

Cathy turned to Josette, "I'm sure you understand that when Guylaine did a portrait, it wasn't necessarily intended to be a photographic representation."

Ben shook his head, "When she sees it, she'll understand."

Cathy disagreed, "I don't think so. There's a reason that Guylaine never showed her the piece." Then, looking directly at Josette, "Guylaine loved it, but she didn't think the family would understand."

"Guylaine never showed it because Hélène was such a dip about *her* portrait. Josette *isn't* Hélène." Ben pushed back his chair. "If everyone's finished, we can let the art tell the story." Estelle drained her cup as they stood to follow Ben into the bowels of the building.

He flipped on the switch and the space was flooded with light. Josette and Estelle squinted in the unexpected glare. The vast space was a jumble of building supplies, trash and household junk, punctuated with sculptures of all sizes. At the far end, by the loading bay, were mostly cast bronzes, but the rest of the basement held treasures in plaster, carved wood and mixed media. *Guylaine's orphans.*

Once her eyes adjusted, Estelle gasped. It was treasure trove. She could see that even Guylaine's rejects and experiments told volumes about the sculptor. Ben led the way to a corner near the

loading bay. There, surrounded by a crowd of rejected gargoyles was a half-life bronze of Josette.

"She named this piece, *Josette's Talents, Josette's Burdens*," Ben moved around to the front of the sculpture. Josette and Estelle followed.

It was an odd piece, portraying a woman in a shortened, almost dwarfish view. She wore a formal mannish suit, with one of those frilly, 80s scarves knotted in a full bow at the neck. She teetered on platform, open-toed heels, with squat short toes peeking out from the open tips. An overstuffed briefcase, with papers poking through the seams, leaned against her left leg. A tiny, elderly couple sat holding hands on the edge of the briefcase, looking up. Over her shoulder she wore a sling, the sort used to carry infants. Climbing out the bottom of the sling, as if to make his escape, was a young boy with a lacrosse stick clutched in one hand. Behind him, curled asleep in the sling was a younger boy, holding a hockey-stick. The woman's arms were outstretched, attempting to juggle balls of different sizes with trailing ribbons— one in each hand and a third suspended mid-air, held aloft by a diaphanous ribbon-band of bronze, twisting in the air behind the ball. Her long hair was tied up in a chignon, some hairs flying loose with the effort of the juggling. The best part was her face—it was wide and open, a slight smile through parted lips, crows feet in the corners of her eyes and a tear coursing down her cheek. The face was gorgeous. While the shortened effect of the squat body appeared to keep her seriously earthbound, the light in her broad face soared.

Estelle glanced up at Josette for her reaction. Josette was entranced.

"What is this, late 80s?" Josette fingered the exaggerated bow. "Oh, God. I really used to wear this stuff." But her eyes were locked on the face. It was beautiful, radiant, simultaneously burdened but full with the love of the act. Josette turned away, teary-eyed but thrilled. "She really caught me. It's all there. *Damn.* I wish she had shared it with me."

Ben nodded, "I knew you'd like it. I told her so, but she wasn't so sure."

"Are you kidding, I love it. It's totally me, and it's *so* eighties. We tried to be little businessmen—those god-awful,

ridiculous clothes. I was an assistant manager at the bank then. Divorced, two kids. I really *was* juggling. I just love this. Can I have it?"

"*Of course!* You should have had it a long time ago." Ben put his arms around her and Josette began to weep. Ben rocked her slowly and quietly added, "She really loved you. You can feel it in the way she saw you." Now, Estelle wiped tears from *her* eyes. She was going to have to hang on tightly to her role as observer. Ben relaxed his grip and held Josette at arms length. "Tell Bill we'll load this into the truck. Your assignment today," he looked across the chaos, "is to find the works that should go home to Red Wing. There's something for everyone. Bill's going to load up the gravestone materials in *his* truck, and that way we'll have room in our truck for the picks for home."

Josette wiped her eyes with her palms and glanced back at her portrait. "Nobody gets what *I* got. Wow!" She straightened up. "Thank you so much, Ben. This is really special,

He checked his watch and turned to Estelle. "If you're coming, we've got to fly. It's going to be a long day." The decision was made that Estelle would go with Ben. Cathy and Josette would stay. Estelle thought of the buddy system for kids—everyone had someone to look after them.

As they were climbing into the truck, Bill came out. "We'll have whatever's ready to load, when you get back. Just pull in next to the foundry and we'll use the forklift." Ben nodded. Bill reached over to shake Ben's hand. In the same move, he passed him a small, cassette tape. Ben looked at it, puzzled.

Bill explained, "It's from the answering machine. I grabbed it before the cops could get it. I thought it might be private." Bill lowered his voice, "Nobody else knows about it." Ben nodded, and pursing his lips, he shoved the micro-cassette into his jacket pocket.

"What's that?" Estelle asked as Ben slid into the driver's seat.

"Cassette, from the answering machine." His face was grey.

"So?"

"I hadn't thought about it, even in Toronto. There may be messages from Guylaine." He hesitated, "I don't know how I'll handle it, if there are." Estelle reached over and touched the back of his hand. Ben threw the truck in reverse and lurched back, out

of the parking lot. With one palm flat on the steering wheel, he turned and looked over his shoulder as he smoothly executed a three-point turn and then wheeled up the road to the freeway. Ben was driving on autopilot.

"I've always loved it when guys do that." Estelle commented.

"What?" He was interrupted from his thoughts.

"You know, when guys palm the wheel and roll with it, to steer through a turn."

Ben looked at her strangely. "Yeah, Guylaine did, too. I don't get it. What's the big deal?"

Estelle tipped her head back and to the side. "It looks strong, confident. Guys in the city don't do it so much, but if you handle a tractor or a truck, it seems natural."

Ben laughed. "In Toronto, Guylaine has a sculpture of it. Personally, I never gave it much thought." He shook his head, "Must be a *chick* thing."

"Girls never flat-palm, they grip the wheel."

"I dunno, never really noticed. But, it's true, women seem to notice."

"Can I ask you questions while you're driving?"

"Sure, I thought you might." Ben reached up and flipped the visor down against the early morning sun.

"If I get too personal, or you feel uncomfortable about something, just say so."

"Sure."

She hesitated, "I can be pretty pushy. I'm used to interviewing, but not so soon after a loss." Ben nodded and ran his hand through his hair. They drove a while, and then took the ramp onto the freeway to Toronto. Estelle cleared her throat, "Did Guylaine do *all* the decorating here in Oakville?"

"Pretty much. There are some paintings in the living room we collaborated on—the nudes and the abstract piece below the guest stairs."

"How about the religious stuff?"

"That's all Guylaine. My last name's Levin. Why?"

"I was noticing the arrangement in the office, and then the breakfast nook. I don't get the feeling that the choices were casual, but I don't understand why she made *those*."

"Nothing was ever casual for Guylaine. She lived in a world that always resonated with symbolism. Everything had almost magical significance. What was it that struck you?"

"Upstairs, in the office, she has a collection of ivory crucifixes."

"Yeah, they're Dieppe ivory carvings. She loved them. She'd pick a few up every time we went to France."

"So, what's the *magical* significance?"

"In the 17^{th} to 19^{th} centuries there were guilds of carvers in Dieppe. Traders brought the ivory back from Africa, and those guys spent their lives carving those little Christ figures. They were perfect and each one was a little different. They're incredible. Did you notice how detailed the crowns of thorns are?"

Estelle shifted her weight so she was leaning back, against the door. That way, she could see Ben better and it kept the sun out of her eyes. "They *are* gorgeous. And, the expressions on the faces are truly amazing."

"Guylaine thought their faces reflected a range of attitudes about Christianity. Some of them have faces twisted in pain, some look asleep or even dead. Her favorites are the ones with their eyes open and their faces serene. Anything else, she felt, missed the whole point of the religion."

"In what way? I mean, that's a lot of significance for a little, ivory carving."

"Guylaine took those crucifixes seriously. Essentially, those carvers were her forebears. They created the images of faith, just as she did with her primary clientele. She felt it was a heavy responsibility and, obviously, the Dieppe carvers did, too."

"Sure, but what did she mean by *missing* the point of the religion."

"Guylaine liked the serene faces because she felt the point of Christianity was transcendence. Christ, on the cross, having suffered the pain and indignity, found forgiveness. Even before he died, there was peace. While the pain-tortured faces may be an artistic challenge, she felt they put the emphasis of faith on suffering. To her, that undermined Christ's role and the whole purpose of the New Testament."

"So why'd she buy *them*, the suffering ones?"

Ben shrugged, "Professional courtesy. Recognition of the art of it. Recognition of the differences of opinion, about faith. She thought too many Catholics, and Christians in general, put too much stock in suffering. If that was the whole point, why bother? The Old Testament is full of suffering." He grinned, "The Old Testament, that's *my* department."

"But, why so many of them?"

Ben sighed, "At first she was entranced by the variety of styles and the intricacies. Then she began to focus on the faces. She kept collecting them because there was something in them that she wanted to understand. These were not specifically *church* art. They were sold to the wealthy and to the emerging, merchant class. They reflected the consensus view of the day—the meaning of the crucifixion. After awhile Guylaine even thought that religion made a mistake about that. She would have preferred that the Christian symbology had focused on the Ascension. That was the real promise of Christ. She eventually stopped buying them. She had enough to contemplate. She felt they reflected an artistic commitment to excellence, to beauty. Even the tiniest among them was exquisitely rendered. She used them as an inspiration to always keep the purpose in mind. But, she warned herself that too much, even of a good thing, will undermine the message, and after eleven of them, you stop seeing the details. They become a cluster. For a sculptor there's a message in that, too.

"But, how does that explain the collection downstairs, in the breakfast nook?"

Ben laughed. "Now that really *was* a warning—one she couldn't get through breakfast without seeing. It's the *attack of schlock*. Catholic kitsch. The warning against lowering herself to the sentimental and cheap. When more that half of what you do is religious art, you need to be vigilant that you never phone-it-in. She had the breakfast nook to keep her honest. She laughed every time she saw those things. She never wanted to make that kind of stuff."

Estelle smiled. "Was everything so... so thought out?"

"With Guylaine, it always was. She was a mystic. She was not a conventional Catholic, but she did see what she called *the grace of God* in most everything. Like the Renaissance artists, she was forever inserting hidden meanings in everything. It was like

living in a secret code. It might even have been a compulsion. Whenever she could, she'd try to insert her version of a transcendent Christ into commissioned art. Sometimes, though, the client *insisted* on the suffering, and Guylaine would acquiesce."

"What other kinds of work did she do?"

"Portraits, grave-stone pieces, public art, personal pieces, you name it."

"I've seen some pretty risqué and sensuous pieces. How did that square with her religious beliefs?"

Ben grinned widely, "*That* never posed a conflict. She had a healthy view of God's gifts and thought we were put here to enjoy them, fully. Guylaine was no prude. She wasn't conventional in *any* way. She was spiritually observant, but not dogmatically religious. She truly understood the tug of mysticism and felt Catholics had lost their way—buffeted between symbolic beliefs and modernity. They failed to make the jump to a mystic interpretation and became mired-down with the fundamentalists. All of the organized religions had lost their connections with ecstasy and joy. Still, the churches supported Guylaine's work. Because of the sensitivities of her primary patrons, she didn't flaunt her more *ribald* pieces. But, of course, she still did them."

"What do you think was the most *risqué* sculpture she ever did?"

Ben leaned into the back of his seat, thinking. "I think the fountain."

"Is this a public fountain?"

"Oh, no. A wealthy older patron came to her with a request for a fountain. He wanted it to be sexual, but not necessarily explicit. Guylaine drew the line at pornography—but it was a wiggly line. This guy had seen her *pleasure forms* and wanted something more graphic for an outdoor, garden environment…"

Estelle interrupted, "Pleasure forms?"

"Yeah," Ben back pedaled, "Guylaine did a series of abstract forms. She got the idea from some of Georg Jensen's early, plant broaches, they were of plants but they had a sensuous, sexual feel to them. Guylaine wanted to recreate that feeling in a larger sculptural form, but to pull back from recognizable flora or fauna forms. They were mostly marble, a few in onyx, each a little larger than a breadbox. They were seductively rounded, sometimes

joining forms. Nothing in them was specifically objective so you had trouble relating to what you were actually seeing, but they were still arousing. I'm sorry we didn't keep any of them. They were beautiful."

He laughed, "Hélène thought they had a *spell* on them. She wouldn't let her boys near them. I have to admit, they really were arousing." Ben checked his rear mirror, and then changed lanes. "Our joke was that the test for a *pleasure form* was to bring the completed piece into the house for a critique. If the appraisal didn't lead to sex, it failed as an acceptable part of the series. She started doing them during a particularly busy period of religious work. Guylaine thought she was losing herself in that, so she created the *pleasure* series as a counterbalance. She made them for several years."

"Wow, I'd love to see one. What happened with the fountain?"

"Okay, so this guy wants a bacchanalian fountain but not anything with overt sexual contact. He says he wants sensual, not sexual. After a lot of discussion, and a site visit, Guylaine did a small model that looked like a large, chip-and-dip bowl. The center was a traditional fountain spray, from within a higher, center portion that was a rocky embankment, encircled with four or five male figures sprawled on the rocks. Several of them were fully erect and, um, part of the fountain's spray mechanism. Below, all around the circle was a shallow pool area with curvy, female figures lounging in the water and entwined with one another. It was breathtaking, but even without any physical contact, *very* sexual. The women and men were in contact by the line of their gaze. It was bold, maybe even provocative. Even the patron was taken aback by it. He stalled and finally decided he was too uncomfortable with its boldness. It's a shame, because it would have been a tremendous piece. They discussed it repeatedly and he admitted that she'd done exactly as he'd requested, but he wasn't as brazen as he wanted to believe. So, finally, Guylaine suggested a change. While he was sitting there, she attacked the mock up, pushing and pulling the Plasticine averting the women's gazes. She made them demure. She never said a word, just showed him. Now, it wasn't overtly sexual, but a little voyeuristic. He liked it, but it still wasn't quite what he'd wanted in his garden.

They talked for a few more weeks and she came up with a solution. Without altering the basic design, she converted the men to satyrs and some of the women to mermaids. They were just as sexual, but with their new goat-and-fish-mix bodies, it was no longer personal, more pastoral. He loved it. Now, with the species difference, he was comfortable with more sexuality and wanted the female figures less demure. He wanted a suggestion of the breaking-down of the distance between the male and female figures. What she did was brilliant. It took it *way* beyond sex and anchored it in sexuality and ambiguity. She gave two of the satyrs nets. One was seated, his net hanging over the edge of the rock face, peering down below. The other was leaning back against the rock face, straining, hauling in his catch, a startled mermaid struggling against the confinement of his net. The only crossing of the distance is by the nets. The net presses deep into the captured mermaid's flesh, her breast. Her eyes are wide, her mouth open. Her fingers entwined in the net, but it's not clear whether her reaction is fear or anticipation, if she struggles with, or against, the net. She made one of the remaining women sitting up, observing the capture of the mermaid. Her lips are parted and she watches in rapt interest, but no fear or engagement. Just behind her, the other satyr's net is suggestively spilling over the edge. That's how it ended up. The finished fountain is amazing, an incredible technical achievement and just stunning. It's a monument to modern plumbing too, since she made every fountain outlet adjustable. He can decide just how sexually outrageous he wants to be by increasing or decreasing the water flow. I hope there are photos of it, somewhere. The sales agreement was confidential—this gentleman wanted *his* fountain private. He absolutely loves it. He and his wife send Guylaine a Christmas card every year." Ben fell into silence. Along the highway, farmers' fields were giving way to light, industrial developments. "I always wanted to keep that fountain, more than any other piece she did."

"She had a sensual nature," Estelle mused. "I didn't really get that from *her*, just from the work."

"Yeah. But, if you got to know her, it was there. She was amazing. It colored the way she saw the world. You know, one of God's gifts."

"It's just that she came off as, well, almost *a*sexual."

"In an interview, maybe. Most of how our culture does sexual is window dressing, a meaningless dance. How women dress for instance. But, that's often a come on, not really sexuality. Guylaine didn't play that game, or even understand it. She was very reserved in her dress, almost to the point of appearing androgynous. That made sense, given what she did. Her day-to-day wear was jeans and T-shirts. She dressed like a workman, no frills, nothing dangling to get caught in the equipment. It was just practical. Underneath though, she always wore French or Scandinavian underwear, a lacy bra or camisole. She was practical, but next to her skin she was *all* woman. I thought it was sexier than no underwear at all. And, she didn't do it for me. It was just her, who she was. I got to enjoy it, and it was a reminder about judging outward appearances."

"Did anyone else notice?"

"I'm not sure what you mean. Did she go around showing her underwear? No. But, it was a more subtle distinction as to whether others were aware of how sensual, or in her body she was. I know from time to time she shocked Bill and Marc with her matter-of-fact sexuality. They're actually pretty conservative." Ben paused, "Once there was a disagreement in the shop over a female nude—Guylaine insisted on a firm nipple. You'd have thought she'd stripped naked on the shop floor—they were *so* shocked. But, she was the boss and that's the way it went down. To Guylaine, the human form was about communication. Her art is silent. Form has to communicate.

I never really thought about it this way, but it goes back to that language thing. Form, movement those were her first language. What's sensual to us is natural to her. We observe, but she imparts. Through her we see more. Maybe like you and I would think of punctuation."

"I guess that explains Hélène's Madonna."

"Exactly. The hubbub about it was all us. For Guylaine, it was just a beautiful, sensual rendition. She was giving her sister the best she could do. Once the fracas started, it surprised her, and she actually found it very funny. She was good at recognizing when the problem was her, and when it was someone else."

"What would Hélène have thought about the fountain?"

Ben rolled his eyes and snorted.

"You know, she'll find out now. It'll be in the book. Does it make you uncomfortable to reveal Guylaine this way?"

Ben sucked in his breath. "Well, I either share her or I don't. If something is too personal, I'll tell you. I'm not worried about Guylaine's *warts,* though. She wasn't."

"How was she in business?"

"What do you mean?"

"Well you've just revealed a story about the creative, even collaborative side of a particular sculpture and its commission. How did she work with clients otherwise? What about things like price negotiations?"

"Well, I wasn't often in on those things. I was there in the background, for the fountain, because she wanted back up. After all, it was an unusual exchange with sexual overtones. She wanted to be sure that she wasn't at risk in some way. In that case, there was no negotiation on the price. Once they decided on the design, she did some calculations—size, weight, the casting costs for each section and the plumbing issues. She gave him her price and that was it. I don't think he ever suggested anything different. That's how she worked. Her prices were pretty much in line with those in the rest of the art world. Given her name, and the size and caliber of the work, she'd just set a price and didn't dicker. Occasionally, a commission would be paid over time, but she never compromised on price, itself. I don't think it even occurred to her." He paused, "Early on Josette helped her on the business side and it served her well. After a while, she'd occasionally ask Josette for help drafting agreements, payment schedules and the like, but mostly Guylaine made a deal with a handshake."

"Cut and dried."

"Funny, given how rich the results were. But yeah, it's what she did."

Ben changed lanes and got off at the Spadina exit.

"Why did you live separately?"

"It just evolved that way. I bought my place before we got back together and Guylaine bought the studio in Oakville. There wasn't room in metropolitan Toronto for the kind of workspace Guylaine needed, and I couldn't bear the idea of commuting to the university." He grinned, "I love walking to work."

"Didn't it make you less… together?"

"I used to think so, but over the past few years it's felt right. We were both immersed in our work and needed private, recharge time." Ben drummed his fingers on the steering wheel as they made their way in fits and starts through traffic—the double parked produce trucks and swarms of pedestrians on Spadina. This section brought them through old Chinatown. "You know, it keeps it present. We never take the *us* part for granted. "

Estelle noticed Ben slipping into the present tense. It pained her. Guylaine's loss would be fresh and raw to him for a long time. Without expecting it, she hoped that Ben's recounting all this would help. She winced at the idea that she'd get the story either way.

"How much time was *together* time?"

"Usually more than half, depending on schedules, workload and such. We juggled—places, cars, and wardrobes but mostly it worked. The nice thing was, it wasn't my place or hers; it was Oakville or Toronto."

Ben made a series of quick turns through the one way maze of his Annex neighborhood, then down an alley where he pulled over and stopped. He got out, opened a garage door and climbed back into the truck. "You might want to get out here. It'll be easier." Estelle slid down out of the truck and waited by the gate. These older Toronto neighborhoods were all alike—she lived over in Parkdale with the same, semi-detached configuration with alley parking. Ben pulled into the small garage. In the big truck, it was a tight fit, and even as far as he could pull in to the right, his driver's door wouldn't open all the way. He managed to squeeze out and joined her at the gate, scratching his head, confused.

"What's wrong?"

"It's nothing, I just…" he shook his head, "I can't figure out where the Toyota is."

Estelle winced, "Maybe Crowsfoot?"

Ben's cringed. He leaned against the garage and caught his breath. Estelle wondered how many times he'd be hit with the then and now of it. "I'll be okay."

 Ben led the way, past a tidy garden, through the back door and into the kitchen. It was a small but elegant brick, semi-detached, Arts & Crafts era home. Estelle glanced up and smiled—it made perfect sense for Ben. The kitchen had been

redone, to period, cream colored walls and white cabinets topped with soapstone counters. Again Estelle chuckled to herself. She wondered how many revisions it had seen before the Arts & Crafts academic had restored it to its original, and now updated, glory.

"Can I get you anything?" Ben was now the host.

"Sure, I'd love a coffee, if it's not too much trouble."

Ben reached across the counter and flipped on a coffee grinder. He pulled a coffee carafe from the cupboard and measured the water.

Estelle said, "Your floor plan is essentially the same as my place. I'm sure I can find my way to the restroom. So, if you'll excuse me…"Estelle made her way towards the upstairs, stealing a peek at the house along the way. It was very similar to hers, except a little larger, with an office downstairs between the kitchen and living area. Ben's house still had the folding beveled glass doors between the living and dining rooms. As in her house, the staircase was on the common wall between the two attached units. The house had been completely renovated, emphasizing the original Art & Crafts features—the woodwork, the tall ceilings, and the multi-paned windows, all restored to retain the home's original character. On her way to the stairs, Estelle had to step over a pile of accumulated mail, spilling into the entry hall from the letter-drop in the front door. Once upstairs, she could see there were two bedrooms flanking the bathroom and a tiny, additional room, sparsely furnished with a sofa and small television. Becoming self-conscious of spying, she found the bathroom, and then hurried downstairs.

Ben looked up, grinning. "So?"

Caught, Estelle replied, "So…?"

"What do you think of the house? I know you're astute, and in the business of observation." He handed her a cup of coffee. "Want anything in that"

She blushed. "Black's fine, thanks. The house really is lovely. I can see where your expertise informed the remodel."

Ben bowed. "We really enjoyed doing it. It's a little more spare than Oakville but it's worked for me and it's a delightful pied-à-terre in Toronto."

Ben picked up his cup. "Come see the sculptures."

135

Estelle followed him to the living-room, where the coffee table sported one of Guylaine's, Nana sculptures—a small rose patina bronze. In this version, the apple peels spread wide at the base, but instead of busily peeling apples, this smiling Nana figure held her over-filled bowl, outstretched in an act of gentle generosity. Estelle sat down to examine the details—the caning in her upright chair, the gnarled but capable hands and how the folds in her housedress were echoed in the soft wrinkles in her face and neck. It was a loving portrait.

She sighed and ran her fingers across the bronze. "Amazing isn't it. She repeated the same theme endlessly, but every time she found something new to share."

Ben nodded. "Come to my office. I have another one that's totally different."

And it was. This Nana was mounted on the wall across from his desk, and was more abstract. Pared back to the sparest of details, it was elegant and simple. Details disappeared in the wide sweep of her dress, repeated in the arc of the bowl. Again, the apple peels spilled over, burying her feet, and then forming a sphere on which her chair rested, balanced to the size of the figure, shaping, in apple ribbons, the very tangle of a planet on which she existed. This Nana floated in the air, a thin bronze bar securing her peel-planet perch to the wall. Absent were some of the details— the fine wrinkles and folds, the arthritic knotted knuckles. Instead, her age was deftly suggested by the stoop of her shoulders, the frailty of her neck and the subtlest show of slack in her upper arm.

"Wow. This may be my favorite."

"It definitely *is* mine," Ben nodded. "Her grandmother died when she was still pretty young. Yet, she kept conjuring-up these images from memory for years afterwards."

"I think that you're right, that she had her own internal language of form, and that she kept these memories crisp, like a type of language, a story. She looked around his office. Like Guylaine's, it was small and neat, but his was a testament to written language. Bookshelves flanked the only window—chock full of tomes on art, history and technology. On the wall above Nana were four illuminated, framed pages of manuscripts. On the opposite side, a larger framed section of music notations. His desk was neat as well—stacked with textbooks and student papers. On

the wall behind his desk hung a large, colorful landscape, almost fauve, done in some kind of fabric layering. Estelle made a mental note to ask him about it. A computer occupied a small table at the end of the desk. An assortment of eyeglasses peppered the desk and table and a neat stack of correspondence stood at attention in a metal organizer. It was a man's room—Spartan in a refined way.

"I noticed there's a lot of mail piling up in the front entry." Estelle waved.

Ben stepped out of his office, Estelle in tow. "*Jesus*, look at all this." As he stooped to gather the tide of envelopes, Estelle noticed that he was distracted by something outside. Ben stood up, cradling a stack of mail in his arms, and put his forehead against the beveled glass of the front door. "Oh, my…"

Estelle stepped over to look. Outside, Ben's side of the double front porch was a sea of flowers—bouquets knee-deep and overflowing down the steps onto the walk, below. Some had obviously been there a while, the blooms wilted and curled. Others were fresh, an ongoing tribute to Guylaine's gift, and to Ben's loss.

He turned to her, his eyes brimming, "What do I do?"

"It's okay. Why don't you collect the mail, and I'll get the porch." Estelle stepped out into the crisp, November air and cleared a path to the walk. She found the trash bin and filled it with the older flowers, tucking the cards into her pocket when she found them. Then, she knocked on the door of the adjacent neighbor. An older woman answered. Estelle spoke first.

"Excuse me, my name is Estelle Dumas and I'm…"

"I *know* what you are and you ought to be ashamed."

"Pardon me?"

"You reporters, you're like vultures. He's not home. That poor man is suffering. Why don't you *all* just leave him be!"

"But… you don't understand." Estelle was flummoxed, "I'm here with Ben, helping him out. I just wanted to know if you could possibly take some of these flowers."

The neighbor stepped back, "Oh, excuse me. I'm so sorry," she stepped out onto her side of the porch. "You're *with* Ben?"

"Yes, I am." Estelle extended some flowers.

"How *is* Ben?"

Now, Estelle was caught without words. She glanced down at the porch. "The flowers, they kinda got to him."

"*Oh damn.* We should've done something about them. I didn't even think of it. Hello, I'm Anna," she extended her hand. Estelle juggled the outstretched flowers and shook Anna's hand. The neighbor set to picking up flowers.

"I hate to see them go to waste," Estelle lamented. Anna stopped, held up a finger and disappeared inside. She came out a few moments later with a large bucket of water.

"We'll save the best, *eh*? I'll find homes for them. I'll save any cards I find, but most of these are just from regular folks, no connection to Ben or Guylaine. Just people, sharing the loss. I've been talking to some of them as they drop by." She nodded at the bucket," I'm sure the church would take them." They stuffed the remaining bouquets into the bucket. "Is there anything else we can do, for Ben?"

"Just keep an eye on the place."

"We have been. There've been some unsavory types trying to peek in the windows. I went in and pulled the curtains." She glanced up at Estelle, "You see, I have a key."

"Thank you, so much."

"Where is Ben?"

Estelle stepped back and opened the door, "Why don't you come on in. I'm sure he'd love to see a friendly face."

Anna stepped by her and stuck her head in the door. "*Ben?*" They heard his voice answering from the office. Estelle followed Anna inside.

They found him wrestling with a mound of mail on the desk. Anna strode across the room and wrapped him in a long hug.

When they separated, Anna took charge. "Don't you worry about this stuff, Ben. Estelle says we can clear away the blooms, and I'll come in each day to sort the mail. You know, cards in one pile, bills in another, just so's it's a little more manageable when you get to it. A lot of this, I can toss." she pulled out a piece of junk mail and threw it in the wastebasket.

Ben sunk into his chair. "Would you save the newspapers?"

She put her hand on his, "Of course. Don't worry about a thing. We're here if you need us."

"Can you tell McGuire I'll call in a couple days?"

138

"Sure." Anna looked at Estelle, "We're in the same department at the University," then back to Ben, "Jerry's been covering your classes. McGuire's not making any fuss."

Ben reached into the file drawer of his desk, removed three files, which he handed to Anna. "They're supplemental materials. Would you give them to Jerry? He'll get it." She nodded and tucked the files under her arm. Anna quickly brought him up to speed about Departmental developments.

Estelle stood back, observing. She'd made a typical, journalist's error—she'd seen only one side of the coin. Based on the enormity of Ben's grief, she'd put him in Guylaine's shadow. She'd missed the obvious cues that Ben was more than what she'd seen in Red Wing; how he'd taken charge in Oakville, how Guylaine's friends turned to him in their grief. Everything she knew about Guylaine should have screamed to her that Ben was no *houseboy*. Guylaine would have had nothing less than a full partner—one with his own interests, his own life. Ben was mourning but he wasn't broken. Here he was, still grieving, but connected to a neighbor, a member of the academic community, a whole man. Estelle reminded herself to always push beyond the surface.

Anna turned back to Estelle, "I apologize for my reaction, earlier. I admit to a dim view of the Press. They've turned this tragedy into a circus."

Estelle rolled her eyes, "My profession has good cause for self-examination. And, they call *lawyers* sharks! I'll confess, I've missed most of the circus because I've been with the family in Red Wing."

"Don't worry, Anna," Ben grinned, "I'm in good hands. This woman is half writer, half therapist."

Anna smiled broadly, "Then, welcome to the family." Then, quietly, "Ben, I got a call from Rosemary, have you talked to her?"

Ben winced. "No, that's one of the many balls I've dropped. How is she?"

"Not great. She could really use a call."

"I'll call her, if not from Oakville, then tomorrow from Red Wing. Could you let her know?"

"I'm on it."

Ben stood up and embraced Anna. "I'll be home soon. Thank you, and thanks to Julie, too."

From within the folds of his arms Anna murmured, "Get well and come home. You're missed." Ben kissed the top of her head. She turned to Estelle, just a little teary, "You take good care of him, for us."

"Me, and the rest of the crew." Estelle nodded her head. She knew she couldn't take credit for any of this. It was an ensemble effort.

After Anna left, Ben asked, "Did you see the sculpture in the stairwell?"

Estelle shook her head—she'd missed it.

"Check it out while I grab some clothes."

They headed upstairs and, for the first time, Estelle noticed the sculpture mounted on the common wall above the stairs, in the front hall area towards the windows. It took some looking to discern the point of the piece. Initially, the viewer was greeted with the door to a red pickup and, in bronze, a man's left arm rested, casually extended along the frame of the open window, a cigarette nestled between the index and second fingers. Peering through the open driver's window, a large masculine right hand— rugged and veined with strong thick fingers, flat palms the steering wheel, turning it far to the left. The only parts of the image conveyed are the arms, hands, vehicle door and steering wheel, with just enough suggestion of the dashboard to hold the thing together, yet the power and control of it convey its meaning. The piece resonated with deep images of confident, masculine power. Estelle laughed out loud.

Ben came out of the bedroom, duffel-bag in hand. "You like it?"

"I *love* it!"

"So did Guylaine. I don't get it, but women do, so it must speak some larger gender truth." He shrugged. Ben pulled on his jacket.

Estelle laughed again, "I'm not even sure if I could tell you what I love about it, but I do. It's… so, guy." She thought back to the foundry's parking lot, earlier that day—Ben's effortless, three-point turn.

140

He nodded, enjoying her reaction. He slung the duffel over his shoulder and shoved his other hand into his jacket pocket. Ben's face fell, his shoulders slumped. Estelle cocked her head, wondering what had just happened. Then, Ben pulled a micro-cassette out of his pocket. Estelle bit her bottom lip.

"I've got to listen to this."

She nodded, "Did you want some privacy?"

Ben held the tape in his palm, flipping it over. "Naw, I could use the support and, if there's anything important on it, *police-wise*, maybe it'd be good if you were there."

They walked back down to the office. Ben dropped his duffel at the door and pulled up the desk chair. Estelle took a seat on the edge of the desk, watching. Ben shifted some papers on the computer table, revealing an answering machine, its own red light flashing with a matching, red, digital number, *39*.

"Wow, I didn't even think about messages." He looked at the cassette in his hand and then at the machine, flashing with its own load of contacts, before flipping the lid on the machine and exchanging the cassette in his hand for the one in the machine. He punched a series of buttons, and the recording started with the telltale *beep*. The first few messages were mundane—suppliers regarding orders; Cathy's voice reporting she'd be a few minutes late for work; a call from Rosemary about an idea for a trip to New York before Christmas. Ben advanced to each successive message without deleting the old ones. Then there were a series of messages with multiple clicks, but no voice. After the next beep, it was Ben's voice, "*Hey babe, we still on for Friday? Do I need to bring anything?*" Ben pushed the *pause* button. He turned to Estelle, shaking his head, "I can't even remember what the event was." Grimly, he turned back to the machine. There was a message from Françoise—silly stuff that made them both smile. The machine beeped again, to a man's voice, "*So Guylaine, been a while, eh? My guess is you've been following what's up here at Crowsfoot. Maybe you figured out it's me. It's that old debate of ours, whether we make change by taking charge or, like your grandma, by sucking-up. You know how I feel. Look what it got her. You didn't put that in the damn statue. You've gone and made her into some kinda hero. There's more story to be told here, and I'm telling it. You and your little Cultural Center put a pretty face*

on an ugly past. We're gonna show Canada how ugly. We're gonna show the world how ugly. Too bad we didn't connect on this trip, eh?"

"It's him." Ben's voice was certain.

"Labute? Paul Labute?" Estelle wondered how he knew.

"Yeah. I've heard his voice in interviews."

"Did *she* ever hear this?"

Ben was staring at the machine, "No, these were new messages." His hands were shaking. "It sounds like he's goading her."

"Well, it sure doesn't sound friendly. What does he mean about *her grandmother*?"

"I'm not sure."

"What happened to Claire?"

"I don't know. Guylaine never would talk about it."

"Do you know why?"

"She went out west, to search out her family history, and didn't come back. She had hooked up with him, somehow. When we finally got back together, it was sensitive territory so I didn't push it." He rubbed his hands together and blew on them, as though to warm them. "Père Michel knows about it."

"What makes you think that?"

"Something about the *nature of the confessional*. They'd intimated about it. Guylaine didn't want her mother to know."

"Are there any more messages?"

Ben pushed the play button. Two more messages—Rosemary again and a hang up.

"That's it?"

Ben dropped his head, "Yeah. The calls stop, when you're dead."

She put her hand on his shoulder. "I'm sorry, Ben."

He opened the machine and extracted the tape cassette. "What do you think; is it evidence?"

"If it was his gun that killed her, it is. I'd turn it over to the police."

"Then, he wins. He gets the story told, *his* way. Guylaine is dead and he blows the lid off of whatever the family history is." He hissed, "She may have died to protect that secret."

142

Softly, Estelle responded, "The alternative is, maybe *you* let him get away with murder."

Teeth clenched, Ben shoved the tape back into his pocket. He put the original cassette back into the machine. "Do you mind if I fly through these?"

"Not a bit." Estelle got up from her perch on the desk and settled back into one of his guest chairs. Her heart ached as she watched Ben hunched over the machine. His was caught between his loyalty to Guylaine, her family and wanting Paul Labute to pay. Estelle hoped, for Ben, that the facts rolled out in a way that he'd never have to make that choice.

The messages started out routine—students seeking office hours; Anna asking if he could watch the cat. There were a series of clicks—hang ups with no message. Then, there was Guylaine's voice. It was electrifying. Both of them sat up. Ben's hand reached out to touch the machine.

"*Ben, I haven't been able to reach you. Your machine at work is full. Call me. I have to leave soon.*"

Followed by the *beep* and then, "*Call me, please.*"

Ben held his head in his hands as seven brief messages from his lover washed over him. Between each he pushed the *pause* button and sighed. This was all he had left. Estelle could see him both recoil and then pull closer to the answering machine, each message a connection, another lost opportunity, each an internal rebuke at not being there for her call.

Then a *beep* and, "*Hey babe, I can't reach you. I'm headed to Crowsfoot. I need you to know, before I go, that this is not about Paul. We were nothing. We were just anger. This is about my grandmother,*" her voice faltered, "*My mother, my family. I put them out there. I made my Grandma Claire a symbol and I need to support and explain that. I can't let him make them dirty.*" There was a pause in the message, and then haltingly, "*I can only do this because of you. You—us, it's my strength. You must know that you are my center. Nothing comes between us. I love you. I'll do this, and then it's us. However you want us to be—Always has been. I never told him about music.*"

Ben sobbed, his head resting on his arms. The sound was agonizing. Estelle did not know what to do, where to go with the pain of it. She sat, frozen, in her professional, journalist's silence.

143

Tears ran down her cheeks. She wanted to ask—there was more there, but she was no shark. The afternoon light was beginning to pale. She sat, immobilized, not wanting even her breathing to intrude. Estelle studied the wild landscape above Ben's desk. It was an autumn lake view, through pale, shining birches to the water and through to the opposite forested shore, whites, golds, the occasional flash of green with brick red earth against the lake's deep blue and echoes of the near palette across the lake. It was stunning, and at the same time, calming. But, for the life of her, Estelle could not tell what the medium was. It was framed behind glass. She wanted to get closer to inspect, but couldn't move, couldn't shatter that crystalline moment of Ben's grieving. This was what they'd come for.

Ben raised his head. He wiped his eyes with his palms, pressing his face back into control. Without speaking he turned again to the message machine. Now the messages between *beeps* were short; Josette looking for him; Père Michel; Anna, again. Stricken voices, reaching out to bond, in shock and loss. Ben paused between each one until he stopped.

"These can wait." He turned to Estelle but his eyes did not meet hers. "We need to get back to Oakville—to load before we lose the light. She nodded and, wordlessly, they rose. Estelle picked up the coffee cups and carried them to the kitchen sink. Ben grabbed his duffel and led the way out the back to the truck.

They were in Mississauga before he spoke. "I'm alright."

Estelle nodded.

"Really, you can talk now."

"And when I figure out what to say, I will." She shrugged. "I'm hungry."

Ben laughed.

"Can we stop and grab some chocolate."

"Chocolate, *again*?"

"It's just that it's fast."

Ben pulled off the Gardiner Expressway, at the next exit, directly into a service station. Estelle hopped out and turned, "What do you want?"

"Get me a *Coffee Crisp*. And, maybe some licorice."

"Black or red?"

"Black. Red's *not* licorice."

When she came back with her stash, Ben had a squeegee in hand, and was cleaning the windshield. Estelle leaned against the truck and peeled open an *Oh Henry* bar. Ben's long reach peeled the rubber blade against the glass, each pass a ribbon of clean, in turn. He finished and dropped the squeegee into its bucket of soapy water. Estelle held out the bag.

Ben took it and peered in. "*Jesus.* How much chocolate do you need?" He reached in and fished out his *Coffee Crisp.* Tearing open the golden wrapper, he leaned back against the truck next to Estelle. "Thanks."

"It's nothing. There's your licorice in there, too."

"Not that. I meant thanks, for back there." He bit into the bar.

Estelle finished chewing and swallowed. "Can I ask questions, now?"

Ben smiled, "Can I stop you?"

She laughed. "*Touché!* You know I have to ask. What did she mean, *about music?*"

Ben blew out between pursed lips. He looked out over the highway. Traffic was thin. He feigned interest in the cars and trucks speeding by. "Okay, but this is really personal. It's not for publication."

"Fair enough."

"When Guylaine and I first hooked up back at Windsor, it was awkward. There was the faculty/student thing, so we were discreet. We had real interest, real chemistry. We liked each other, but... no common language. I felt like I got more of *her* from looking at her work. She liked to listen to me talk, but that was too one-way. Sex was good, you know, fun, but not fully connected. I didn't know how to bridge the gap.

"She had one of those little, graduate-student, office cubes and sometimes I'd visit her between classes. One day she was working with the door closed, so I knocked. She came to the door, face flushed, you know the look, flushed with passion. I was jealous. I pushed right past her into her workspace, to see who was in there. But, she was alone, working on a pieta and wearing headphones. It took me aback. I wanted *that* passion. But, I'd only seen it in her in work. It made me crazy. Guylaine had a reputation for working with music. She drove her classmates nuts with it. I got to thinking, and decided to experiment. Guylaine had a ton of

music, all kinds. I secretly went through it and picked albums that had a sexual feel to them. The next time she came to my place, I was ready. I stacked up my turntable with the selected tunes and turned up the volume. We were supposed to be cooking dinner together but we never got that far." He was shaking his head with the memory of it.

"What? You seduced her, with music?" Estelle snorted. She took the bag back and rummaged through it for more chocolate.

"It's not so simple. It opened the door to a different kind of connection. We were already a couple but *this*... wow! It was incredible. She knew it, too. She figured out that *I'd* figured it out, and laughed. But still, there it was. We never lost it." Ben fell silent, but it was a happy reminiscence.

"So, the message?"

Ben squinted, into the sunlight. "It told me it was *ours*. Ours alone." He pushed away from the truck and tossed the wrapper into the trash. Estelle, taking the cue, climbed back into the truck. Ben walked around to the driver's side and opened his door.

Estelle didn't wait for him to get in, "But with that, how does that explain *him*?"

He stopped, "It's always plagued me, but I think she said it— it was about anger. That's something we need to ask Père Michel, about." He slid into the driver's seat and put the key in the ignition. "Remember, that's not for the book." Estelle nodded. "Hand me some of that licorice."

They pulled out of the service station and back onto the expressway.

The gate was open when they pulled up to the foundry. Ben parked just as Josette and Bill came out of the shop. There were several sculptures on the grass, waiting.

"Ben, could you call Père Michel? He's at my parents." Ben stepped into the shop, lifted the receiver from the phone on the wall and dialed the Maisonneuve home. Estelle had trailed in behind him and was listening. She couldn't catch much because Père Michel was doing most of the talking. Ben wrote down a number and, after hanging up, made a second call. Now, she couldn't hear what was said, over the conversation going on between Cathy and Josette. When Ben hung up, he turned back to the group.

"Let's load up, everybody. We're headed to Red Wing. We've got a funeral to attend."

Bill looked up. "So you need us, too?"

"Yeah, tomorrow would be good. We need you to load up and bring the headstone materials. What's the installation time?

"Cement needs to set. So, at least a day, day and a half."

Ben nodded. "Okay, so that's the timing. We want to move it along quickly, for Françoise and Guillaume, and also to stay one-step ahead of the Press. Cathy, can you come down tomorrow, too? We're going to put a group to work, making calls."

Cathy nodded, "I'll bring the Rolodex."

Ben stepped out, onto the lawn in the fading, afternoon light. Josette joined him.

"So, what did you pick?" He asked.

She smiled, "What you see here, and more. But, this is all the truck will take."

Bill and Mark had already loaded Josette's portrait and were tying it down. Ben surveyed the pieces still on the lawn.

"Nice choices."

There were three smaller bronzes. The first was a low ring of children's feet—mostly barefoot, of various sizes, but two in flip-flops and one in Keds. A single, child's hand reached into the ring, touching a foot with the tips of the fingers.

"*Eenie Meenie*," Ben laughed. "This is a fun one. Who gets this?"

"Hélène. It's the only one we could find that we thought she'd like, *and* that wouldn't be wasted on her."

"Nice choice. And, this?" his foot nudged an odd sculpture of a bronze emu. The bird stood almost thirty inches tall. Its feet were poised, almost in a ballet pose, its head elegantly tipped back and its shining, black eyes, half lidded. It wore a rough, little sweater, knitted of linen twine, with holes for the emu's wing-buds and tied at the neck with pink ribbon.

"That one's for me." Josette beamed. "I love it."

"You know it's a spoof on Degas' *Dancer*?"

"Yeah, Cathy told me, that's why it'd have been wasted on Hélène. So it's *all* mine."

Ben grinned, ear-to-ear.

147

"So, who gets this one?" He pointed to a sculpture that was a seated, half-life of a Native American woman, in traditional garb. She was barefoot and one hand held a pair of moccasins, on a string, over her shoulder—the bottoms of the moccasins were worn completely through. With the other hand, she was shielding her face. The side she shielded was badly scarred, but the other side was stunningly beautiful.

"That's for my folks." Josette answered.

"Do you know who that is?"

They all shook their heads.

Ben explained, "She's *Saint Kateri*, the only sainted Native American. Guylaine loved this one because of her story. She was ostracized by her tribe for becoming a Christian. She'd survived smallpox, but bore its terrible scars. Her people rightly blamed the Christians for the spread of the disease and the decimation of the tribe. Needless to say, Kateri's conversion was unwelcome. To save herself, she walked hundreds of miles to find a community of converted Indians. There, she served faithfully, helping everyone. Her miracle was that, on her deathbed, all of her scars vanished. In God's eyes, she was beautiful. Guylaine did the sculpture for herself. There was no commission. She just loved the story."

Josette gasped. "That would be perfect for my mom. It's like Claire."

"Actually, all these pieces Guylaine did for herself. You couldn't have made better choices. I hope they'll all fit." Ben was beaming. Marc and Bill were loading the third piece. Bill nodded to Ben that there was room.

"Okay, Ladies, gather your things, we're off to Red Wing."

The drive was uneventful, but pleasant. Josette recounted the stories of the sculptures and her day with Cathy. For dinner on the road, they ate more chocolate, shocked and delighted at being so irresponsible. As evening fell, the riders grew quiet. By the time it was fully dark, Josette was snoozing, her body leaning against the door. Estelle took the opportunity for more questions.

"Did she have steady work?"

Ben nodded, "Always. Remember, Guylaine had a viable sculpture business before I met her. Over the years some of the religious commissions slowed down. The seventies and eighties were not booming times for the Catholics, but the other work

picked up. Guylaine wasn't rich, but she was more than comfortable and that says a lot for a female sculptor."

Estelle laughed, "Define rich."

"I don't know. But, Guylaine bought the Oakville cannery and converted it on her own. Later, we combined resources and she never came up short. We lived well; we traveled. There was never anything material wanting."

Estelle sat quietly reflecting. She didn't want to push too hard and there'd been a great many personal revelations on this ride. She adjusted her scarf and kicked off her shoes. Pulling her feet up, she tucked them under her.

Estelle studied Ben's face in the dim, evening light. The strain of this week was showing on his face.

"Life couldn't have been perfect. What was *wanting*?"

Ben looked stricken. "Not much." Then softly, he added, "And so much." He shuddered.

"Were you *un*happy together?"

Ben turned to her, "Not at all. It's just I wanted marriage. I wanted everything. We were perfect together. Guylaine had a lot of fears. She'd long since rejected a traditional relationship because she didn't think she could deliver in the role of a conventional wife. I was happy but *I* wanted more."

"What more is there?"

"Acceptance. Maybe children. It was selfish. I knew her reasons and mostly I accepted them. She was afraid to have kids, afraid that her style, her lapses would not support them. Afraid that... they'd be like her."

Estelle didn't understand. "What would be wrong with that?"

Ben smiled, but it was bittersweet. "In a perfect world Guylaine's language deficits would have been recognized early, and she'd have had special instruction. As it was, she grew up different in a farm community. There are still folks in Red Wing who are astounded at her success. They had thought of her as a retarded child. She was never stupid, just not book smart. But, she compensated. She was always loving and sensitive. She was always loved. But, outside of her field, she still had a lot of insecurities." Tears ran down his cheeks, "She loved kids, but thought they would interfere with her work. She was afraid that she wouldn't be able to relate as a mother. So, she wouldn't marry

me because she assumed that the marriage package included children. Just marriage would have been enough, for me."

"Does it matter, now?"

"Yeah. It shouldn't, but it does."

"I don't see her family treating you any differently then if you *had* been married."

Ben paused, "No. There's no real difference. I am family. Unfortunately I wasn't sure of that until… this happened."

"Which brings up another issue—should *you* be giving away her sculptures? What should really be happening here, with her estate?"

"I know what her Will says. Everything is left to me. And, I'm more than happy to share some of these works with Guylaine's family. I think this all went very well, *even* Hélène will like her sculpture."

"What were the phone calls, just before we left Oakville?"

"Père Michel has been negotiating with the Mounties. They're concerned about liability if it turns out Guylaine was killed by *friendly fire*. Essentially, they've been holding her remains hostage, concerned that the family would want another autopsy. They agreed to release her *if* we'll waive all rights to sue. The Maisonneuves don't have any interest in litigation, and neither do I. There'll be papers to sign but now, with my okay, they've released her."

"Can they do that? It's just plain wrong."

"I know. But now, it doesn't really matter. We need her home."

150

Chapter 22

Ben stepped into the kitchen, just as things were getting ugly. He poured himself a cup of coffee and slid into the seat next to Estelle, in time to watch Hélène ramp-up to *full* tantrum.

"You *can't* do that. She's been practicing all week!"

"Excuse me, young lady," Guillaume bristled, "I'm in charge of this, and *I'll* pick the singer who's best for it."

"Oh, now that you've got some *fancy* idea about recording this, you want to cut her out, after dangling *that* possibility. You've used her, and now, I'm sure *I'll* get stuck picking up the pieces."

Father Tony, who was sitting next to Guillaume, looked uncomfortable.

Françoise tried to intercede, "Hélène, it's a difficult piece and your friend was struggling with it. It's just the *one* piece, after all."

"Go ahead, defend him. You *always* do." Hélène was flushed and indignant. "You both know that *that* song is the highlight of the program. Besides, what have you got, a day? How are you going to find anyone else?"

"I have someone else in mind." Guillaume was resolute, "This *isn't* a debate."

Hélène looked like he'd just slapped her. She looked from face to face. "Why bother to include me, at all? Go ahead. Bring in total strangers and outsiders."

Françoise was quick to counter, "Rosemary is hardly a stranger."

Now, Hélène lost it, "*Rosemary!* Rosemary's singing? The fucking *laundry queen!*" She quickly glanced at Ben, but her gaze settled on Estelle. "And what are *you* looking at?"

Ben shuddered. Françoise and Guillaume couldn't have known about Hélène's loathing for Rosemary. Something clicked in Ben's mind—*Hélène had an audience.* It explained why this conversation was even happening in English. Everyday chat between his in-laws was usually in French. Ben had always appreciated how the family made the adjustment in his presence, but he hadn't been there at the beginning of *this* fracas. Now that it

had gone so badly, Hélène was slowly realizing she wasn't playing so well to the Press. *Maximum drama.*

Guillaume stood up and said, firmly, "That's *quite* enough, Hélène. Rosemary is your sister's best friend and has been for years. She belongs. She's singing. That's it!"

Hélène grabbed her sweater from the table, "Rosemary belongs but *I* don't. My friends don't. This is *some* family!" She launched herself from the table and stomped down the back stairs, slamming the door behind her.

Silence reigned. Guillaume picked up the coffee pot and refilled his cup. Pot in hand he turned to the group, "Coffee?"

Ben felt the table shaking next to him. He looked around. Estelle covered her face, trying to suppress her giggle. Finally she blurted out, "There's one in every family, isn't there?"

Estelle was just the first ripple. Soon, Guillaume, then Ben, then Françoise were gripped with the silliness of it. The giggling had done its magic though and the tension was broken.

Only Father Tony remained straight-faced and incredulous, "I'm sorry, I don't get the joke. That girl is hurting. What's going on here?"

Françoise tried to explain, "She's always got some issue. Guylaine is dead and Hélène feels slighted because *her* friend won't be singing. Really, if it's not about her she's offended. She came in this morning with a bee in her bonnet because the boys were setting the footing for the headstone. Apparently *we* were supposed to have consulted with *Hélène*, as to the placement of the stone."

Tony nodded, but he didn't quite understand. "I hope her friend won't be too upset, she seemed fine with the substitution when we talked to her last night."

"It'll be fine." Guillaume shook his head. "The only one piqued is Hélène. And, she can't sing."

They collectively held their breath as they heard footsteps up the back porch. Josette poked her head in the door, "Okay, *now* what have we done?" Her voice was edged with tedium, but there was a mischievous glint in her eye.

Françoise reacted "Okay, what did she say?"

"She didn't say anything. But, she was driving like a bat-out-of-hell and almost hit me. I figured we must've done *something*."

"Your father told her we had a new soloist."

It took a moment for this to register with Josette, "Oh, shit! You didn't tell her *who* did you?"

Françoise and Guillaume exchanged puzzled glances. "Is there something we don't know about?"

Estelle jumped in, "Yeah, and why did she call Rosemary *the fucking laundry queen*? Excuse me, Father Tony."

Josette threw her head back and laughed. "She didn't! You notice she never pulls that crap around Roger or her boys. That's really rich."

"But, what does it mean?" Françoise really was confused.

Ben volunteered "It goes back a long way, between Hélène and Rosemary. Basically it comes down to the simple fact that Hélène is jealous." He felt relieved to finally get the truth out.

"Jealous of what?" Françoise asked. "Hélène has it all—a devoted husband; good family; great kids; nice home. What's the problem?"

Ben shrugged.

"Ben, you're being too kind." Josette explained, "It's not rocket science. Ever since Guylaine turned into the art *wunderkind*, Hélène has been jealous. Until she went away, Hélène didn't give a fig about Guylaine. That's not unusual. Little sisters *can* be a pain. But, when Guylaine was suddenly a talent, Hélène wanted in. But, they still didn't relate well. So, Hélène blames Guylaine—she's difficult, she's not verbal, whatever. Then, Guylaine goes to Windsor and snaps-up a great friend. Rosemary is funny, talented and, always, a great friend to Guylaine. Hélène, a little jealous, maybe? But the *big* rub came after Art School. Rosemary gets knocked-up and has to marry. Hélène, of course, looks down on her. A couple of kids later, she and the husband split. Now, Hélène really looks down on her. Then, Hélène has difficulty conceiving—jealous again. So, struggling to get back on her feet, Rosemary starts painting again, and does the lint-art thing. And, it's a big hit. Within a year, she's in high demand because Rose *is* really talented. Once again, Hélène is overshadowed. *Hélène* decorates farm houses. *Rosemary* is in galleries."

It was Estelle's turn to be puzzled, "Lint art?"

"Yeah, she does paintings with laundry lint." Josette was matter-of-fact about it.

Estelle turned to Ben, "The landscape, in your office?"

He nodded, "Yup, now you know the secret—felted laundry lint."

"It's beautiful. Whatever made her think to...?"

Josette answered, "She says it's the inevitable call of single parenthood."

Estelle broke into a wide smile, "Ah, the laundry queen!"

"That's *fucking* laundry queen to you, stranger." Josette laughed.

Ben added, "It gets a little weird when you wear new clothes. She offers to wash them for you. She's after your fresh lint."

The Maisonneuves and Father Tony sat incredulous. Ben looked over and they were slack-jawed at the rapid-response-team analysis.

Josette turned to her dad, "So, can she sing?"

"Like an angel." He paused, then, "It makes you weep." Father Tony nodded in agreement.

"I thought we'd get a little bit more of a honeymoon period out of the sculpture. Didn't Hélène like it?" Josette was looking at Ben.

"Don't ask me, I just got up."

Josette turned to Estelle.

"Don't ask me, I'm the journalist. It's not my place to be giving away sculptures."

"Nobody gave Hélène her sculpture?" Josette moaned.

Françoise intercepted, "Well, don't give it to her *now*. She can wait, as far as I'm concerned." Guillaume turned and looked at his wife, shocked at what she'd said.

"I don't want to reward bad behavior. She'll get it, but not just now." Françoise seemed steadfast.

Ben looked up, "Okay, just tell me when."

Françoise grinned and then the grin was quickly replaced by a scowl.

Ben caught it, "Françoise, what's that about?"

"I just realized. We we're supposed to work out the food today, Hélène and me."

"Food?" Ben was new at this.

154

"Typically, we would hold a gathering after the funeral." Françoise's shoulders slumped. Ben couldn't tell if it was from thinking about the work or from the idea of working with Hélène's difficult mood.

"How many?"

"Eh?"

"How many do you need to feed?"

"It's hard to say. We've never done a funeral for someone so... so renowned. And, she's a local. Gosh, maybe five or six-hundred."

"No problem, I'll have it catered." All eyes turned to Ben. "What?" He reacted to their reactions. "She's *my* wife, I can get it catered, if I want to." Eyebrows went up at the *wife* word.

The phone rang. Josette picked it up. After a few words, she hung up, and the catering discussion continued.

Ben was arguing his choice, "It should be simple. Beef stew—Guylaine's autumn favorite, and a vinaigrette slaw and pumpkin pie."

Françoise didn't look convinced. Guillaume looked thrilled.

"It's unconventional, but so was our daughter." He beamed at Ben. Turning to Josette, "Could we cater such a thing, in a day?"

Josette interrupted, "You'd best wait on that time-table. Sorry Ben, I almost forgot. The boys wanted to talk to you about the timing. Something to do with concrete. And that, on the phone, was Père Michel. Robert arrived and they'd like to see you."

"Well, first we'd best nail down the timing, then." Ben reached for the coffee pot and drained it into his cup.

Josette continued, "But if you want to have it catered, I have the connections. We can get this taken care of overnight, if we have to." Ben nodded his appreciation. He took his coffee mug and stood to go outside.

Before leaving, he turned to Estelle, "When I get back, let's go see Père Michel. We have a few questions to ask." She nodded.

Everyone remained at the table while Ben stepped out to talk with Bill and Marc. They were left to earnestly debate the menu.

Chapter 23

Robert and Père Michel were out in the bushes in front of the rectory. Robert gesticulating like a maestro, trying to explain proper pruning technique to Père Michel. Pulling up to the parish house, Ben and Estelle surveyed the scene. Ben laughed at yet another of Robert's fruitless efforts to domesticate his priest-friend. Stepping out of the car, Ben called out. Robert turned and, at the expression of tender concern on his face, Ben imploded again, under a wave of loss. While, from moment to moment Ben functioned, he found himself repeatedly vulnerable to acts of kindness. Robert strode over and wrapped Ben in an enveloping bear-hug. He didn't speak, he just held him while they both cried. Estelle disembarked and stood patiently, awed by this unabashed expression of grieving and support. Père Michel, pruning shears in hand, joined her—two career observers to life's dance.

The embrace unlocked and they stood, speaking quietly for a moment before Ben turned and introduced Estelle. She bowed her head acknowledging Ben's generous description.

Robert said, "I like your work. I thought the interview with Guylaine was amazing. I was opposed to it at the time, and now, I regret that. And, your Crowsfoot piece only compounded my guilt."

"Thank you. I know it's not always easy to be open with journalists."

Robert smiled, "It's a little, control-dance. I think we all do it. For each of us it's critical that our slice of the view be shared, usually the best of us. Unfortunately, not all of us agree on what's best."

"And admittedly, all too often those in my profession sink to the lowest, common denominator."

Ben watched, intrigued by this formal, almost courtly, exchange. As Guylaine's agent, it had always been Robert's job to manage her image. He was extending the reins gracefully, but not without some reservation. Père Michel stood next to Ben, also surveying this new dynamic. Robert was not out of the game, but the rules had changed.

"I think," Robert paused, reflecting, "that you and I are on the same side, now. It's easier because the stakes aren't totally financial, but I am connected to Guylaine by our shared past and by being entwined in her family. I'll still want what's best for her, for her name and for her rightful place in Canada's, cultural history."

"Then, we're in agreement. Sometimes though, a three dimensional view is more enduring, especially," she smiled, "for a sculptor. I've resisted the temptation to beatify her. She's much too rich for that."

Now, Robert returned her smile. He stepped forward and extended his hand—they had a deal. Ben wanted them to like each other but he couldn't referee in the process. It was too close.

Père Michel beamed. "Now's my chance to lay down my shears and invite you in for tea. Ben's mentioned that he has some questions." They made their way into the rectory, but not before Robert marshaled them to his cause on strategies for taming the shrubbery out front—he had a plan. Père Michel laughed good-naturedly and threw his hands in the air, helpless to this force of nature. Ben knew that the helplessness, ultimately, would manage to summon a parishioner over to finish the pruning.

Ben loved the interior of the rectory. Saints Simon & Jude Church was one of the oldest in the area. Its furnishings were the result of its most recent remodel, the one from back in the early '20s. That put it squarely within Ben's aesthetic and academic expertise. The heavy oak furniture was ecclesiastic Arts & Crafts—spare, but with gothic elements, substantial hand holds at the ends of the seat's arms and the backs adorned with carved gothic, quatrefoil emblems. The parlor was spotless—the golden oak of the upright couch, chairs and floor lovingly polished to a rich glow. Père Michel had an army of dedicated churchwomen who looked after him like a wayward son. The homey feeling of his parlor was a testament to their ministrations, and his larder the beneficiary of their competitive, baking prowess. Only the upholstery showed signs of neglect—worn thin on the edges by the regular visits of thankful, or chastised, congregants. Ben knew that Père Michel liked this well-tended but also parsimonious appearance. He resisted the efforts of the well-meaning who wanted him to upgrade. As he'd implied knowingly to Ben, in the

past, a little threadbare bought a lot of credibility in this frugal, farming community. He loved to entertain and so, a visit with Michel was always a treat.

Père Michel invited them to sit in the parlor while he set himself to preparing goodies to sustain them. Estelle used the opportunity to gather background on Robert's relationship with Guylaine. He was warm, revealing but measured and, above all, protective. When she pushed, she met a firm resilience and, Ben noted, a little bit of the ragged edge of loss. Despite the fact that Robert had repeatedly thwarted Estelle's reporting efforts, Ben could see Estelle warming to him and appreciating his motives.

Michel finally joined them, carrying a huge tray, laden with a steaming teapot, cups and plates piled high with cookies.

"Michel! Your usual excess, I see." Robert clucked like a mother hen, "*This* is not good for you."

"But, this is for you, my friend. It's time to fatten you up, a bit. My church ladies live for just such an opportunity." Michel handed him a cup of tea, its saucer lined with baked goodies. "Come now, eat up. It'll warm their hearts."

"I can see you've been providing them with ample practice."

"Alas, it's a requirement of the calling." Michel laughed and patted his belly. He turned to Estelle, extending a laden cup and saucer. He winked, "You should never trust a skinny priest."

Estelle chuckled. Ben could see her being wooed, woven into the fabric of Guylaine's circle. He unwound, feeling that Guylaine would be safe with her. He looked up to find Père Michel's eyes on him, tea and cookies in his outstretched hands.

"I understand that you have questions."

Ben set his plate on the coffee table. "I need to know what happened when Guylaine was out West. Those two, lost years…" His voice trailed off.

Père Michel's face clouded. "I'm not comfortable with this, Ben. Guylaine had her reasons for keeping it secret."

Ben hadn't anticipated this. "But she's dead. There's nothing to protect, now."

"The privilege of the confessional, of the confidential relationship with one's priest, didn't die with her."

"But *she* wasn't guilty of anything. This is about something that happened sixty years ago. Guylaine doesn't need the protection of your silence, now."

Père Michel sipped his tea. "No, that's true. In our discussions, Guylaine wasn't specifically confessing anything in the conventional sense. But, she was sorting out her spiritual position, and protecting others. I have to honor that."

Ben felt betrayed. "So you're going to protect the bastard that shot her? What about us, what about family? We need some sorting, too."

Père Michel lowered his eyes. "I didn't say I was protecting *him*."

"But that's the result. And, he'll tell the story his way. Guylaine loses. We all do."

Robert put his plate down. "Michel, certainly you can relate *some* of the facts without revealing Guylaine's intimate concerns. I mean, there is some factual history. How could that be a problem?"

"I'm not going to go slicing-and-dicing what's confidential and what's not."

"What are we talking about here?" Estelle asked. "After all, wasn't this about her grandmother, Claire? How does that figure into anything covered in Guylaine's confession? Who are you really protecting?"

Père Michel looked cornered, "So, now I'm supposed to second guess Guylaine's wishes? Just blurt out her concerns, but not her words? Doesn't that undermine the privacy of the confessional? Would my parishioners feel free to bare their souls if they thought the moment they died, I'd run to the Press with a tell-all book?"

Estelle pressed her point, "But if its factual background, it'll come out anyway. It's the basic history issue—who gets to tell the story, and which version?"

Ben was becoming lost in all of it. He needed to find some clarification—looking for guidance as to whether he should bring the message tapes to the police. Doing so could pull back the cover on decades of Guylaine's family history and on intimate details of their lives together. Ben had to know whether it was necessary before he did. Was it evidence?

159

Robert looked disgusted, "It's *his* precious church he's protecting. Michel, you should be ashamed." Robert stood and walked to the front window. Looking out he added, "I know some of this, but I'd rather it was told by someone who knows *all* of it. And, from what I *do* know, there's no sin in it anywhere except for the church." He did not turn his attention to Michel.

Michel was stunned. He sat back in his chair, feeling slapped by his friend's words. Ben had never seen him look so torn.

Ben implored, "I need your help with this, Père Michel. I need to know what's right." Ben did not want to reveal his own reasons.

Père Michel stared into his teacup, "What's right isn't always easy. Truth isn't for our own convenience." Père Michel lowered his voice, "I'm stung by your accusation, Robert. I can see why you think that, but I can't tell Guylaine's story, any more to clear myself, than I can for any other reason. "

"Even if it comes out, in any event?" Estelle had her reporter's hat on. "If Paul Labute gets the last word on this, how does that help?"

"I have no reason to believe Labute has anything relevant to say on the matter, other than what he and his thugs haven't already said with bullets. The damage has been done, and nothing will be served by opening old wounds." Michel looked down, folding his hands in his lap.

Robert turned back from the window, "What you call *opening old wounds* is the light of truth, my friend. I'm sorry *you* don't see it that way."

"Wait." Ben appealed to Père Michel, "Would it make a difference if Labute *were* to tell his side?"

"Of course it would."

"But, why?" Ben leaned forward, anxious to hear the priest's response.

"Because of those, in Guylaine's heart, who could still be hurt by this. They would need to know if he wasn't being truthful. I'd still be honoring Guylaine's wishes by cushioning the blow."

"Well, he's going to tell it all." Ben reached into his jacket pocket for the cassette. "Do you have a player for this?" he extended the tape.

Michel took the tape and stared at it blankly. "I don't understand."

Robert stepped over and snatched the tape from his hand. "There's an answering machine in his office." Before Michel could respond, Robert has heading out the door.

Robert led the way with the others trailing behind. In Père Michel's office, he popped out the existing cassette and dropped Ben's in. "Just hit *play?*"

Ben nodded, "Yeah, it should be cued-up."

Robert pushed the button and Labute's message started. Though Ben had heard it before, it sounded even more sinister the second time.

They all sat in silence, listening to Paul Labute's message. No one needed to ask who it was.

"Where did you get this?" Michel demanded.

"It's from our phone machine, in Oakville."

Without missing a beat, Michel announced, "This *must* go to the police." He shook his head, "My poor Françoise. She will lose her daughter and now her mother, all over again." Michel reached out and took Ben's hand. "I am *so* sorry, Ben. Guylaine did not want her mother to know any of this. If it *is* to come out, anyway, I can tell you. *But,*" his face pained, he looked around the room, his eyes finally settling on Robert, "No one will say *anything* until I've had the opportunity to tell Françoise."

Robert, satisfied with the terms, nodded his agreement. He ejected the cassette and handed it back to Ben. Ben looked at Père Michel, who was laboring to get up from his chair. He looked old. "Please, come back to the parlor. I'll need some fortification to tell *this* story."

Père Michel poured himself a generous glass of port. "The summer Guylaine finished her degree, she decided to go west, to discover her family roots, as it were. Her understanding was that when Françoise was about fourteen, her mother had been contacted by her original family with some kind of emergency. Leaving a young Françoise in Father Cooper's care, Claire went off to attend to this family business. But, she never returned. It was the middle of the Depression, and not a very safe time for a woman traveling alone. Françoise was now treated as an orphan. She continued with her schooling, but stepped up to assume her

Mother's housekeeping duties in the Parish House. After some time, Father Cooper suggested that the only possible explanation was that Claire had met some tragedy, and that she had died along the way." Michel took a sip of his port.

"Guylaine found the parish easily. Even today, St. Boniface is not a large town. She found her grandfather's headstone, Lucien Trottier, in the graveyard next to the church. She introduced herself to the priest and explained her mission. He was kind, but not terribly helpful. He gave her access to the church's records and she was able to find the records of her grandparent's marriage, Françoise's baptism and her grandfather's death. That was it. But, she was looking for something more substantial."

Ben glanced around the room. The tension had melted. Père Michel's guests now sat spellbound, munching their cookies as Michel wove his tale.

"Guylaine did not give up. She attended Mass, and quizzed elderly parishioners, *Did anyone remember her mother? Her grandmother?* A few remembered her mother, or at least her story—the bright young housekeeper's orphan that the church had sent off to college. One woman in particular was helpful, Giselle. She had been a contemporary, even a passing friend of Françoise. She told Guylaine stories about her mother's childhood that helped to fill in some of the gaps. Françoise was, apparently, a happy girl—her parents' miracle child. Françoise's father wanted to name her Therese, in honor of his favorite saint, but Claire insisted on Françoise. The name was *very* French."

Robert interrupted, laughing and shaking his head, "And, in so doing, saddled her with a name that placed her squarely in the midst of the second, most reviled, of Canadian minorities!"

Michel shrugged, "The view from the bottom of the totem pole, I suppose. But, In Claire's eyes, the French-Canadians had made it possible for her to find grace, the church and, ultimately, her family. These were the gifts of God. Claire thought that Françoise's fair skin was a vindication, protection against the judgments *she* had suffered. Claire did everything she could to distance her daughter from the cruelties visited upon the Indians."

Michel got up, lifted the tea cozy from the pot, and offered more, all around. Then, he passed the port. "In any event, Giselle reported a happy childhood cut short by her father's death and

then, her mother's disappearance. After that, friendship was becoming impossible. Françoise was so busy keeping up her schooling and handling all the housekeeping chores, that there was little time left for girlish games. But, it was a safe environment, a good place to live. It provided a full belly in an era when these were not guaranteed for an orphan child. Giselle felt that Françoise was lucky, for a Métis orphan."

"It's always about race and color," Robert sighed, "We think we've come so far, but then, there are reminders. This week Guylaine was killed because Labute thought she was too soft on the issue of race and color."

Michel nodded, "My own family was divided over language. For me, religion was a refuge from that. Some criticize the church for coddling bigotry. Too often, the church doesn't lead social change. It only reflects social reality. Anyway, Guylaine was given a tip by an ancient parishioner that a retired priest from the parish still lived in a Catholic Care home in Vancouver. Just in time, she hopped on a plane and found Father Cody."

"Just in time?" Estelle queried.

"Father Cody was old, and not well. He was a soft man, tender-hearted. This is not a good attribute for a priest. He suffered the sins of his parishioners, personally, often softened with ample drink."

"You're not suggesting that a priest should be cold-hearted, are you?" Estelle pushed.

"Well, many are. And, if so, it serves them well. This is a tough business. Father Cody, for example, took far too much on. As a young priest, he traveled Western Canada as a *relief priest*. One looks differently at a relief priest. Maybe there's a need for a traveling priest, or maybe it's someone who's too soft to be settled into a parish, too lenient, too tender. In seminary it was my secret fear that I'd be denied a Parish of my own. Sometimes I think my only luck was being bilingual." He sipped his port and selected a cookie from the tray.

"So, Father Cody traveled in and about Western Canada, including Edmonton, St. Boniface. Father Cooper was somewhat of a lazy man, and getting on, so he frequently requested help. Besides, Father Cody was a wiz with the Church books and especially with budgeting. Father Cooper called on his assistance

regularly. When Father Cody first saw Guylaine, he went white as a sheet. She was the spitting image of Claire. In all his years as a priest, Father Cody had never recovered from what had been done to Claire. Guylaine came asking after her family history and Father Cody made her *his* confessor.

"Father Cooper never much liked the Indians, much less, the Métis."

Michele turned to Estelle, "I don't know how familiar you are with our Canadian history. The Métis have a distinct, cultural past, drawing from their roots as a mix of early Canadian settlers and the indigenous population."

Estelle nodded, "You mean, like the whole, *Louis Réal* revolution?"

"*Exactly*. Father Cooper snubbed even the faithful of the *half-breed* community. He did, however, have a fond spot for money. When Claire first approached him, he spurned her but when he was forced to take her on, after complaining bitterly about training her, he knew he had a good thing. He worked her like a dog. Claire ran the Parish House and the Church. She was up at dawn, started the fires, cooked and cleaned all day, waited on Father Cooper and his guests, then got up the next day and did it all over again. Mind you, she was unfailing and without complaint. She saw it as *her* contribution to God's work. Cooper never paid her a cent. Remember, Father Cody did the books and when he discovered that Claire was never paid for her work, he was shocked. Claire was a perfect employee, dedicated, loyal and, a true believer. Today you might wonder if she had been stupid. But, life on the frontier, especially for Indian women, was brutal. It was *open season*, literally, on natives, making parish life a welcome alternative. She was thankful.

"When Lucien Trottier started to court Claire, Cooper was livid. He made quite a row over it—arguably on the basis that he opposed the racial mixing, particularly of such a well-heeled parishioner. This was a foolish argument in a parish that was half Métis, anyway. But, Lucien was a wealthy widower with grown sons. Cooper tried to characterize the union as beneath him, given his station. In reality, Cooper didn't want to lose his slave, and he confided to Cody, as much, in privacy. Cody had a soft spot for Claire and was kind to her. She'd noted, early in his visits, what he

164

liked and whenever he came she baked all his favorites. On Claire's behalf, Cody argued that marriage was a Sacrament blessed by God and if Lucien loved Claire as a Christian man, it was his right and duty to exercise that Sacrament. Finally, Cooper relented and gave his blessing, particularly when he learned that Lucien would be traveling frequently and that would leave Claire with time to work as a volunteer at the Parish House. At the time, it was a respectable thing for the wife of a prominent man. It was a working balance, for years.

"But, things changed when Françoise came along. Claire now had family responsibilities and she bloomed with the love of it. Françoise was a gem of a child, loving, engaging, everything you'd expect, knowing the Françoise we love today. Lucien and Claire couldn't believe how blessed they were—they cherished their daughter and their lives together. Lucien cut back on his travels. Father Cody told Guylaine they were the happiest family he'd ever seen. Lucien taught Claire to read and write and taught her money and household management. They were true partners."

Tears were running down Michel's cheeks.

"When Guylaine told me this story, she described her grandparents' marriage in terms of the same bond that exists between Guillaume and Francoise. In her mind, *that* is the gold standard of unions." He looked up at Ben, "After Josette had her troubles, Guylaine came to me and asked if I'd intercede, on Josette's behalf, in the community. We talked about relationships and she reminded me of our conversation about her grandparents. She said that the Maisonneuve girls were lucky that way. Roger and Helene were a good match. Josette's private relationship had that same sweetness and that it was also what she shared with you, Ben."

Ben covered his face. Père Michel rested for a moment before resuming.

"When Lucien was killed in a railroad accident, it was devastating for Claire. Father Cody told Guylaine that God must have been so jealous of them, that he called Lucien home early. Claire was crushed—left widowed with a nine-year old daughter." Père Michel stood and stretched. He rubbed his face and then looked at his audience. "*That's* the happy part of this story.

"Claire and Françoise had a home though, and in hard times that was a blessing. Claire was welcome to return to the Parish House, again at no pay, but Claire didn't question it. She didn't question why the part-time girl was paid and she wasn't. She was providing a home for her daughter and to do so, she just returned to the fold. It was a hard life, but with the joy Françoise brought, Claire recovered from Lucien's death and made a life for them. More educated now, Claire began to see the indignities of life with Father Cooper but she held her tongue. With a daughter to raise and educate, she couldn't afford to rock the boat. On his visits, she spoke freely with Father Cody. It was his shame that he did nothing but offer solace and the diocese didn't look too closely at the affairs of small churches. What did they care whether the priests paid housekeepers, or whether they were fairly treated? The parish was the domain of the parish priest."

"When Françoise was a teenager, a widowed, Indian friend of Claire's passed away. Despite the fact that she'd made the advance purchase of the plot next to her white husband, when she died, Father Cooper refused to bury her in the churchyard cemetery. It was his position that Indians didn't belong there. The lesson wasn't lost on Françoise and she approached Father Cody for assistance. She told him she wanted to be buried next to Lucien, but Father Cody said he couldn't help. Knowing what he knew, he couldn't even look her in the eye. So, Claire approached Father Cooper about her burial. Predictably, it was a terrible row. Father Cody heard it from his guest room. But, Claire was not the pushover of her earlier years. She pointed out her diligence, her faithful contributions to the Parish House. Father Cooper wasn't patient enough to wait and cheat her in death. He spat at her that no Indian whore would ever be buried in *his* churchyard. He told her that if she wanted to stay, and continue raising her daughter under his roof, she'd shut up and never mention this again, to anyone. The Lord might mind her soul, but in St. Boniface she was still, just an Indian.

When Claire refused to cede and pressed on with the argument, Cooper banished her. He told her Françoise could stay, but that she had to go. She could take her daughter with her, if she could feed her but either way, the next day, she had to go. If she decided that Françoise would stay, they'd say Claire had been

called away on a family matter. Claire would never be allowed to come back, except perhaps to take Françoise. They argued for hours, but Cooper's anger and hatred held firm. So after thirty-six years of loyalty and service, Claire was out on the street, penniless. Early the next morning, Claire made hurried, tearful explanations to her daughter and headed out, into the early, morning mist. She was gone before Father Cody woke."

Père Michel sighed. He stood and held up the teapot, but in the silent room, there were no takers. He set the teapot down, massaged the small of his back and then took his seat.

"Here's the rub of it. By the standards of the day, Lucien Trottier was a wealthy man. He left his entire estate to his beloved wife and daughter, in trust, with Father Cooper as the trustee. Father Cody knew, because he did the books, that Father Cooper took it all. Cody never said a word and, for that, never forgave himself. For years he searched for Claire but never found her. Finally, it was on his deathbed that Guylaine found *him*. He manages to clear his conscience, but burdens young Guylaine with all of his anger, his guilt and angst. It filled her with hatred for the church, for the weakness of men, for greed. She cannot bear to go home, unable to face her mother, the pain of the loss. Guylaine cannot let on what she knows because her mother's one, sure pillar is her faith. How can she tell her mother that the church robbed her of *her own* mother, of her family memories and her estate? I don't know if you're aware how poor Guillaume and Françoise were in their early years, not that money could undo what was done, but that bastard stole a fortune and destroyed lives. Guylaine made me promise never to tell."

Quiet reigned. Estelle broke the silence, "How does all this explain Paul Labute?"

Michel sighed. "Understandably, Guylaine was consumed with anger. She was determined to find out what happened to to her grandmother. She combed the local records for information, to no avail. Finally someone suggested that The Movement was creating its own database, so she contacted them. Through them, she met Labute. Through them she found Claire.

Claire died on a reservation north of St. Boniface, almost twenty years after leaving Cooper's parish. She spent her remaining years working with Indian children, in the Government

schools. She taught them to read and write, she comforted them when they were stolen from their parents, she mothered every lonely brown baby she could. They kept in touch, they wrote. When she died, her students came back. She had a huge funeral; it was a tribute. Who was this withered squaw? She was love. In those years her daughter had married and had daughters of her own. Of course, she never knew, as best we know—she honored her word and never returned to St. Boniface."

"Guylaine's anger spilled over her edges. They'd stolen her grandmother and deprived her mother of the comforts of family and history. That anger drove her into the arms of the other angriest person around, Paul Labute. The relationship lasted until Guylaine's good nature finally returned. She realized that what she had with Labute, wasn't love, it was a shared rage. As she recovered herself, the ties, for lack of a better word, frayed and broke. She told me she left because she could no longer match his fury. He had no tolerance for reason and no patience for real love. She was tired. She wanted to go home, to feel love and forgiveness and to the mercy of regular work." Tears streamed down Michel's cheeks. "She told me that until she went to St. Boniface, I'd been the face of the Church. And, given the choice, she picked my version, flawed but loving. She came home. The rest you know."

Chapter 24

Estelle stood on the rectory porch with Robert and waved as Ben backed out of the driveway in her car with Michel in the passenger seat.

"I'm not sure how it panned out *this* way."

Robert smiled, "Michel needed to talk to Françoise and he needed Ben's support. Well, you said you wanted to check out the church and I want to show you something."

"You do? What?"

"I brought a sculpture with me, it dovetails nicely with this morning's *installment*, but I wasn't sure about sharing it, yet, with Ben."

Estelle's eyes narrowed. "And, why not?" She felt protective of Ben.

"You'll understand when you see it."

"Where are you *hiding* it?"

Robert playfully crooked his finger at her and turned into the house. She tagged along behind him. Robert led the way through the kitchen and down an enclosed back porch to the fenced yard behind the parish house. The garden was stunning—even in November you could see that this enclosed courtyard had a coiffed European feel to it. They stepped out onto a bricked patio with wrought iron, outdoor furniture.

"Wow, look at this garden! It's lovely." Estelle shook her head, "And you were trying to tell *him* how to prune!"

"Oh, don't think for a minute that Michel did this!" Robert waved at the garden. "He has vision but he also has a minion of willing helpers. As the parish priest, he entertains back here, frequently. More than a few French-Canadian couples have enjoyed hasty, but marvelously appointed, garden weddings back here. They all owe him." He grinned. "I get regular updates on the comings and goings of Red Wing. I'm an honorary townie."

"And there's no problem with his being a priest and your being gay?"

"Nary a word, so far as I know. You see, I'm connected to Guylaine, and in the Arts. It's an amazing, protective bubble."

169

Robert continued on, to the back gate. There, on the edge of the brick, was a sculpture.

Estelle gasped. "*Jesus*. It's him."

Robert nodded, "But look closely."

Estelle squatted down. The sculpture, a portrait of a protester, was just over a meter tall. It was Paul Labute, with his chiseled jaw and long hair pulled back into his predictable braid. His face was twisted in an enraged grimace, his mouth open, and his lips curled back, yelling. You could almost feel the spit, the vehemence of his vitriol. Even in this perverse view he was immediately recognizable, still good looking despite the overall, shocking anger of him. The figure sported a t-shirt, and jeans ripped through the knee. His arms, sinuous and veins bulging, were outstretched—one holding a sign, the other raised a clinched fist. It was compelling and, at the same time, jarring. Revolting *and* attractive. Estelle stood and circled it. Every detail was perfect, though not literally. The head was a little oversized, the legs a tad short, the hems of his jeans worn through at the back— their unraveling threads revealing skinny ankles and roman sandals on splayed toes. The bottom edge of his loose t-shirt was luffing in the breeze. Still, something bothered her, made her squeamish. Looking, she circled it again and then, it hit her—the tight jeans revealed an unexpected bulge, an ample erection, reined in only by folds of zippered denim. Beneath that fury, Labute was aroused. It was beyond sexual It was warped, almost scary. Estelle sank to her knees.

"Oh, jeez!" she shook her head. "This is incredible. Kind of ugly, but incredible."

Robert joined her sitting on the grass. "I know. I hate it, but it may be one of her finest pieces." It was cold, but neither was in a hurry to pull away.

"Who could even stand to look at it?"

"I don't know," Robert answered, "Maybe it should be a museum piece. Great art ain't always pretty."

"When did she do this?"

"Oh, about eight years ago. She knew it was incendiary and didn't want Ben to see it. So, it's been in my basement ever since."

"It's prophetic." Estelle was overwhelmed with its power and with how it played perfectly into Guylaine's drama. "What does Michel think?"

"He thinks it's an abomination."

Robert stood up and offered his hand to Estelle. "Like the tape, it might be evidence." She took his hand and he helped her up. Together they walked over to the church to see Guylaine's *Stations of the Cross*.

Chapter 25

The tears welled up and overflowed. Françoise pulled her hand to her mouth and drew in tremolo breath between her fingers. Père Michel took her hand and squeezed it. Ben sat by quietly, helplessly.

"I'm so sorry. I know I should have told you years ago. But, I promised Guylaine."

"Thank you. Thank you for your silence, but even more, thank you for this. It makes it all okay." She wiped her tears with her fingers.

Ben looked at Père Michel. Michel wore a blank expression. They sat silently. Ben tried to conceal how confused he felt. It had been an emotional morning. He didn't understand what it was about the tragedy of Françoise's mother's treatment, at the hands of the Church, that would make it okay.

"Poor Guylaine, she carried this all those years, holding it in. I should have discussed it with her. It would have helped me, too."

"But, how could you have discussed it with her? Ben asked. "We *just* told you."

"Oh, I've always known. I remember some of it. I remember the bitter fight between my mother and Father Cooper. As usual, he was drunk. I couldn't hear it all, but I knew it was bad. I knew it was because she was Indian. I just curled up in bed wishing she weren't Indian, wishing we could just go on the way we were. They were both stubborn. My mother couldn't live with *any* suggestion that her marriage wasn't sanctified. She had a simple faith and her love for my father was so pure. The gravesite issue, and Father Cooper, said it wasn't. It was sullied because my mother was Indian. The funny thing is, I didn't know, *I was, too.* My mother shielded me so much, that I didn't realize it till much later." She wiped her eyes again. "When she left, I was so lost. It was like all the color drained away from my world. Cooper worked me terribly hard. I fell into bed every night, exhausted. It was cruel. *He* was cruel, but it probably saved me. Awhile later, when he told me she was dead, I believed it. I thought he'd killed her by driving her away, and I hated him for it. But, there I was, stuck. If being forced out had killed my mother, what could *I* do?

172

She was strong and honorable, and I thought it killed her. I couldn't even confess my hatred—he was *my* priest!"

"But neither of you did anything wrong." Michel was ashamed for the behavior of the Church, the cruelty, the theft. And, he was clearly baffled. "*You* were the innocents."

"Sure, *now* I know that. Then, I was young and grieving. Then, it was the stain of Indian blood. My mother was an Indian and was driven away because of it. There was no hue and cry—no rally of support for her. When she left, I had to step into her shoes. It was the only way. Father Cooper tried to get me to quit school by heaping more and more work on me. I wouldn't, though, I was determined to escape and a scholarship was my only hope. He screamed that I was stubborn, just like *her*. I was one drunk away from the streets, and I knew it."

"But, you never said a word." Michel's face was slack with disbelief.

"What, and speak against a priest? By the time I arrived in Red Wing I was safe, and I was loved. I had to face the fact that my mother had died, and that she'd died doing what she could to protect me. With Guillaume, I understood what my mother had had with my father. Guillaume was my life, so kind, so gentle, safe. I told him some of it, but by then I had to let it go. I put it behind me as best I could."

"You know, this was not an uncommon story. All over Canada, Native and Métis wives were cheated out of their property and possessions when their husbands' died. Here, in Ontario, we have *The Curse of Pêche Island* to remind us that no good, comes of cruelty."

Françoise got up and went to the window. She stood looking out. "When Guylaine was in St. Boniface, she connected with Giselle. Then, Giselle called me when Guylaine left and went to Vancouver. We pieced it together. People knew, but never did anything. I never knew they all saw it. Just about everyone in the Parish whispered about our lives, about my mother's enslavement and then exile. They knew about Cooper and the Trottier estate. They knew that she left me in order to protect me." Tears coursed down Françoise's face as she sank weakly, down onto the sofa. "She couldn't feed me or provide for me and had to leave me there. That's a mother's love. All these years I've known. I was

ashamed. I told all those stories about my mother, how she came to God, how she loved my father. All true. But, in my heart I felt that the stories lost value in the face of what was done to her in return. *And, by the Church!*" She turned and buried her sobs on Ben's chest. He held her. The losses came full circle.

"But," Michel was still baffled, "What is the part that you thanked *me* for? I don't understand."

Françoise turned back to him, "For the end of my mother's story. I never heard that. I still thought she had died years earlier."

Michel still shook his head, "But that's the part that injured Guylaine so, that your mother was alive and you were kept apart."

"But, my mother continued. The best of her, continued. She turned her losses into gains. She helped all those children. She still kept faith and love. *She was loved.* And that," she sniffed, "Is God's grace."

Père Michel buried his face in his hands and wept.

Chapter 26

"No, you'll need more than that." Josette motioned with her hands. She was in the Maisonneuve's kitchen with Cathy, both of them wrapped in Françoise's flowered, bib aprons, making lunch. "Those guys have been working all morning and I've seen how much they can eat." Cathy laughed and added an extra package of pasta to the pile. "I remember when I was a kid, how much my uncle and Jean Luc could pack away when they were farming."

"Just how many, exactly, are we expecting?"

Josette shrugged and tipped her head back, with her eyes closed, counting. "I think we're looking at twelve. Jean Luc and Claudette won't be in until later tonight, but I'm pretty sure Rosemary will be here."

Cathy looked around, "I don't know where we'll put them." She sounded nervous.

Josette smiled, "Don't worry. It's informal. We're just making food available. There will be a bunch, but probably not all at once. I just wanted to make sure we had something ready because I know Bill and Marc will be hungry." She looked at her watch. "Already, it's a late lunch and they've been out there in the chill, for hours."

Cathy nodded. "When do you think will we'll get to the calls?"

"When they come in for lunch, Bill and Marc can confirm the timing for the headstone, and then we'll know for sure. Right now, it looks like we're ready for a Mass at one o'clock, tomorrow. The caterer is already getting her end going. I'm really glad Ben decided on that, it makes it easier on the whole family." Cathy stirred the sauce as Josette slid the last batch of diced tomatoes into the pot.

"So, the calls, how long will they take?"

"You and Rosemary and I should be able to cover it in an hour. We'll do it from the funeral home. They have multiple lines there. We'll get to it, say, four or five. We're using the church and choir phone trees. Mostly we need to reach the tree captains."

Cathy sighed, "You certainly seem to have a handle on all this."

175

Josette nodded, "Well this family has been holding funerals for as long as I can remember... just not for our own." She was quiet for a moment. "You get used to it and there's a rhythm in it." She turned and pulled several loaves of French bread out of their paper sleeves. Without missing a beat, she lined them up, filleted them and then set them in front of Cathy, who spread garlic-butter on them and wrapped them in foil. Josette walked over and turned on the oven. She reached in the cabinet above the oven, pulled out a green, shake-canister of grated parmesan and handed it to Cathy.

"Where's Hélène?"

Josette rolled her eyes. "She had a blow up with my Dad this morning. I figure she'll sulk for a bit and, in the meantime, we'll get things underway."

Cathy nodded. "Was it about Rosemary?"

Josette looked up, "Yeah, been expecting it?"

"Well, Guylaine talked about it. So, when I heard Rosemary would be singing..."

"It'll get worse, before it gets better. She's on my phone list this evening. *I* get to tell her tomorrow is catered. Hélène usually directs the food service." Josette put her hands on her hips and surveyed the room. Two gigantic bowls of salad graced the end of the table, surrounded by bottles of dressing. Behind them sat a small army of desserts. The spaghetti sauce just needed to simmer another twenty minutes, or so. Already, the aroma of garlic, tomatoes and oregano filled the kitchen. The pasta sat, waiting by a huge pot of simmering water. The oven's preheat-light blinked off and she watched as Cathy slid in the torpedoes of garlic bread.

Satisfied, Josette pronounced, "We're ready."

"You need to give her something to do."

Josette tipped her head, "Pardon me?"

"*Hélène*. Give her something to do. Something important."

"Yeah, right."

"I'm not kidding. She decorates, so have her do the church, or flowers, or *something*."

Josette raised her eyebrows. "You may have a point, though we don't usually decorate for a funeral."

"Well, it's not exactly your *usual* funeral. It's turned into a national event. There'll be reporters and *who knows what*."

Josette thought about it, "Actually, it's a great idea. I'll talk to Ben." Josette stood, nodding her head, "But, don't mention it to my parents."

Cathy peeled off her apron. "How's everybody doing?"

Josette leaned back on the kitchen counter, "Changes, minute to minute, but generally, better. For me, the trip over to Oakville really helped. The gallery show, the Lucille piece. I don't know how to thank you guys. Ben's still pretty shaky. My parents are amazing. It's not that they're not grieving, but they just seem to get softer and more loving every day. My Dad is working through this, with the music. And, my mom seems to be pulling the loose ends of her life together. When Ben gave them the sculpture and told the Saint Kateri story, I thought she was going to melt. It was so tied to who Guylaine was, who Mom is. My Dad put his arms around her and they rocked each other." She sighed. "My uncle, Jean Luc, is hanging in there, but Claudette is pretty fragile. And, I'm really worried about Père Michel and Hélène. Père Michel is *carrying* too much and Hélène is *avoiding* too much. And, how about you?"

"Setting up that gallery exhibit really pulled us together. I'm better than I would have thought. All three of us connected with a lot of memories, doing it. When we went through all those old sculptures, we realized how much work Guylaine did for herself, you know, without commission. We were inspired. All of us have decided we need to get back to doing our own work— back to why we were attracted to working with Guylaine, in the first place. For the guys, setting up the headstone is a wonderful way of saying goodbye and *thank you* to your family, at the same time. So, we're okay. I'm a little worried about Rose, but I think singing will do the same for her."

Josette smiled. "Let's see if we can round-up some of these folks. It's time for lunch."

Chapter 27

Josette bent and collected dirty paper plates from tables in the living room. Spaghetti had been the perfect choice. All afternoon, folks had filtered in, grabbed a bite and connected—talking to Françoise and whoever else had assembled. Nobody was specifically in charge of serving, but it was working out fine. She eyed Marc and Bill, who were back for seconds, or, it might have been thirds. They were telling Françoise shop stories about Guylaine and her sculptures. Josette smiled. Things were going well. Her call to Hélène had been successful beyond her expectations. Of course, Hélène bemoaned the lateness of the suggestion to decorate the church, but Josette could tell that she was inspired by the challenge. She hadn't even asked about the food. They discussed objectives—tasteful and understated. Josette had every confidence that Hélène would come up with something perfect. Josette checked her watch, wondering when Rosemary would arrive from rehearsal with Père Michel and Guillaume. There was still much to coordinate and she still had the telephoning to do before the end of the day.

She headed back into the kitchen with an armload of discards. Estelle was standing by the kitchen door and reached out to relieve Josette of her burden. But, Josette waved Estelle into the living room to join the others—as much as Josette enjoyed the company and the help, the wages of journalism did not include a scullery role for Estelle.

The back storm-door closed with a slam. Josette looked up and watched as the second shift clambered up the stairs. Guillaume and Rosemary chatted in hushed tones. Right behind them, Ben, Père Michel and Robert extolled the musical program. Josette greeted Rosemary at the top of the stairs with a warm embrace. She pinched Rose's cheek and whispered, "Well if it isn't the laundry queen, herself!"

Rosemary cackled and swatted Josette's backside. "Don't you go making trouble, now."

Guillaume's eyes met his daughter's, "She's incredible. The voice of solace, I tell you." He reached over and touched Rosemary's shoulder, "*You* complete the program, my dear."

She looked back at him and said, "Can I say something, you know, before I sing?"

Père Michel looked up, "Sure, I guess. What is it you would like to say?"

"I want to introduce the song and talk about how I came to know it."

"Sure. A couple of minutes?"

"Yeah."

He nodded, and turned his attention to Josette, "What's the plan?"

Josette rolled her eyes. "*Lots* still to do. Sculptures to set out, calls to make, but it's under control. What's our start time?" Before he could answer, the others swarmed around them, drawn by the aroma of the spaghetti and garlic bread.

Père Michel took her hand and led her over to the kitchen table where they sat down, facing each other. "We have some flexibility, so anytime between noon and two. I wanted to talk to you about logistics because it's dicey. The Press is on to us and we all need to be on the same page."

Josette raised an eyebrow, "What gives, exactly?"

Père Michel shook his head, "Apparently someone noticed a hearse from the Ottawa area, parked at the funeral home. It's sparked a renewal of interest. Guess we missed that one."

Guillaume set a loaded plate down in front of the priest and settled down at the table next to him with his own dinner, heaped on a paper plate. "Who would've thought it? Since when do people have their company's name emblazoned on the sides of a hearse? What do they think we are, *plumbers*?" Josette couldn't help but laugh—even with Guylaine gone, there was room for professional critique.

Père Michel held up his hand, "I don't think we can criticize. This is a favor, and on short notice."

Guillaume grunted. "Some favor, now the town is crawling with reporters, *again*, and tomorrow is the funeral!"

Michel grinned, "We're not without options Guillaume. I think we have a fine plan."

Guillaume grunted and dug into his spaghetti.

Père Michel continued, "On your end Josette, how can we help you?"

179

"I think we're good. Marc and Bill will finish the headstone installation in the morning. They can set up the sculptures, and they want to set up lighting. Somebody needs to be here anyway, when they deliver the Porta-potties."

Père Michel almost spit out his spaghetti. *"What?* What are you talking about?"

Josette sat back, "Well, we're expecting up to five-hundred. This house can't accommodate that, so the caterers suggested renting outdoor tables. We'll set up the sculptures around the perimeter…"

"Stop." The priest placed his palms on the table as a quiet punctuation, "This is not a *picnic*. It's November. It's a funeral. We have a church hall for these things. Put your sculptures in my back courtyard, let the Press in and let's celebrate and mourn her together."

"But the headstone is here," Josette continued, "We've never done a funeral in the church hall."

Père Michel looked at Guillaume, "Do you have a better suggestion?"

"No. But, I think the reporters will be a disruption and I *don't* want them here for the interment." The three of them exchanged looks, and then, between bites, the details began to fall into place.

Chapter 28

Estelle settled-in, near Françoise and Guillaume, to listen to the family stories, along with Father Tony, Robert and Père Michel. The afternoon sun had faded into early dusk. Josette, Cathy and Rosemary had gone over to the mortuary, across from the church, to make their calls. Compromises had been made and logistical details ironed out. In the aftermath, and until tomorrow's whirl, all that remained for the older folk, was stories. Everyone had a role, divided by talent and generation. A well-oiled machine, the family pulled it together for a fitting farewell to one of its own. This was to be a funeral by invitation, except that, as best Estelle could tell, *everyone* was invited. The whole country was invited. Tomorrow she would step out from under the family's wing to narrate the event for the world. Estelle felt like a mole, a double agent. Tonight though, her allegiance fell with this family. In the quiet of tea and cookies she followed the family lead and shored up her journalistic objectivity with sugar.

Ben, Marc and Bill were loading sculptures into two, waiting trucks, to take advantage of the early-evening darkness, in order to cover the transfer, and set, up of Guylaine Claire's retrospective in Père Michel's, courtyard garden. The bereaved were throwing a party for the world. In the throes of sorrow, they were sharing. Estelle wondered at the dynamic of it, knew the depth of the loss, and was awed by its resilience. Estelle knew she should be paying attention, but she was exhausted, and saturated. The family patter rolled over her like a warm summer shower on rounded pebbles. There, she'd missed another pearl—Père Michel was balancing a cup of tea in his lap, chuckling with such vigor that with each shake the tea lapped over his cup's top and into the saucer below. She sat up and stretched. Françoise came in with another tray of sweets, offering it around, slices of apple-turnover bread.

"Oh my, I haven't seen *this* in years!" Père Michel helped himself to two slices. Guillaume looked over his shoulder and gasped, "Françoise, apple cake!" and he laughed heartily.

Robert looked at Father Tony and shrugged. He said, "Sometimes, it feels like *everything* is an inside joke."

"But this *is* a delicious inside joke." Michel finished chewing and swallowed. "In my early years here, Guillaume and Françoise, with little help, we're expected to provide everything for a gracious funeral. Old man Marc Maisonneuve was a bastard."

"Père Michel!" Françoise chided.

"It's true." Michel turned to Guillaume, "Let's face it, your uncle was the cheapest man on the planet, and he treated you both like slaves."

Guillaume shrugged.

"This family lived like mice in the upstairs of the mortuary. But, they saw to it that every funeral or wake had home baked goodies. Françoise grew flowers, she sewed, *and* she provided the heart to the operation, just as Guillaume provided the stolid comfort, regardless of Marc Maisonneuve's, miserly ways." Françoise nodded in agreement. "One of the favorite desserts she made was this yeasted apple-bread. The parish never knew, but Françoise would steal the apples from an abandoned farmhouse out on the highway, by Point Aux Roches."

"Michel!" Françoise blushed, "*That's* from the confessional!"

Père Michel grinned broadly, "Françoise canned the apples and baked this lovely, braided, apple concoction. Everyone in the parish *loved* it. Not that we looked forward to funerals, mind you, but this comfort was always appreciated. Then, one day at school, there was a bake sale and Françoise pulled an apple cake out of her freezer. Her girls would have nothing to do with it. They were *not* going to bring *Death Bread* to the bake sale. Well, it changed our lives. I regret to say that thereafter, this lovely sweet became a rarity." Michel raised his dripping teacup in a toast to Françoise.

"But, Guylaine loved it and she'd ask me to make it." Françoise smiled. Guillaume reached over and took his wife's hand. He sat for a while, holding it, though it meant neither of them could drink their tea or eat the cake.

Estelle felt she needed some background. "How is it that you came to the funeral business through your uncle?"

Guillaume knitted his brow.

"I don't mean to pry," Estelle back-pedaled. "It just helps me put all the pieces together."

"I understand that. It's just that it's complicated and goes back a ways." He let go of his wife's hand, took a bite of his cake

and then a sip of tea. "My grandfather was a philosophical free-thinker. He looked at the English and the French, and decided the French problem was the dissipation of wealth. The English left their property to the oldest son, while the French split the farms amongst the all the sons. Over time, and given the number of French sons, French lands were split into smaller and smaller farms. If you look along the lake, towards Puce, you'll see the results. Narrow, ribbon farms, each with access to the water but over time, became too small to be sustainable for much. Many of those lots are barely wide enough for a summer cottage. The English though, gave the farm intact. They educated the younger boys and *that* was their inheritance. They made their way. Only the oldest was tied to the land. English lands stayed intact. They conveyed wealth and, ultimately, political power. So, Grandpère decided to follow the English practice.

"My father, Gaston, was the oldest son and the farm was left to him. Uncle Marc was sent to university and encouraged to pursue business." He nodded at Père Michel, "Maybe that, in part, explains Uncle Marc's surliness. I'm sure he felt cheated by the arrangement. My uncle took his education and, when old man Marcotte wanted to retire, bought the funeral home from him. It wasn't quite what Grandfather had in mind, but then it was Marc's affair. My father was a successful farmer, abundant in all things, except sons. I was the one and only. In his eyes a cripple could never be a farmer. And, *I* was a cripple. So, when it became apparent that there were to be no more sons, he cut a deal with his brother. I would get Marc's business, and my cousin, Jean Luc, would get the farm. We were raised with that expectation. I went to college and worked under my uncle. Jean Luc stayed home and farmed with my dad. It's true that my uncle was not generous, but he kept up his end of the bargain. *And*, he was no more generous to Jean Luc, so it's not like he played favorites. Nobody much liked him.

Françoise could no longer hold her tongue, "He cheated us. Marc pulled all the equity out of the business, and took off for Florida. We were serfs when he was here, then spent years digging out of debt. Everything that the business is, is because of Guillaume."

Estelle frowned, "I'm sorry, I didn't know this was such a sensitive topic. I thought Jean Luc owned the hardware store?"

"Yes, it's funny. Farming isn't what it once was. Since most of Grandpère's farm was lakefront. Jean Luc sold it off for expensive homes and went into business with the proceeds. He and Claudette have done very well. My father would have laughed—two Maisonneuve boys in business." Guillaume folded his hands together contemplating the outcome.

Françoise nodded. "I was bitter at times, being a new wife. It was hard to watch Guillaume struggle, but I didn't blame Guillaume's father. And, maybe because of the way Marc was, Jean Luc bonded with Guillaume's family. They are like brothers, and I wouldn't trade that for anything."

Estelle kept digging, "But, how did *you* end up in the farmhouse?"

"That's because of Jean Luc." Guillaume went on with the story. "After Marc absconded with the money from the business, there was little my father could do. By this time, Jean Luc had been on the farm with him for years, and none of it was Jean Luc's doing. He had more than earned his right to the farm. But, when my father passed, the first thing Jean Luc did was to deed over the farmhouse to Françoise and me. He felt it evened things out. He didn't have to do that and I'm sorry my father never got to see it."

Françoise added, "There *is* a little more to it. Papa Gaston suffered his shortcomings. He always expected another son would come along to be the farmer, but only girls came—five of them, in all. So, while waiting for the farmer son, he missed out on the one he had. Turned out, Guillaume was a genius with machinery. Over time, farming changed and relied more and more on tractors, and such. Guillaume was always tinkering with the engines and other equipment, keeping things running. We saved a fortune over the years by running old hearses long past their expected lives, because Guillaume could keep them running. With the changes that came along in farming, Guillaume *could* have been a farmer. And, Gaston hated the things his brother had done to Guillaume. As an older man, Gaston finally embraced his son. At the end, they truly did love each other. *That* is the greatest gift. "

Guillaume smiled, "If I had been a farmer, I would never have met Françoise. These things have a way of working out."

Père Michel added the final note, "Gaston didn't regret the deal, though he regretted that at the outset, he'd sold his own son short. He regretted missing your childhood while he waited for the *better* son to appear. His cross to bear was that he didn't recognize it sooner and enjoy one of God's gifts—a smart son with a kind and just heart. And, in a way, Gaston really ended up with *two* wonderful sons. He so loved both Guillaume *and* Jean Luc."

With tears in his eyes, Guillaume laughed. "What is really missing in all these stories is that they all failed to see the wonder of their daughters." Françoise reached and took her husband's hand while he finished, "I don't know what I'd do without the wonder of my daughters."

"Bien sur! Good point, eh?" Again, Père Michel raised his cup in a toast. Then, he turned to Estelle, "Do you have any more trouble-making questions, young lady?"

"Now, I'm almost afraid to ask."

The priest made a show of checking his watch. "Well, now's your chance. Tomorrow we'll all be too busy."

Estelle took a breath, "Okay. I don't mean to disparage Red Wing, but you have to admit, it's not exactly a cultural capitol..."

Father Tony interrupted, "I think you should hold your judgment on that. You haven't yet heard Guillaume's choir."

"Fair enough," Estelle agreed. "Though I may have to rethink this, I have a gap in my understanding. I know Guylaine went to a private art school for part of her high school studies, but I'm curious as to what led to her going there. When was her talent recognized?"

Robert started laughing. Otherwise, the room was silent.

Estelle looked from face to face, finding them guarded. Guillaume and Françoise sat, still holding hands, eyes averted. Père Michel busied himself fixing another tea, not looking up.

Robert stifled his laugh, and looked at the others, "Well, certainly you knew she'd ask?"

Françoise crossed herself quickly and looked up. "It was *my* problem really. I didn't handle it well."

Estelle let the silence do its work.

Père Michel added, "And I was no better. But, in the end, it worked out so well I think it was meant to be, though it came with a lot of ...baggage. It *was* hard on Guylaine."

Estelle tilted her head a little, without breaking her gaze.

Françoise and Michel exchanged furtive glances. It was Michel who blinked first. Estelle quickly shifted her focus to the priest and now he squirmed under the pressure of her quiet intensity.

"Well, okay. But, *you'll* have to decide for yourself how well we handled it." He sighed, "Guylaine was young, sixteen or seventeen, and no one will deny that she was an odd girl. She did not relate well with her classmates, especially the girls. She didn't talk much and she wasn't interested in clothes and makeup. But, she did like sports and mechanical things. She liked to build things—projects. There were a couple of young men she considered friends. Nice boys, though not the popular or fast type.

One late, spring day I decided to walk over here from town. I knew Françoise had been under the weather and I thought I'd drop by and see how she was. I took a short cut, crossing the creek on the railroad bridge. Well, when I cleared some willows, I looked up and discovered a young couple having sex in a *somewhat*, secluded grove. They didn't see me and I would have let it go, except that, even from a distance, the girl looked familiar. So, I continued along the railroad tracks to stay above them and get closer. And then, I recognized *Guylaine*. Needless to say, I was completely flummoxed. It was so far beyond my expectations of her, I… well, I just walked up and announced myself, demanding to know *what* was going on. Of course, it was obvious what was going on," he put his hand to his forehead, "It was all so lame. They were stunned, to say the least. Now, looking back, it was almost funny. I can imagine it would be a young couple's *worst* nightmare, to be caught by their priest! The young man was Bill Campeau, and he looked so scared and, oddly enough, *skinny*. I made them dress and marched them right up here, to the house. I dumped them in Françoise's lap. She *was* the mother, after all. It completely left my head that she was ill and already stressed, but there it was."

"Partly it was the times." Françoise looked up, "It seems lots of kids were, you know, *doing it*. Guylaine was my youngest and I'd never had to deal with the issue of premarital sex, before. If Josette was active in that way, she was discreet about it. And, Hélène? Well, no need to worry about *her*. I was going through

the change, and having a rough time of it. I was so emotional and I just couldn't handle having a brazen, hussy of a daughter. I'm ashamed to say that I was worried about how it would *look*, of all things. We were seen as leaders in the church, the choir, and everything. And, Billy was an altar boy! Well, I called Mrs. Campeau and asked her to come right over and pick up her son. She was so embarrassed, poor thing. So, then I grilled Guylaine— how long had this been going on? What if she got pregnant? Did she think she was ready for marriage? Her answers didn't help things. As an excuse, she said they were just *experimenting*. They were friends and I shouldn't worry because they were using condoms. Well, I slapped her… *hard*. I'd never hit *any* of my girls before that day, but I slapped Guylaine across the face, for her honesty. To her, this was a safe way to experiment. To me it was blasphemy. And, she wasn't even drunk."

Estelle couldn't suppress a giggle. "*Alcohol* would've been a defense?"

"Oh, you can laugh now, but you can't know how distraught I was. Things were very different back then. I couldn't believe it— couldn't believe that her values would allow her to contemplate casual sex. And, the condoms meant she'd *planned* it! But, I couldn't believe I hit her. I banished her to her room—trying to get a handle on it and figure out what to do. I think she was in there for days. It was Père Michel who came up with the idea of art school."

"Actually, it was Robert's idea." Père Michel admitted.

Estelle was surprised, "You couldn't just ground her, like other parents?"

"Like I said, we didn't handle it very well. When Michel suggested we send her away to school, it seemed like a solution. It was an all-girl school. I couldn't just go on like nothing happened because she felt no remorse."

"Did she show any signs of talent?" Estelle turned to Guillaume, "What did you think about all this?"

Guillaume threw up his hands, "This was *girl* stuff. Françoise was a mess over it. So, I went along with what she thought best."

"Didn't you wonder what people would think? Suddenly shipping her off like that?"

Michel fielded that, "Well, because people already thought she was a little different, art school seemed perfect. Red Wing had little in the way of art instruction, so sending her off for enrichment seemed like just the thing."

Estelle threw her head back and howled. "You're telling me that Canada's *foremost* talent was sentenced to art school for promiscuity? She developed as an artist because you sent her away?"

Françoise nodded, "Like I said, it turned out well."

"So, how did Guylaine handle it?"

They all turned to look at Robert.

For the first time, he was serious, "She didn't do very well. It was really a shock to her. She felt like she was being exiled, exiled from everything familiar, from language, even from the love of her family."

"Why are *you* telling this part of the story," Estelle asked.

"Well, she lived with me. I was near the school and had the contacts." Robert was matter of fact about it.

"Wait, wait, this is *too* rich. You sent your promiscuous daughter away to art school, to be chaperoned by a gay man?" Estelle was trying to keep a straight face. She sat down on the floor, next to the coffee table, so she could watch everyone's faces.

Françoise broke into a grin, beginning to see her point. "Well, it seemed like a good idea at the time."

"I really don't think this is funny," Robert said, "She really suffered. It was almost a year before she found her stride. If she hadn't discovered sculpting, I don't know what would've happened."

"Why was it so difficult, for her?" Françoise was earnest.

"She was lost, there. She missed her family. School was taught in English and that was a challenge. And, while she *did* show talent, even from the start, she was way behind the other girls. They were all there because *they* had art backgrounds, and they *wanted* to be there. She didn't fit in."

Michel added, "Robert was really a gem. He stepped in and coached her in the arts. They spent weekends in museums, and their other free time pouring over art books. His friends even became cheerleaders. They also taught her to cook. They even

188

taught her about wine. It was like she'd landed in charm school. If there *is* such a thing as art, charm school."

"But, he's gay. No offense Robert. It seems such an odd set-up."

"Not at all." Françoise was completely sincere, "He was Michel's friend so we knew she'd be safe with him. Robert's friends certainly weren't going to be interested in her. She could just go to school without boys around." She paused, "We did miss her terribly, though."

Now, Estelle was seeing *Françoise's* point. "So, when did she demonstrate any, real talent?"

"Almost a year later," Robert nodded, "There wasn't any kind of sculpture in the curriculum. But, they *were* working with clay for part of her design class. And, when that clay fell into her hands, magic happened." He sighed. "It was certainly a big relief. Without that, I don't know if the school would have let her continue, and she *couldn't* have handled another failure." Even now, his brow was furrowed with the worry of an anguished parent. Estelle could see why. Seventeen years later he was *still* her devoted friend and agent. "I put her in an art camps, over the summer, and by September, she'd bloomed. Not only did *they* recognize and nurture her talent, *she* could really see and feel it. She *owned* it. She came home, an artist."

Estelle sat nodding. She could see the pieces of the puzzle falling into place and that, in a funny way, things really did work out. She looked up at Michel, "Bill Campeau. Isn't he the local cop?" Michel nodded.

Estelle reached over and took a piece of the apple cake from the tray. Everyone was looking at her, waiting, while she nibbled reflectively on the cake. "Hey, you know, this stuff is really good."

Chapter 29

It wasn't yet light. Ben was alone, back in Guylaine's pink room. Alone in a still way, that wasn't anguished, but had a flatness to it that he was slowly beginning to inhabit. These past few days, sometimes waking up, or falling asleep, he'd felt Guylaine there by him. But today, the day they would bury her, he was alone and, with that finality, the air was grey and bleak. Ben dreaded what would come after today. Time stretched slowly forward, feeling empty and somehow aridly academic.

Ben rolled over and his muscles groaned. Moving heavy, bronze, statuary was for younger men. It had been a shock, seeing the Labute sculpture in Père Michel's back garden. He'd never seen it before and understood why. It took him almost half an hour to finally absorb it and find his footing. In the end, it explained more about Guylaine's lost years than she could ever have verbalized. The study was not cruel, but a cold assessment of the nature of that attraction. Strangely, it was salve for what ailed him. It punctuated Guylaine's telephone message and reaffirmed their connection. She hadn't loved Labute. Maybe *that* was why she was dead today. The sculpture told the story. Ben hoped that, someday, Paul Labute would get to see it.

Now, he wanted to see the sculpture exhibit in the daytime. They'd done the placements in the dark, hoping not to attract attention. For the public, it would be seen in the waning, afternoon light, and then by additional illumination. He needed to check on that. He swung his legs out of bed, got up quietly and pulled on yesterday's clothes. There was no need to dress for the funeral if he was going to be wrestling the bronzes again. Once downstairs he was relieved to see he was the only one up. In the early morning darkness, he put the water on to boil.

Estelle came in, unnoticed, just as he poured his coffee. She flipped on the light. "You're up early."

Ben jumped. "Sorry, did I wake you?"

"No. I didn't sleep very well. You?"

"Yeah, well…"

Estelle pulled a cup from the cupboard and poured her coffee. She took a seat at the kitchen table. She now had a conscript's

190

familiarity with the kitchen. She thought that maybe women just found their way. Ben looked at the top of the fridge, where the Maisonneuve's usually kept the sweets.

"Hey, look," He pulled the tray down, "Apple cake." He slid the tray onto the table and took a chair opposite Estelle. "Guylaine *loved* this stuff." He fetched a couple of plates and helped himself to two slices.

Estelle smiled. "Yeah I know." She reached out for a piece. "I heard about it last night." She took a bite and savored it slowly, thoughtfully. "This is a wonderful family, Ben."

He looked up, "It has its warts, but, yeah, they are great."

"What's Josette's story?"

"What part?"

"Well, she's single. Two sons, I think. But, she never says a word about them. Something strikes me a little *off*, about that."

Ben nodded, realizing that Josette was grieving, too, on many levels. "They'll be here for the funeral, her boys. One's in Windsor and the youngest one will be flying in from Calgary, this morning." He added, "Josette's had a rough time of it—a touch of *small-town scandal* that's put some distance between her and the boys. They're slowly coming around."

Estelle cocked her head. "Well, it's none of my business. Not even in the Guylaine story."

Ben grinned back and wagged a finger at her. "You know, lady, I'm on to you. You're a hard-core, story addict." He finished his first slice of apple cake and sipped his coffee.

Estelle waited but Ben fell into his own reverie.

"Well?"

He looked up, "What?"

"Don't be mean. You know I'm an addict. So, what's Josette's story?"

"You're serious." He smiled. "Okay. But really, it's not a big thing. In a big city, no one would even care. Josette had a long-term affair. It lasted sixteen, maybe eighteen years. Most people never knew about it. He was married—no kids, but his wife was institutionalized. There had been a terrible car accident and she never really recovered. For years, she drifted between a coma and semi-consciousness. Josette was his banker, helped him to set up a trust for her care. Over the years they became close, and quietly,

the affair developed. Only close friends knew about it and I'm not even sure if Josette's parents did. Guylaine and I knew. I'm sure Hélène didn't. They'd come to visit us from time to time and outside of Red Wing, they were like a regular couple. I think they assumed that eventually his wife would pass and they would be able to marry. But, as you know, life isn't tidy. A few years back, he up and drops dead of a stroke. Josette was a mess. She couldn't openly grieve, so her loss went unrecognized. Even *we* didn't respond as we should have. Now, I get it."

"So where's the scandal in that?"

"Well, two years later, the wife finally died. As the trust administrator, Josette continued to take care of their affairs till she passed. Her death went almost unnoticed, initially. The woman had been out of it for years and her husband had been her only visitor. After she passed, an attorney showed up with new estate documents. Everything was left to Josette."

Estelle leaned forward, "So? No kids, what's the problem?"

"The nieces and nephews went ballistic. They challenged the estate. Before she knew what hit her, Josette was the talk of the town. If she'd thought about it for a second, she'd have waived the bequest. Suddenly, she was the thieving, manipulative bank manager. Then, the only way to clear her professional name was to reveal the affair." He sipped his coffee, "It's a small town, and adultery is an ugly word. Of course, folks took sides. Josette's boys were drawn in. They were friends of the contesting family members. They were shocked by her secret life. In the end, Josette won, but not without raising more than a few eyebrows. Over time, it all settled down, but the chill between her and her sons remains."

"Wow, nothing's easy. In Toronto, that might've been a sweet romance."

"Yeah, well, money always brings out the best in everyone." He popped the last bite into his mouth and licked his fingers. "I'm headed over to Père Michel's to check out the sculptures in the daylight. Interested in coming along?"

"Anything I haven't already seen?"

"Yeah, actually. There are a few. Two *Pleasure Forms*, and some others, from Rosemary and Robert. It's a different mix—more Canadian. But, there's no rush, they'll be there all day."

"Canadian? Sure, I'll come."

"Great, you can drive. I realized this morning, I still don't have a car here."

They climbed into Estelle's rental and pulled out towards Red Wing, just as dawn broke over the willows, along the river. The sleepy town was still quiet, though Ben noticed extra cars at the funeral home, and Red Wing's only motel looked full. Estelle pulled up to the rectory and parked in the driveway. They saw Rosemary sitting in her car, on the street out front, but she didn't seem to notice them.

Ben, grinning form ear to ear turned to Estelle, "Want to have a little fun?" He motioned with his thumb towards Rosemary's car.

Without missing a beat, Estelle nodded, "What ever it is you're up to, I'm in." Following Ben's lead, she slipped out of the car, and quietly closed her door.

Ben signaled to stay low and together they approached Rosemary's car, couching down, both trying desperately not to blow their cover by laughing. But, Rosemary was onto them. She'd seen them in the side mirror, sneaking up on the driver's side. Not to be outdone, she stealthily slide out the passenger door, worked her way around the rear of the car and came up behind them as they stalked *their* prey.

In aloud voice, Rosemary barked, "What in the *hell* do you think you're doing!" The two, would-be jokesters jumped up, shrieking.

Ben was the first to catch his breath, "Jeez, Rose! You trying to give me a heart attack?" Both women broke into laughter.

Rosemary stepped over and wrapped her arms around Ben. "You're just mad cause I beat you at your own game."

Roger woke up cold and feeling alone. He rolled over and reached for Hélène, but found her side empty. He opened his eyes, letting them adjust to the pre-dawn shadows, and saw that her side of the bed was undisturbed. Today was the funeral. Roger pulled on his robe and slippers and padded down to Hélène's workshop in the basement. She was sewing an endless river of black fabric. She looked up when he came in. She looked tired, but her face was intent, fully engaged.

"Wow! Perfect timing. I just finished the last seam."

"It's about time." He checked his watch, "It's three-thirty."

She nodded, "Yeah. If I get these up now, any wrinkles will fall out in time for the service." Roger watched as she stood and gathered the yards of material in her arms and loaded it loosely, accordion style, into a waiting box. His eyes followed along the line of completed boxes.

She leaned over and kissed him. "Thank you. You are such a sweetheart."

Roger realized he'd just volunteered. He looked up at her, worried, "And then some sleep?" She smiled and made a little cross sign over her heart. "How long will it take?"

"The installation should be just over an hour." Hélène put her hand on his chest, "*Then*, we can sleep in." She sighed, "This is important."

Roger wrapped his arms around her and buried his face against her neck. Sometimes her energy and her drive amazed him. "Okay, sweetie. I'm at your service."

Josette's alarm went off. She reached over and slammed her hand down on the clock. *The last snooze cycle.* Out her window, the sun was just breaking over the top of her back fence. Now, with the leaves fallen, dawn came earlier to her bedroom window. She'd set the alarm early to pick Sonny up at the airport. Josette was dreading this day. A funeral in the family tested all of them. It stretched their hearts just as the logistics pulled at their thinking. This was no ordinary funeral. Josette was relieved that Father Tony would manage the choir. Her parents needed to focus on each other for this. She hoped her sons could let go of their rancor, at least for today—at least for her parents. It was dicey. She felt like she couldn't mention it to them, because it was *too* obvious and yet, at times she thought they still needed guidance. Adult sons were difficult that way.

For almost two years now, she'd suffered their cool distance and their sudden, overt chumminess with their father, and *his* family. For far too long she'd been counting her losses. But, today was not about her. Josette sighed and untangled herself from the sheets. She pulled on her sweats and tied her hair back. She could shower and dress properly later. Now, there were relatives to

gather along with last minute calls to make and arrangements to be made. She microwaved a cup of coffee for the drive, collected her purse and keys, and headed out into the quiet of the morning.

"Shouldn't we call first?" Claudette looked up the stairs at Jean Luc. *He'd* been up for hours, rattling around the house. Claudette finally joined him and made a fresh pot of coffee. *Decaf.* Rarely was her husband so agitated. He was the one everyone relied on for steadiness.

"Don't be silly, they're burying Guylaine, today. No one will be sleeping."

"Okay, but let me whip up some eggs or something. You cannot show up and expect to be fed, today, of all days."

Jean Luc nodded. "I think *casual*, for now. We'll dress later for the service. But now, we'll just see how everyone is doing." He stood at the kitchen counter and worked on his coffee. He sighed repeatedly.

Claudette turned from the stove, where she'd just cracked half a dozen eggs into a pan, already sizzling with bacon. She reached out, put her arms around her husband, and drew him in. Finding the center, she held him. He towered over her, but for this, she was in charge. He leaned into her embrace, enveloped her with his gangly arms, and tucked her head under his chin. His breathing evened. She gave him one last squeeze and loosened her grip.

"Best see to them eggs, eh?" He kissed her curls, letting her go. She dropped a couple of pieces of bread into the toaster and turned to flip the eggs over easy.

They ate in silence, but the disquiet slowly lifted. Claudette watched him. This would be a tough day. Jean Luc had loved Guylaine Claire like a daughter—they both did. And, she knew his heart was breaking for his cousin, Guillaume, and Françoise. Yet, in Red Wing, they were always the ones who provided the comfort. Claudette could feel his torment. She wasn't equipped with answers. She tidied up the kitchen and slipped into a housedress while Jean Luc pulled the truck around. Claudette climbed up into the cab, buckled in, and put her hand on Jean Luc's shoulder. At the end of their street, Jean Luc made a left onto the main road.

"Jean Luc…?" She didn't finish the question.

"Just thought I'd swing by Edna's, ya know, pick up some donuts."

Claudette smiled in the dark as the truck crunched in the loose gravel of the bakery's, empty parking lot. The neon, *Open* sign flickered in the window.

Père Michel tossed and turned. He couldn't sleep. He'd been working on the eulogy for a week now, and he was completely lost in it. His desk was littered with scores of pages, all covered with his scrawling efforts to crystallize his feelings for Guylaine and her family. He was running out of time. Perhaps he was just *too* close. Perhaps he should sit in the front pews with the family, and let a more objective priest take the pulpit—it was too bad Father Tony was needed for the choir. He worried that he would break down when his dearest friends and family needed him to lead them to still waters.

This was another crisis of faith. He knew he wasn't the only priest who, from time to time, lost the connection to his conviction. It was a challenge. For this, they were given ritual. At least it kept your hands busy. Sometimes its rhythms brought you home again. Of course, sometimes priests tippled in the sacramental wine, or worse, and lost their way forever. He sighed. Michel knew *his* wasn't lost forever, but his faith had picked a hell of a time to go on vacation.

When Michel saw devoted couples like the Maisonneuves pull together in adversity, and strengthen their faith during the worst of times, he wondered at the wisdom of his vow of celibacy. Some people just got it right *without* the dogma. Not that he had regrets. Michel felt blessed that, as a nervous young man battered from the squalls of a tempestuous home, he'd picked the priesthood as his refuge. But, it had become so much more. Many broken souls were drawn to the life, and remained broken. In his case, the love of this parish, and in particular the Maisonneuves, had scooped him up and mended him. He so wanted to return that favor, but the eulogy he needed was in tangles. He had narrowed it down to one or two versions that would do, but nothing that soared. And, for *this*, he wanted it to soar. He wanted to celebrate Guylaine—her talents, her eccentricities and her family. He

wanted to offer her up as evidence of a loving God but his efforts, so far, just put her to rest.

He rolled over again and tried an old trick for sleeping. He counted his breaths. In that silence, Michel heard it—hushed voices and the quiet, closing of a door. *Someone was in the church!* Michel sat up, and there it was, again. Standing up, he slid into his slippers, grabbed his robe—tying it snugly around his girth, and found his keys on the top of the bureau. With his eyes already accustomed to the dark, he set off down the stairs and out through the back way. For a moment he was startled at the sculptures, with their long shadows in the moonlight. It was as though the courtyard held a small, milling crowd. Père Michel let himself out the gate and trotted across the churchyard at a brisk clip. He entered the church from the back—into the labyrinth of small rooms behind the altar. He tiptoed forward and peeked through the openwork of the reredos.

It was Hélène and Roger. In the middle of the night, no less, they were up, decorating the church. Of course, Hélène had keys, but Michel was dazed by it all. It was so beautiful, so unexpected. Perhaps, perfect. There were flowers, naturally, but she'd also made draperies—vast swags of flowing, black fabric along the side walls of the church. Each section gathered in a bow. Well, not exactly a *bow*, but something like a large, flat fabric peony, centered below each of the Stations of the Cross. The fabric was a honed satin, not shiny, but richly nuanced and nearly reflective. Mixed in, with the drape of the swags, were bands of burgundy ribbons. He had never seen anything like it. It was dramatic and still understated. With tears filling his eyes, Père Michel slowly and carefully backed up and made a quiet retreat to the rectory. Back in his room and now, wide awake, Michel sat on his bed, in awe and wonder. After a bit, he slipped down to the floor next to the bed, and kneeled in prayer.

Armed with doughnuts, Claudette and Jean Luc made their way over to the Maisonneuve's. Claudette was grinning and shaking her head, with three large boxes cradled in her lap.

"You can wipe that smile off your face. *You'll see.*" Jean Luc was convinced that a minimum of six dozen doughnuts, were absolutely necessary. They stopped to unlock the chain gate and

slowed to check and see who it was, moving around the family graveyard. Jean Luc slipped out, and when he recognized Marc and Bill, finishing up the tombstone installation, returned to the truck for a half dozen doughnuts. Claudette couldn't help but laugh out loud.

"That's… that's doughnut pandering," she called after him in French.

He turned back to her and flashed an impish grin. When he returned to the truck he was still smiling, smugly. "They want more. I told them there were plenty, to come on down to the kitchen when they're ready."

Now, Claudette laughed *with* him. Maybe they *did* need all those doughnuts, after all. Jean Luc pulled the truck up behind the farmhouse and stepped around to release Claudette from beneath the boxes. He followed her up the stairs carrying the load. They found Françoise in her robe, in the kitchen.

"Maudit!" she exclaimed, as she peered into the top box. "What's with all the doughnuts?"

"You just watch," Jean Luc answered, "These will disappear, soon enough." Françoise didn't look convinced, but she put a selection on a platter and set out a stack of plates for the breakfast table. Guillaume came in, uncharacteristically dressed in jeans and a plaid flannel shirt.

"Ah, *doughnuts!*" He took a plate and selected two. Françoise rolled her eyes. Claudette laughed. Jean Luc grabbed a plate and took two, as well.

Claudette's eyes opened wide. "Jean Luc!" Françoise laughed.

"He just ate a big breakfast *and* a couple of those things on the way over." Claudette explained.

Jean Luc changed the subject, pointing at Guillaume's clothes. "You can try to dress like me, but you're not gonna fool anybody."

Guillaume laughed, "I want to clean up around the graves a bit after the boys finish up."

"Let me give you a hand with that, eh?" Jean Luc grabbed the coffee carafe and several cups. He poured for everyone. Quietly, Françoise took a plate and snuck a doughnut. Everyone laughed.

"Up at Edna's," Jean Luc jerked his head in the direction of town. "There's talk we'll have a full house today," clearly reveling in the small town, business talk.

Guillaume paused before sipping his coffee, "Based on what?"

"Motel's full. They had to send some folks up Point Aux Roche way. *And,* Edna's made extra doughnuts, cause of the numbers." Jean Luc grinned.

"Press?"

Jean Luc shrugged, "Some, I suppose. And, some returning locals, some Art people."

"Hardware open?"

"Till noon. Gotta let the farmers get their stuff for the week, then we're shut down for the rest of the day."

"I'm worried about there being enough seating in the church, for townsfolk. I don't want them squeezed out by the reporters." Guillaume looked serious.

"I wouldn't worry," Françoise said, "The telephone calls gave locals the right time. The Press release said forty-five minutes later." She winked. "I think we can assume that the only reporters that will know the right time will be Estelle's people."

"That's sly. Who's idea was *that?*" Guillaume was impressed.

"I think Josette and Estelle came up with that one." She replied.

Jean Luc stood up, "Well, that's one way to get an exclusive." He put his empty plate and cup in the sink. He looked at Guillaume, "You ready?"

Guillaume leaned over and gave Françoise a kiss. "Back in a bit." He pushed away from the table and joined his cousin, who was already half-way down the back steps.

Ben, Estelle and Rosemary were doing the sculpture tour in the rectory's courtyard. Most of it they'd already seen in Oakville. They kept their voices low, conscious of their intrusion at this early hour. They started with the *Pleasure Forms*—one each from Rosemary and Robert's collections. For this display, they'd perched them on slate, stepping stones. Estelle bent down to see these strange, amorphously-sensuous pieces. One was carved of

199

white marble, the other of soapstone. Ben loved these sculptures and was anxious to see Estelle's reaction.

After studying them, individually and then back and forth for comparison, she stood up and announced, "Yup. I can't say why, but they're certainly not *PG-13*. They're beautiful *and* they're the sexiest pieces of rock I've ever seen!"

Ben winced, "Shhhh." He pointed towards the house.

Estelle put her hand to her mouth in a wordless, "Oops, sorry." And then, softer, "Is there any way these could be lifted up some? They don't display well on the ground." Ben nodded.

Rosemary chipped in, "Maybe we could displace a saint or two from their pedestals, you know, just for the day."

"That's what you might call, *The Sacred and the Profane.*" Ben said, "Let's put Robert on that. He has a way with Père Michel when it comes to aesthetics."

"What's that? Did I hear my name attached to some kind of plot?" Robert came down the back steps, coffee in hand. He joined them and immediately saw the problem. He scanned the yard. "Most of these need to be up at least three feet." He looked at his watch. "I'll get on the horn to the museum in Windsor. They'll have proper pedestals and I know we can get them on loan." He counted soundlessly.

Ben smiled, "See?"

He took Estelle by the elbow and led her to what appeared to be a white cube, about 18 inches square, with a Plexiglas cover. She squatted to see it closely. The top of the otherwise smooth white surface had a channel cut into it, about two inches wide, with little, white piles on either side. She got down on her knees and peered into the channel. There, in the semi-darkness of the trench, well below the surface of the piece, was a small bronze figure of a man shoveling snow. She laughed out loud. "I love it. What's it called?"

Snow day, answered Robert. "I love it, too. I bought it the minute she showed it to me. This agent thing can be a dangerous business."

Robert guided her to a bronze—a man standing with a leaf rake, knee deep, in a pile of fallen leaves. Behind him the pile was taller, up to his hips. He was wearing a baseball cap, with his head tilted up to the skies, and his free hand shielding his eyes from the

glare. Estelle nodded. "Yeah, I've been there. Checking the trees to see how many leaves are left and wishing for snow. These are funny. Now I know why you said they were Canadian. What did Guylaine call this one?"

Rosemary answered, "She never really gave it a name, but I've always called it, *Waiting for Winter*. Did anybody notice that it's Jean Luc?" They all examined it more closely, and nodded in recognition.

"It took me awhile to figure it out, too. Guylaine never said anything."

Ben stepped back into the role of tour guide, "And this... is one of the pieces I had Bill and Marc bring up from Oakville. Guylaine called it, *Canadian Gothic*."

It was about three-quarter sized—two figures, an elderly couple clad in street clothes and winter jackets, barely touching as they stood together. In a heartbeat one recognized that it was Guillaume and Françoise. The man held a snow shovel, blade up, à la *American Gothic*. The woman wore a bib apron, over her coat. She held the apron outstretched by its hem, with one mittened hand creating a pouch filled with rock-salt. Her other hand, bare, was broadcasting the salt. Both faces were serene—happy without smiling, leaning almost imperceptibly together, connected both physically and emotionally. It was stunning and humorous at the same time.

"Have Guillaume and Françoise seen this?" Estelle asked Ben.

"Not yet. They'll get to see it after the service."

"They'll cry. I'm ready to cry, and it's not even of me." Rose actually *was* tearing up.

Ben stepped back, "Yeah, but it's such a tribute that they'll be *happy* tears. I think it's one of her best pieces."

They stood, admiring the sculpture.

Estelle broke the silence, "Would it be okay if I got a film crew in here, before the service?"

Robert and Ben exchanged glances and shrugged.

Robert said, "Well, I'd hate to have them filmed without proper pedestals." He looked at her slyly and added, "I'm sure we could work something out, if *they'd* stop in Windsor and pick them up from the museum on their way here?"

Ben's jaw dropped. "*You*, Robert, are amazing. What do you think, Estelle?"

"For an exclusive, like this, they'd give their firstborn."

Ben backpedaled, "But not the Labute piece. They can't film it. It can be on display, for the public, but he does *not* get center stage for this event. Not today."

Before Estelle could ask, Ben said, "Show it to her, Rosemary, please." He looked almost stricken. He backed away, walked over to the patio and sat down. Robert followed, and took the chair next to him.

"Good call." Robert reached over and put his arm around Ben. "*I* should have caught that."

Rosemary took Estelle's hand, leading her over to the sculpture of the protester.

Quietly, Robert asked Ben, "How are you holding up?"

Ben shrugged. "Ask me tomorrow."

Robert nodded. "I'm sorry I couldn't reach you... you know, after. There I was, *stuck* in fucking Lichtenstein."

"It's okay. I dropped a couple of balls, too." Ben was remembering Cathy.

Robert flared, "No, it's not okay. None of this is *okay*. It really pisses me off—here's this wonderful family, pulling so hard for everything to work out, to honor her. So many people loving her, missing her. And, *that* bastard is *still* holed up at Crowsfoot."

Ben held up his hand, "I know, but right now, I can't go there. It doesn't help."

Still seething, Robert muttered, "If I had a rocket launcher..."

Ben laughed, "It's funny. The first few days, I couldn't get that song out of my head."

"I couldn't get the image of *Third of May* out of mine."

"The Goya? Me, too."

"What is it, the curse of art history? I was stuck in the damn airport, couldn't get a flight out and the image of that painting whacked me every time the newsreels started in about the situation in Canada."

They looked at each other and laughed.

"Being here has helped," Ben said, "Spending time with history, and with the stories." He looked out at the sculptures. "I

meant it. *Ask me tomorrow*. I don't know what to do, how to go back."

Robert paused. "You work, you teach. You fix the meals you loved together and invite people over. You promise never to forget, even while wishing you could. And then, it's not there every day, the loss. Sometimes you notice and feel unfaithful, but you keep living and loving. In your case there's so much good to see, and share. There's all that incredible work." He stopped, tears running down his cheeks. "She loved you, and that *never* goes away."

Ben sat looking at the sculptures. Most of them were tributes. Tributes to loved ones. Cherished moments or perspectives and to humor. His cheeks were wet, but he felt buoyed by the work, by all these people. *Family.*

Père Michel came down the steps and put his hand on Robert's shoulder. "You doing my work?"

Robert smiled. "We're *all* just doing the Lord's work."

Michel laughed. "Françoise called. She wants you to know that if anybody's hungry, they got fresh doughnuts. The odd thing is, when she told me that, people in the background started laughing." The priest shook his head.

He then looked out at the sculptures, "You know they're placed well, but you got to lift them up. This here is an exhibit for dwarves." Now, Ben and Robert were laughing.

Guillaume and Jean Luc finished the last bit of raking. Guillaume picked up the leaves and garden debris and carried it down to the river. Jean Luc grabbed their tools, walked out to the driveway and waited for Guillaume. He heard a car and turned. It was Josette in her Mercedes, with the boys. She stopped and the window rolled down.

Sonny leaned out, "You need any help Jean Luc?"

"Thanks, but you just missed all the fun, eh. We're done." He smiled, "Head on in. There might be a doughnut, or two, in the kitchen. Tell your grandma that doughnuts make it perfect."

"You want a ride?"

"No thanks, I'm waiting for your granddad. We'll be up in a few minutes."

The car pulled away just as Guillaume stepped out from the trees. "Was that Josette?"

"Yup, *and* the boys."

"How did they seem?"

"Everything looked okay to me."

Guillaume relieved Jean Luc of some of the tools and they started towards the house. Overhead the sky was clear, but it was filling with what was now, a familiar, low rumble.

Guillaume looked up, but couldn't see them. Jean Luc saw them first and called it, "Helicopters."

Guillaume nodded, "Yeah. Here they come, again." The two old men continued up the lane.

Chapter 30

Père Michel sighed and set down his pen. The house was still—he'd sent everyone back to the Maisonneuves' so that he could finish this. He was surrounded with crumpled and discarded papers—early skeletons of this final draft. Staring at the wrinkled pages, he barely recognized his own looping, rangy scrawl, marching across the foolscap. Taking up his pen once again, he collected the newest version and neatly numbered each page at the bottom, circling the page number before moving on to the next one. He reminded himself that *regular* sermons were much easier.

He glanced at his watch. He still had plenty of time to shower, dress and compose himself before the Mass. In his almost fifty years as a priest, Michel had learned to control, but never tamed, his anxiety over speaking to his congregation. Every week it was in his prayers. *His* was no ordinary phobia. Since the seminary, Michel had been daunted by the weight of speaking *for* God. He did not have a problem in most other circumstances but, in church, he felt compelled to test every word for its purity, to ensure that it was not merely him speaking. Even after all these years, he doubted his soundness as a vessel of the word of God. Only prayer and reflection, each week, opened his heart and renewed his faith enough to lead him to the pulpit. Today carried the extra burden of an overwhelming, personal loss.

In his heart Michel believed that Guylaine was a work of God—flawed, loved, imperfect. Somehow, what came from her in her religious sculptures—always came pure and direct. He looked down at his hands, still shaking from the fervor of finding the right words. The hair on the back of his hands glinted silver. Michel was no longer a young man. Age had come, gradually, as a relief. The life of a priest was fraught with the temptation of professional intimacies. Less so, now. Michel looked down and chuckled. It was an odd reflection for an elderly priest, clad *only* in his underwear, sitting in his office, writing a eulogy. He straightened and jogged the stack of papers, then laid them flat and smoothed them with his hands. It wasn't perfection, but delivered with any measure of gravity, these words would do. He sighed again. He was dog-tired.

Michel pulled back the curtain and peeked out, down the street. The parking lot at, the funeral home, was full. That would be the Press, since the Maisonneuves had been careful that none of the memorial events would take place at the family business. Michel wondered whether Josette's planned slight-of-hand could work in so small a town. He shrugged. He'd do what he could. He rose and headed for the shower, buoyed by that feeling of floating, of a shimmering unconnectedness that comes with fatigue. He'd planned that he'd just wear his standard, black soutaine. He didn't want it suggested that the funeral for a family intimate should reflect a change of attire more appropriate to a higher holy day, or to the festival of a saint. Still, since he'd seen the elegant bunting Hélène had installed, he'd wondered whether he shouldn't make some special effort. Was this vanity? Michel loathed any inkling that he, too, might be playing to the cameras. Opening his drawers, he selected an *alb* with black and grey embroidered sleeves and hem. With his regular cassock, this would be understated enough, and yet, still subtly integrated with Hélène's efforts. He grinned at the thought of accessorizing like a woman. Tipping his head back, he thought of the various chasubles and matching stoles he had in the clerical, linen chests in the church. Surely there was a black and white or grey and white—he squinted, searching his memory. This was the sort of decision that his housekeeper usually helped him with, but he dared not ask today—dared not give the impression of preferential treatment. He tightened the cincture over his alb, hoping he hadn't gained weight, and wondering, *Does this soutaine make me look fat?* Straightening up, he pulled on the black cassock and fastened the long line of covered black buttons up the front. He smoothed the placket with his hands and glanced to the mirror. *This would have to do.* As a last touch, he opened his top drawer and selected two linen handkerchiefs and, after dabbing at the line of perspiration already on his upper lip, stuffed them in his side pocket. He gathered up his sheaf of papers and let himself out the back door. Looking up at the garden, from the steps, Michel saw that Guylaine's sculptures had been raised up on plain white pedestals. The day was bright and he stood for a moment to admire the effect, nodding in approval—it looked good. At the garden's gate, he was brought up abruptly and, realizing it was locked, Of course, precautions were necessary

today. He fumbled around in his pockets for the key and, after letting himself through, carefully relocked the gate behind him.

As he made his way to the back of the church, he noticed a lone helicopter hung in the sky at the end of the block. Around the edge of the shrubbery he could see that the church parking lot had filled early. He stepped up his pace and entered quietly. Once inside, he stopped for a moment, to let his eyes adjust to the subdued light of the church interior. The altar boys were already there, suiting up. Père Michel nodded, and then, looked again. Donald, Hélène's oldest, was dressed and had stationed himself at the linen chest. He was sorting through it and had already selected several choices for the priest's chasuble and stole.

"Donald?"

"Yes Father?"

"Wouldn't you rather sit with your family?"

The boy paused. "No sir, I'd rather do this."

"Today, your mother might need you."

Donald looked up and met his eyes. "My mom has Daniel today." Donald dropped his eyes, "She was my aunt and I loved her."

Père Michel swallowed and nodded. He put his hand on the boy's shoulder. "You know that once we start, you can't change your mind?" He took Donald's chin in his fingers and tilted it up towards him. "Understand?"

"Yes sir. But, this… this is for Aunt Guylaine."

Père Michel reached into his pocket and pulled out one of the handkerchiefs. "Stick that in your pocket, in case you need it. Everyone will understand." Donald took it, folded it again and, pulling up his own black and white tunic, stuffed it in his pocket.

Père Michel gestured to the vestments Donald had spread before them, "And, what do we have here?"

"Mom said to pick out the black and white, or the grey. But, *I* like this one," he pointed to an embroidered, matching chasuble and stole—white with black and burgundy stitching.

"Well, let's have a look." Michel picked up Donald's choice and led the way through the hall, to the reredos. There, through the lattice work, he got a screened view of the church interior. Both sets of front doors were wide open with the sunshine streaming in. In a swath of sunshine, near the entry, the choir had already

assembled and was conferring with an animated Father Tony, who was waving his arms with some explanation. A number of young men were running back and forth, laying down wires, and calling out to one another. It was then that Père Michel remembered the event would be recorded, making him all the more nervous. Two violinists, a violist and a cellist, had been set up, with folding chairs, and were tuning up in the back corner by the confessional.

Michel looked up and, again, marveled at how extraordinary Hélène's work was. The swags of black fabric, touched with burgundy vaulted up the sides of the church, each drape pausing below one of the Stations of the Cross, emphasizing Guylaine's elegant bronzes along the way. Those drapes were repeated on a smaller scale, as pew barriers, at the ends of the two family pews in front. The black casket was already in place, surrounded by white and burgundy lilies. At the entry, the flowers were repeated, but with the colors were reversed. Michel crossed himself. He looked down at the vestments Donald had selected and nodded. "Yes, *these* are the ones." The boy grinned.

Père Michel had a new appreciation for Hélène's talents. And, this was no wedding. The challenge had been to adorn a mourning event, and yet, leave center stage to the event itself— *Hélène had done it.* Honoring Guylaine and leaving her own ego at the door. Once more, Père Michel put his hand on Donald's shoulder, "Your mother has done a beautiful thing, here. Guylaine would have loved it."

The boy's grin broadened into a wide smile. "Can I tell her?"

"Of course, after."

Donald nodded.

"We may run a little long. See to the candles, will you?"

Donald looked puzzled.

"We don't want to let them flicker and sputter out. It upsets people at a funeral. If they get too low, quietly take the snuffer and put them out. Remember to genuflect on the approach." Michel looked up to see the choir filing up to the balcony.

"Yes sir."

"You should light the candles *after* the chants, during the first musical selection, okay?"

The boy nodded.

Michel held up the chasuble. "I best get ready." He stepped out from behind the lattice, caught Father Tony's eye and tapped his left wrist. Father Tony responded from across the church, silently holding his five fingers extended, and then closed, three times. The choir would start in fifteen minutes. Père Michel knew they would sing Gregorian chants for 45 minutes while the church filled, and then, after a song to change the rhythm, the Mass would begin. Michel peered out the open doors into the bright sunlight and saw his parishioners arriving, greeting each other and embracing out on the wide stairway leading to the entry. Some wandered around, inside the church, feeling the honed, black fabric on the walls, or reaching up to touch the bronze plaques, fashioned by Guylaine many years ago, representing the passion of Christ's crucifixion. Michel turned back to the vestment room to finish dressing.

He pulled the chasuble over his head, flattening it against him, finger-ironing out any creases. He kissed the neck of the stole and laid it over his shoulders, crossing it over his breast—*the yoke of Christ*. Michel crossed himself, hands shaking, waiting for the flow of ritual to steady the tremble of his nerves and the palpitations of his heart. Returning to the reredos, he waited at the screen to see if the Maisonneuves had arrived. He wanted to greet them, to welcome them to this farewell and, he knew, to gather some of their strength and calm for the Mass. After a flurry of final checks and signals, stillness settled into the church and then filled with the gentle blended voices of the choir.

Guylaine had loved the sweet intonations of the Gregorian chants. Guillaume and Tony had arranged a selection, ordering them carefully to soar and soothe. Père Michel recognized the calming tones of *The Gradual for the Feast of the Holy Confessor*. They had begun. He hooked his fingers into the lattice and leaned forward, eyes closed, soaking in centuries of harmonies, honed for solace. Michel could not keep count of the chants, but from time to time he opened his eyes to a church filling with the faces of his history, his life in Red Wing. Around him the hushed altar boys hovered, as if on wings, setting things to rights by memory, preparing, and letting him gather his wits.

He opened his eyes and saw Hélène and Roger, standing by the door, greeting their friends and neighbors. The family pews

were still largely empty, a smattering of Parents and St. Pierres, the families of Guillaume's sisters. But, the rest of the church was nearly full. His parishioners sat in easy silence listening to the choir. Michel struggled upright and rubbed his face. A quick survey of the crowd showed that it was mostly locals. Across the back, some standing, were a few strangers that he took for reporters. He checked his watch—twenty minutes till starting time.

He turned to Donald. "Your parents and brother just arrived. Shall we go see them before we begin?"

The boy nodded and Michel offered his hand. Under any other circumstances, Donald might have declined, but not today. He was looking a little shaky. The priest wondered if his participation in the service was wise. Hand in hand, they stepped clear of the reredos and into the open church. They walked around the altar, past the closed casket and down the central aisle. Friends nodded, or stretched their hands out to shake or just touch.

As they approached Hélène and Roger, she looked up. Michel embraced her and, in hushed tones, whispered into her ear, "I thought there were *elves* in the church last night, but when I arrived, it appears I was mistaken. Clearly, *this* work was done by angels. Guylaine would weep with joy, at its beauty."

Hélène caught her breath and covered her mouth, as tears filled her eyes. She pulled Michel back in, hugged tightly, then faced him and mouthed the words, "Thank you."

Roger, having overheard, grabbed Michel's hand and shook it vigorously. Then he was holding both his hands. Finally, he just wrapped his arms around the priest, and held him tight. After a few moments, Roger let go and draped his arm, proudly, over his wife's shoulder. Michel tousled Daniel's hair before turning to Donald and complimenting him to his parents.

"He's been a great help. He selected my vestments, and picked the best of the lot, I might add." Michel saw Hélène's eye pick up the colors of the chasuble and then follow around the room, from the ribboned draperies, to the flowers and back.

Softly she said, "Yes, he did well." She rested her hand on the boy's shoulder, "Maybe there's some of his aunt's artistic talent, there." Donald blushed.

Outside the church, the limo from the funeral home pulled up and the doors opened. Josette stepped out. She opened the door to

the back seat, and assisted her mother, and father from the car. Michel's heart broke as he watched. He had never seen his friends look this small, and this old. They dressed in their usual funeral attire—clothing Michel had come to recognize on them, like the uniform of their being. But, in an odd point of departure, Françoise wore a black, veiled hat, festooned with faux, burgundy flowers. Michel noted, and dismissed it.

The Maisonneuves made their way up the steps, Guillaume with his limp, leaning on the rail. Jean Luc and Claudette close behind. They paused in the foyer, making the adjustment from the bright afternoon to the cloistered light of the church. Michel studied their reactions as they entered. Françoise was the first to see it. She gripped Guillaume's arm and pointed. Their mouths were agape, with a look of wonder spreading across their faces. To the lilting tones of the Offertory for Palm Sunday, the Maisonneuves took in the elegance of Hélène's tribute to Guylaine. Tears spilled down Françoise's cheeks—tears of healing as she realized that this pulled her fractious daughter back into the fold and into the place where they could connect and share the loss. Guillaume stood in awe. He spread his arms and turned in a circle, absorbing the quiet beauty of Hélène's gift. Guillaume took his daughter in his arms and sobbed. She melted into her father. Claudette broke into tears, whereupon her protector, Jean Luc, scooped her into his arms. Even though she already knew, Josette was equally amazed.

She embraced Michel and, looking around, whispered, "I had no idea." She shook her head in wonder. Ben, Rosemary, Cathy, Marc and Bill followed up the stairs. As they each entered, they saw the draped swags pulled up into Celtic bows at the Stations of the Cross, and they stopped, mouths open. Rosemary reached over and caught Hélène's hand. Hélène looked up and saw the appreciation on the face of her rival, and wept in thanks, into her father's shoulder.

To the rhythmic cadence of the choir's rendition of the Gradual for Maundy Thursday, Père Michel saw something he'd never seen at a funeral before. One by one, and then en masse, the members of his parish stood and turned to face the grieving family and bowed their heads in a silent homage to Guylaine, to their

communal loss and to the family that had borne so many through other losses.

The choir paused—a moment of complete silence and reverence punctuated the moment when the energy shifted. The choir settled into their final Gregorian chant, *The Alleluia for Third Christmas*. Their voices rose over the heads of the congregation, and the Maisonneuves, still touching, found their way to their seats in the front row of pews.

Père Michel leaned down to Donald, "Light the candles." He stepped back behind the reredos to compose himself for the Mass. Up in the balcony the choir sang their final notes. A silence, filled with shifting seats and settling in, was filled with the first strains of the violins, as the focus from the chants swung to the prelude to *The Shaker Song*. Upstairs, in the balcony, Hélène's friend, Cheryl, sang in a clear voice, ringing out with the familiar words, "*'Tis a gift to be simple, 'tis the gift to be free, 'tis the gift to come down where we ought to be…*" She continued in a voice so pure that every note, every word, rained down on them like fresh air.

The song ended and the congregation came out of its collective trance. Jean Luc stepped up to deliver the *First Reading*. Michel barely heard it, an obscure passage from Romans. Père Michel followed with the standard fare for every funeral, the *23rd Psalm*. Father Tony followed with the *Second Reading*, curiously also from *Romans*.

The church fell silent watching Père Michel as he genuflected, approaching the altar, in an ancient, mystical recreation of the journey up Calvary Hill. He stood before them and bowed deeply, kissing the altar. Without introduction or preamble Père Michel commenced with the funeral Mass. He extended his arms out to include the congregation and then raised them up to heaven.

Père Michel's disquiet diminished as his hands fell to the familiar rhythms of the Mass. He prepared the Host, poured the wine and water. Then, raised them on high, each time to the attentive chime of the Sanctus bells. He lost himself in the ritual cleansing of Lavabo, polishing the golden interior of the chalice with rough linen, and thus removing the stain of sin. Père Michel reflected on the pain and hurt of Guylaine's death. Here in this church there was solace. Here there was love and comfort, even in

the loss. He pondered Paul Labute, the desolate isolation and anger that drove him, the killer of love and talent. He bowed his head in prayer for all of them as he wiped his thumbs and index fingers and recited, *"Credo Domine, Adoro te devote, Dominus meus et Deus meus."* *I believe, O Lord, I Adore Thee, My Lord and My God.* He raised the Host a final time to the Sanctus Bells and was made whole in communion.

Michel completed the sacrament of Holy Communion, and then turned back to the altar, to face his flock, and to lead them in *The Lord's Prayer.* The altar boys adeptly prepared the offering for the parish, as Michel opened his missal to its scarlet ribbon and read from the Gospel. Closing the book, he led the congregation, *"Lamb of God, take away the sins of the Earth"* and they followed, *"Lamb of God, Grant Us Peace."* He closed his eyes as he heard his followers shuffling, rising and falling into the sacred queue to the communion rail. Carried by the sweet tones of the violins and the pulse of the cello, the choir struck up with, *In Heavenly Love Abiding,* for the duration of communion. Père Michel and the altar boys administered the rites solemnly and efficiently. The priest could see Donald struggling as his parents and grandparents filed up to the rail, kneeled and took communion, their faces tear stained, but composed.

Peripherally, Michel watched Ben, who remained seated with his eyes down, during the religious parts of the ceremony. He wondered what comfort he could offer this man, this very good man, who could not be reached through the message of *his* church. Ben was, he knew, suffering the greatest loss of them all, and Michel was at a loss to provide tonic for his grieving. He nodded to Cheryl, who re-ascended the stairs, to the balcony. It was time to share remembrances. Père Michel looked up and saw Father Tony signal to the musicians below.

Again, Cheryl's clear voice filled the church. The violins joined in as her voice rose in that sweet anthem, *Mon Pays.* Michel saw Ben look up, over his shoulder, and smile at the memory of the tune Guylaine had so often hummed as she worked around the house. The crowd also stirred and smiled to the familiar tune, to its fidelity to what was Canadian in their experience—the beauty of wide open space, a tradition of hospitality and, well, winter.

Michel wondered if the song, being French, played into its credence here in Red Wing. Françoise beamed.

Père Michel stood at the altar looking out. Usually, from this vantage, he felt a presence with the congregation. Today they all just seemed... far away.

"Now is the time when we ask anyone to step forward with their remembrances. Our stories are not trivial. They are our shared experience, our love, and our laughter. It is a gift to the family if you have something you can share, so that the best of *our Guylaine* lives on in our hearts. Today one of Guylaine's best friends, Rosemary Richardson, has a special story to start us off." He nodded at Rosemary, who rose and approached the altar. She stopped at the casket, laying one hand on it—the polished surface of the casket fogging over, around her hand. She sighed and straightened her shoulders before stepping up to the deacon's podium. Father Tony joined her and clipped a tiny microphone to her lapel.

"I met Guylaine in art school. She had a little studio space next to mine. We were practically on top of each other. She was a couple of years behind me but even then she was a world ahead of me artistically. I don't know if any of you know how in tune Guylaine was with music. She always listened to music. Today has been especially helpful to me, because in these songs I've been able to feel her here." Rosemary's voice caught, "I hope that these songs will always do that for me, keep her close." She propped her forearms on the podium and leaned forward to her audience. "It wasn't always that way. Guylaine used music to connect her to a particular emotional frequency, something she wanted to convey in her sculpture. She'd search for just the exact tone, find the perfect song, and then she'd play it while she worked." Rosemary straightened. "Over, and over, and over, again." The congregation giggled.

"No, No, No. I mean it. Over, and over, and over, again. It was enough to drive you crazy. So, I went to my senior advisor and complained. He said there was nothing they could do about it. It was the way she worked. Well, I learned to put up with it. Guylaine was working on a series of pietas—you know, those sculptures of Christ in Mary's lap, after he's been taken down from, the cross. It's a heartbreaking image and she picked intense

music." She paused, "I was *not* an opera fan. But, Guylaine was." She pointed Guillaume, "It's her dad's fault, really, that we became friends. From the time she was a tot, he filled her ears with music, and in particular, with opera. Her inspiration for the pietas was a piece out a Brazilian opera, the *Bachianas Brazileiras No. 5, the Aria Cantilena.* Before long, *I* knew it, too. It followed me, day and night, in my head." She looked down, then raised her head and gazed at the crowd. "It came back to me, about a week ago, when I heard she'd been killed. And, I knew I had to share it."

She nodded to Father Tony, who was with the musicians. He raised his hand and the cello led with the tempo, an almost thrumming, smoothed by the violins, which carried the tune. Rosemary joined in with a sonorous, almost keening, operatic lament. It was a mournful, tonal poem, in counterpoint to the instruments. The entire congregation inhaled and leaned forward. Rosemary's voice soared, pausing from time to time, to let the violins and viola dance and keen, with the cello marking time. Then, when the lyrical section began, Rosemary's voice rose, filling the church, and filling Père Michel, till his skin flushed with its intensity. He looked down to see his wide-eyed parishioners, their collective breath held with the beauty of it. Guylaine's parents, perhaps more prepared for this than anyone, sat awe struck, tears running down their cheeks—tears of recognition and gratitude, tears embracing the entire range of loss and love. Ben's face was in his hands. Then, the lyrical section faded back to the tonal poem, back to the comforting thrumming of the cello. The room relaxed as the final notes fell into place, with Rosemary holding that last, long high-note, taking them all by surprise. Silence reigned.

She paused, catching her breath, and placed both palms flat before her on the podium. The congregation waited.

"Well, you can see why this was *so* disturbing, at school." Everyone roared in a release of laughter. When it quieted down, Rosemary continued, "Until now, I never knew what the words meant. The tone was enough. But, in preparing for this, I looked up the translation, and it seemed especially fitting for today, *'Afternoon, a transparent, slow and pink cloud, dreamy and beautiful over all space! The moon appears sweetly in the infinite,*

Decorating the afternoon like a young lady, who buried like a dream, wishing deeply in her soul to be beautiful. All Nature cries to the sky and to the earth! The birds silence as they listen to its laments and the sea reflects all its richness. The suave moonlight now awakens the cruel longing that laughs and cries! Afternoon, a transparent, slow and pink cloud, dreamy and beautiful over all space!"'

Silence filled the room.

"It was a problem." She continued, "I asked around and found out that I wasn't the *only* student troubled by this sweetly, foreboding tune. I decided to go and talk to her, you know, as a neighbor. When I knocked at the door of her little studio, she threw it open. The music was blaring, her hair was wild and her face flushed. Behind her was the most beautiful sculpture I'd ever seen. It was just a wax maquette—you know, a model, but it was breathtaking. She was so gracious. She invited me in and we talked about art. But, I didn't have the heart to mention the music. I would never have wanted to silence that. But, I *did* have a solution." Rosemary smiled. "I took up a collection—I had no trouble getting contributions, by the way, and I bought her a really good set of headphones… with a long cord" She paused to let the giggles subside. "We picked a really crowded day at school, got as many students as we could together, and made a presentation. Guylaine was shocked. And, she was a little embarrassed, but also touched. We've been best friends ever since." Rosemary broke into tears, "And, I will really miss her."

It was an incredible reminiscence, but Père Michel knew it was trouble. Rosemary had just knocked their socks off, and *nobody* was going to want to follow. He reached for his own sheaf of worn papers as Rose returned to her seat with the family. She sat down next to Robert, who put his arm around her. Michel smiled, seeing Bill Campeau, in uniform, sitting with his wife in the family pew. He jogged the papers straight and set them down on the altar. He looked up—he hadn't noticed before, but the church was now filled to capacity, and beyond. The latecomers were wedged in, three and four deep across the back of the church. The entire town, and more, was there. The Press corps was easily identifiable—they dressed better. Père Michel watched as Donald slipped by, genuflected, and then snuffed-out all of the candles

before returning to his station. Père Michel loved the smell of smoldering wick and wax.

No one else made a move to step up to the podium. From where he stood, at the altar, everyone looked so far away. Michel rubbed his eyes. Taking his notes in hand, he stepped away from the altar and down to the casket. Making the sign of the cross with his free hand, he bowed, touching his forehead to the casket's cool, reflective surface. He rose, stepped out past the communion rail and reached out for Guillaume's hand, then Françoise's. With one hand, he held theirs awkwardly, the sheaf of scrawl in his left hand. His parishioner's were beginning to look puzzled. Michel was suddenly feeling a little light-headed. Letting go of their hands, he stepped back and steadied himself against the communion rail. All eyes were on him. He looked down at his prepared remarks. *Just what could anyone say about such a loss*?

Père Michel took in a deep breath and tossed his speech high, into the air. There, the pages separated and slowly sailed down, settling around him. The congregation gasped. Without thought or plan, Michel began speaking, entirely in French,

"On ne peut pas preparer pour ce. ...One cannot prepare for this." He looked around helplessly at the halo of papers on the floor, around him. "One cannot fathom the depth and breadth of such a loss. No matter how many times you write, and rewrite, the eulogy, it is wholly inadequate. It robs you of your breath. It makes you question *where* the goodness of the world has gone. We all suffer with untimely losses, accidents, illnesses, and the sudden breach of life's expectations. There's a gap in the flow of our lives, but it does not always come like *this*." He spread his hands in a helpless gesture. "Here, we are left to wonder, *how could this be*? How could someone so loving, so vital be silenced by such a dark and bitter cloud? Where is the Lord's plan in that?" His parishioners sat upright. This was an entirely different facet of their priest.

"I am an old man. I came to this work, long ago, as a broken, young man seeking refuge in the Church." He grinned, "It is *not* the kind of conviction that should propel you forward into the religious life." He inhaled deeply, "But, I landed here in Red Wing and with the help of this parish, and the love of God, I was mended. I credit *this* family with much of that mending," Michel

gestured to the Maisonneuves. "They have taught me to find strength in gentleness. They have been a family challenged by more than most and have, far more often than not, risen to every challenge. If you ever needed to see the Lord's work in action, you need only look to the example of Françoise and Guillaume." The congregation was nodding in acknowledgement, as Guillaume, clearly uncomfortable with the attention, looked horrified.

Père Michel laughed, "You should see his face, now. He's embarrassed." As a moving force, quiet laughter erupted from the pews. Père Michel, now, with a solemn expression, continued, "I've buried two of the Maisonneuve girls, now. It doesn't seem right. And yet, somehow, their parents find the grace to move forward. Even while *I* rail in anger, they find solace in the love of their remaining daughters, in their family, and in the embrace of their community. I am an old man, but still, I'm learning." He paused.

"Marie—Eva—Simone—Guylaine—Claire—Maisonneuve." He spoke her name with pauses between each word. Still speaking French, he continued, "Is it any wonder she shortened it for her professional work?" He shrugged. "Our Guylaine Claire has always been controversial. She came as a welcome surprise to her parents, even if her oldest sister was mortified by her mother's *abundant* appearance, at her wedding. And, Guylaine's birth was, by no means, easy. I was there when the doctors came to Guillaume and warned that they might not be able to save the mother *and* the child. I remember his words, his love of Françoise. He turned his face away from me, and told them to save his wife. As if *that* were a sin." Michel spread his arms. "I am a Catholic, and I am a priest, but even *I* don't see any sin in that. I think we let dogma get in the way of the true message of Jesus Christ—that we love one another. Even Guylaine's name was controversial. Her mother, knowing that this child would be their last, wanted to name her for Guillaume. Her father, knowing that this would be their last child, wanted to name her for Françoise's mother. He knew that nothing would touch his wife's heart more than that. Both, stubborn as oxen, each went behind the back of the other to ensure that the baby would bear the name *they* thought best. And so, she came to us, Guylaine Claire. I know; I baptized her.

218

"She was a strange and wonderful little girl. One of the happiest children I have ever known. She was always dancing or singing—singing in some strange language only she understood. Her parents said they indulged her. Her father shared his love of music. Her mother shared her passion for baking and flowers. Her grandparents adored her. The child was like sunshine. And yet, everyone thought *something* was wrong—Guylaine didn't speak. She didn't form a single sentence till she was almost four. There was no indication that she wasn't *bright*, she just didn't talk. She was loving and engaged, but silent. Perhaps the death of Lucille had something to do with it. I don't know. The love of her life, Ben Levin, put it best. He said Guylaine's first language *wasn't* language. If you knew her, you knew this was true. Guylaine was real and different to everyone she met. She resonated to your needs and, without compromising who she was, responded in a way that was unique. In the early years, we just didn't know, yet, where her talents lay, hidden. She had parents steady enough to let her grow up, in love. When you see her sculptures, you know that there's nothing *wrong* with Guylaine Claire. She was brilliant!"

Michel strode back to the casket and laid his hand flat against it. He turned and shifted to English. It wasn't clear *he'd* noticed the switch, but the reporters perked up and began writing.

"But she *wasn't* normal. There are those here, today, who think that Guylaine has no place at the Catholic table. Her life was not a traditional, Catholic life. But, her actions were always direct and true, to her. She acted, always, out of love. She questioned Catholic faith in ways that led me to wonder if maybe Guylaine might have had it right, all along. She mourned the Church's emphasis on the Crucifixion—Guylaine felt that it focused too much on suffering. She thought we should emphasize the Ascension. Wasn't *that* the promise of Jesus Christ? Guylaine was transcendent. How many of us ever thought that hard about *our* faith? It brings to mind the adage that while the faithful pray, pray for the poor, the homeless and the hungry, the good provide food, shelter and solace. Who then, does God's work? I have seen Guylaine's work. I invite you to wander through this Church and experience the fervor she brought to the images of faith. I have seen her with loved ones, family and friends. I know her, and have no doubt that Guylaine rests, now, in the Kingdom of Heaven.

The Gift of Guylaine Claire

Jesus tells us that the doors to his Kingdom were open to Dismas, the good thief who also died, alongside Christ, on the cross. How could *our* Guylaine be any less worthy? Let not the faithful rest on their laurels, question the faith of others, and let the good carry the yoke in God's work." He paused, "The amazing thing about Guylaine is that, with all her talents, she was always, exactly, just herself. She meant many different things, to different people, without *ever* changing who she was. That is the true gift, of Guylaine Claire.

Which brings me back to the hard question—how could *this* be God's Plan? How could the tragedy at Crowsfoot serve *His* purpose? I, for one, don't have the answer. I question the loss of her talents. I wonder *who* will fill her loving shoes. In my darker moments, I want vengeance against those who set the stage for her death. I don't know who killed her. I don't know *and* I don't care. But, I know that narrow, small-minded thinking brought guns to Crowsfoot, and put in motion the events that brought her life to this tragic end." He drew in his breath. "My better-self prays for those who did so. My better-self seeks reconciliation for all the souls involved. My better-self knows that *this* hard question is the ultimate question of faith. I am but a small part of God's work. *I* do not have The Plan. I do my best every day, in thought and deed, to ensure that the best of me flows through my work *and* my actions. I fall short, sometimes, as do we all. I pray for guidance. I pray for the strength to keep going, *especially* when I lose sight of His larger Plan. *This* is faith. I find my faith in our Lord. Others may find it elsewhere but my faith tells me that that is not mine to judge. Faith is the leap we take when the Lord's embrace supports us, even when we cannot feel it.

"I am not left with so empty a cup, as that here. The fingerprints of Guylaine's love, of her faith, are all around us. There's Ben. Her family. Her friends. Her art. Their response to this tragedy has opened my heart to their love. It has reminded me of the love of Jesus Christ. In the face of loss, they have pulled together in the memory of the best, of Guylaine Claire."

Père Michel stood there, impassioned. He looked at the Maisonneuves—Guillaume with his arm around Françoise; Hélène and Roger leaning together; Josette, holding Ben's hands. He looked around his parish, at earnest faces following the thread.

He saw the discarded pages of his prepared speech, strewn about the floor. He walked across them, as he returned to the altar and, turning back to the crowd he intoned. "Let us pray."

The rest of the service was fairly standard.

At the end, Père Michel looked up and addressed the crowd about logistics. "Thank you all for your patience. The family is truly moved by your overwhelming show of support. They ask for a few final, quiet moments with Guylaine Claire before the funeral procession. So, the choir is going to sing as we leave the church. Officer Bill Campeau is in charge of the details. Most of you all know Bill, so if you are participating in the procession, please follow his instructions, out in the parking lot. Later, after the burial," he checked his watch, "At about four-thirty, Ben and the family will host a dinner in the Church Hall, and my back courtyard will be opened for a garden exhibit of Guylaine's sculpture." He nodded one last time, kissed the altar and walked back, behind the reredos. He peeled off the chasuble and stole, handing them to Donald.

The choir struck up, this time with the Beatles' tune, *Here comes the Sun*, as everyone filed out of the church. Cheryl was singing the lead. Several people paused to hug or greet the family, but most talked quietly with one another, milling around outside, on the steps, before finding their way to their cars. Bill Campeau, and a few other uniformed officers, were giving directions and handing out paper funeral stickers for their windshields. It took about four songs before the church had emptied. After watching the family stand and stretch, Père Michel stepped into view from behind the lattice.

Ben caught the priest's eye. "All clear?"

Michel nodded. Ben walked over to the casket and opened it, removing a small brass urn, and then closed the lid. The waiting pall-bearers stepped up, took their places at the now-empty casket, and commenced their solemn march out to the hearse. Françoise removed her flowered hat, handing it to her sister-in-law, who put it on. Bill Campeau came in to check the status of the subterfuge.

He turned to Guillaume, "So, where do you want me to lead them?"

"I don't know, maybe out past Point Aux Roches. Not much further. That should give us the hour we need."

Bill nodded. "So, how many folks are in on this?"

Guillaume just shrugged. He and Françoise watched as their stand-ins made their way out the door, following the casket. Father Tony joined them, clad in the black and burgundy chasuble.

Chapter 31

Ben and Estelle pulled up behind the farmhouse. They could see by the cars, others were there already. But, Ben, behind the wheel, did not open his door.

"You okay?" She asked.

Ben nodded. "Just catching my breath. How'd you think it went, today?"

Estelle sat back. "It was pretty amazing. Really affirming, if not a little Catholic. And, you?"

"Yeah, same. It took me aback a bit, but," he bent his head forward searching for the words, "It was so loving. I don't know why, but that surprised me. People were all so wonderful. And, I couldn't believe Rosemary."

She nodded, "Yeah. That was an amazing story, and performance. It made you want to laugh *and* cry," she made a move to open her door. "We have a small window before they're onto us. We need to get going."

Ben stepped out and stood by the car, with the little brass urn tucked under his arm. But, he didn't start out in the direction of the family plot.

Estelle came up beside him. "Is there a problem?"

Ben laughed. "Not really, it's just… my stomach is growling. I'm wondering if there might be some doughnuts left."

Estelle slapped the top of the car and howled, "You've *got* to be kidding!" She glanced around, and then over at the back porch. "Okay, let's check. I could use a sugar fix, myself."

Ben grinned, "And, I know where there's chocolate."

"You're on, but let's make it quick." Estelle bounded towards the back entry.

They let themselves in, only to find the kitchen full. Everyone was there, munching on the last of the doughnuts and brownies. They all looked up, like they'd been caught with their hands in the cookie jar. Jean Luc and Guillaume laughed, their mouths full. There were only three doughnuts left. The *last* three in the *last* box! Ben and Estelle each grabbed one.

"I told you," Jean Luc started in on Claudette, as soon as he'd swallowed.

Claudette countered, "Well, I don't know if it counts when *you've* eaten a whole box, yourself!" Jean Luc just stood there, grinning and licking his fingers.

Daniel scooted through the kitchen, Hélène close on his heels. He checked the box, and seeing that there was only one doughnut left, he nabbed it.

"You wait a minute, young man." Hélène reached out, but Guillaume caught her arm.

"Let it go sweetie. It's been a rough day." To everyone's surprise, she swung around, and gave her father a big hug and kiss.

Estelle stood in the corner, nibbling her doughnut and drinking it all in. Ben, too. He was watching and enjoying the familial rapprochement, acutely aware that, tomorrow, he would ride back to Toronto with Robert to a new, and very quiet, life.

Françoise was rummaging in the cupboard, loading jars into a cardboard box. Père Michel looked over her shoulder. "Françoise, whatever are you doing? What ever it is, I'm sure it can wait. *We* have a funeral to finish."

She looked up, "No, Michel, Bill asked me to do this. We need it today."

The priest sidled over for a better look, "What, exactly, is so important?"

"It's just that Bill was telling the caterer about making our chutney. She asked if she could have some to serve with the stew."

Michel stifled a chuckle. Carefully, he inquired, "The *Indian* chutney?"

Françoise lifted her head and the priest saw the flash in her eyes, "Yup, *Guylaine's* Indian Chutney." And, she broke into a broad smile.

Guillaume downed the last of his coffee. "Okay, everyone, let's get this going." The family broke out of its quiet clusters and disembarked down the back steps. Père Michel picked up Françoise's box and, carrying it outside, dropped it carefully into the bed of Jean Luc's truck. Rosemary fell in step with Ben, who carried Guylaine's remains.

He turned and stopped. She stopped with him.

"You were incredible today, thank you."

She smiled. "I was happy to do it. To tell it *and* to sing for her." A tear slid down her cheek. Ben nodded, and they resumed walking. The wind was picking up a little, and dry leaves swirled in the late afternoon sun.

Rosemary snugged her scarf around her neck. "I liked the part where Père Michel tossed his speech." She smiled. "I didn't understand a word of it, but it *was* beautiful. So much better than from the altar."

Ben called ahead, "Père Michel?" The priest turned back to him. "Is there any way we could find out what it was you said, today?"

The priest blushed. "Sorry, Ben, *that* wasn't planned. It was off the cuff. I had intended the eulogy to be in English."

Françoise disagreed, "It was from the heart, not off the cuff. It's just that you've got a French heart." Père Michel bowed to her.

Estelle came up next to Ben. "You're in luck. My cameraman is bilingual. He wasn't filming, so he wrote most of it down. I'll get you a translation."

"Thank you. That would mean a lot, to me."

To nobody in particular Rosemary asked, "So, what happened to the prepared speech?" Everyone looked at each other, but nobody recalled what *had* happened to the sheets of paper that had peppered the church floor.

Hélène put her finger to her lips. Quietly she said, "Donald has them. Says they're *his*, it seems important to him."

Estelle whispered, "Can I get a copy?"

Hélène nodded.

The group grew quiet as they approached the family graveyard. As they rounded the grove of willows, they saw the gravestone. The shy brothers, Bill and Marc, were there already, their shovels and tools tucked discreetly out of sight. The dark grey, granite tombstone was stately and simple—an arched, double ogee shape, capped with a double ogee, fluted edge. Each side was buttressed with an integrated granite column. Beneath, and following the curved line of the arch between the columns, in gilded, block letters, was carved,

MAISONNEUVE.

The top, ogee edge, wrapped down and around the tops of the columns for strength, and for a finished look.

As they drew nearer, the illusion of a polished finish gave way to the message of the monument. As you faced it, the top of the right column seemed incomplete. The smooth ogee gave way to a rougher, unhewn granite surface, forming a flat pedestal on one side of the curved, top edge. Everywhere else, the stone was polished to a high gloss, but its trailing, stone edge was incomplete. There, perched on the rough stone, was a sculpted set of bronze hands, in a deep patina—women's hands, though not delicate. The right hand held a chisel and a mallet, setting them down to rest on the rough stone. The other hand, weight borne on the fingertips, was pushing off, as though taking leave of the task. Below, carved in the bottom corner of the vertical monument,

GUYLAINE CLAIRE
1958-1993

Even Ben, who'd seen Guylaine's casting-journal notes, was breathless at the serene beauty of the gravestone. She'd achieved exactly the quiet elegance she'd sought, that she'd seen in the graveyards of Paris. Ben swallowed, wishing he could tell her how well she'd done. In front of the vertical, was a substantial horizontal surface, into which were set a half-dozen round, bronze caps.

Daniel nudged his mother, "But Mom, she didn't finish it."

Hélène put her arm around her youngest son, "She didn't get the chance, honey. We never do."

Françoise, stoic all day, leaned against her husband and sobbed. Guillaume put his arm around her and squeezed. "It's beautiful, eh? Even in death, our girl was a class act." Françoise looked up at him and smiled through her tears. Guillaume looked to Ben, "How do you want to handle this?"

"I want Père Michel to bless it, if that's okay."

Père Michel came forward and made the sign of the cross, muttering under his breath, in Latin. He stepped back.

Ben looked up at Marc and pointed at the rounded cap closest to Guylaine's inscription. Marc leaned over and inserted a screwdriver into a groove, in the cap, and unscrewed it, leaving a round hole gently indented in the flat surface. Ben lightly kissed the brass urn, then, Leaning over, dropped it gently into the hole. Bill followed with shovels of earth dropped cleanly into the shaft. He looked to Ben.

"Did you decide on the cap?"

"No cap. Daffodils." Bill nodded and selecting another tool, tamped down the earth, deep in the hole. Then he finished, filling it near to the top. From his cache of tools he took out a paper bag, from which he selected a handful of flower bulbs. Bill dropped to his knees and, digging in the narrow hole, set them into the earth, and covered them. He brushed the spilled earth neatly into the tidy, shaft garden. Bill stood up and, with tears in his eyes, embraced Ben.

Ben stepped back to survey the work. All was right. Turning to the family, he said, "She lived fully, every day. She lived without regrets. And, she loved deeply. I don't know if we can ask for more." He wiped his tears with the back of his coat sleeve, "Thank you, all of you, for everything this week. I don't know what I'd have done without family. Does anybody want to say anything?"

Josette stepped forward and touched the bronze hands. She dropped her head and sighed, "Bye, baby sister. Be well." After that, they each, in turn, touched Guylaine's hands, some whispering, some silent. And, a round of hugs as they each stepped away from the loss.

At the end, Ben looked up to Guillaume, "Is there anything else we're supposed to do, here?"

"No son. That pretty much covers it." He looked around at the assembled group of mourners. "Now, we go to dinner, to comfort others."

Acknowledgements

Again, the initial thrust of getting this book out of my head, and onto the page, was the NaNoWriMo Challenge. Once it started, failure was not an option. For that I thank my family, especially my parents, my friends, and in particular those faithful serial readers, Kelly, Jane, Andreé, Irene and the entourage in Copper Harbor, cheering—coffee cups in hand—at the Gaslight General Store. Once the project reached full manuscript stage, I credit the thoughtful comments and support of Leigh, Bill, Michael-Dan, sharp-eyed Gina, and Bruce, who has a finely tuned ear and held my feet to the fire. For their wealth of publishing information, I thank the Bay Area Independent Publishers Association (BAIPA), who let me tag along as a wannabee, until I made the leap. And finally, for the transition from concept to print, from story to novel, I am deeply indebted to the relentless assistance, guidance and midnight oil of my editor-extraordinaire, Rick Edwards.

A.V. Walters was born in Canada, to American parents. (And after thirty years in California, she no longer says 'eh' at the end of her sentences.) She spent her last years there at a chicken farm in Sonoma County and began writing. Now fully recovered, she's returned to her home state of Michigan, where, it turns out, she belongs.

Look for her next book, *The Trial of Trudy Castor*, also from **Two Rock Press**.

Cover and author photos, as well as graphic designs by Rick Edwards

CPSIA information can be obtained
at www.ICGtesting.com
Printed in the USA
FSOW02n0238160517
34123FS

9 780983 217275